Bollywood dance is flowing off the screen
Bollywood is suddenly everywhere, but as S;
just anywhere. This book shows us that Bolly
adapted and adopted on the ground to mat(
national contexts. Shresthova's experiences
allow her to observe and describe these performances with a nuanced attention
to detail, while her theoretical sophistication gives us a larger framework for
thinking about what live performance means in an increasingly global, but
nevertheless always local, culture.

—Henry Jenkins, author of *Convergence Culture:*
Where Old and New Media Collide

All over the world, and nowhere,
in light and in bodies,
ephemeral but recorded,
move traverse screens that traverse continents. And all this is barely the
starting point of Sangita's book! It is about dances that emerge from inner
dreamscapes as much as they signal identity as well as multiple social locations
and expectations. I find this powerful reading, in that it makes us pay
attention to how moving images of romance, glamour, pathos, luminosity, and
physical vibrance deeply impact and even shape the daily lives of real people.
Researched with passionate involvement over years, but written thoughtfully
with compassion and drama, you will want to leap and gyrate right through
the rhythms of this book.

—Uttara Asha Coorlawala, Adjunct Professor of Dance at Barnard College
and Alvin Ailey School-Fordham University Dance Program,
New York, USA

An exciting, sensitive, accessible journey through Bollywood dance. In this
book, Sangita Shresthova, a dancer/scholar, has celebrated and contextualised
the global phenomenon of the dance of Indian cinema. It is a comprehensive,
accessible and analytical study which takes you on a journey through the
sociology, psychology, politics and artistry of Bollywood dance across the
world. It proposes new meaning and interpretation of the filmed and live world
of Bollywood dance.

—Mira Kaushik, Director of Akādemi South Asian Dance UK, London

Her artistic vision, sensitivity to her subjects, and her eye to story-tell tough
real world issues through visual performance is superb. I believe her rather
unusual Czech/Nepali cultural background allows her to traverse nuanced
cultural issues.

—Peter Sellars, theater, opera and festival director

Is It All About Hips?

Is It All About Hips?

Around the World with Bollywood Dance

Sangita Shresthova

SAGE www.sagepublications.com
Los Angeles • London • New Delhi • Singapore • Washington DC

First published in 2011 by

SAGE Publications India Pvt Ltd
B 1/I-1 Mohan Cooperative Industrial Area
Mathura Road, New Delhi 110 044, India
www.sagepub.in

SAGE Publications Inc
2455 Teller Road
Thousand Oaks, California 91320, USA

SAGE Publications Ltd
1 Oliver's Yard, 55 City Road
London EC1Y 1SP, United Kingdom

SAGE Publications Asia-Pacific Pte Ltd
33 Pekin Street
#02-01 Far East Square
Singapore 048763

Published by Vivek Mehra for SAGE Publications India Pvt Ltd, typeset in 10/13 pt Sabon by Tantla Composition Services Private Limited, Chandigarh and printed at Chaman Enterprises, New Delhi.

Library of Congress Cataloging-in-Publication Data
Shresthova, Sangita.
 Is it all about hips?: around the world with Bollywood dance/Sangita Shresthova.
 p. cm.
 Includes bibliographical references and index.
1. Deance—India. 2. Bhangra (Music). 3. Motion picture industry—India—Bombay. I. Title.

GV1703.I513S57 793.31954—dc23 2011 2011029343

ISBN: 978-81-321-0685-2 (PB)

The SAGE Team: Elina Majumdar, Swati Sengupta and Vijay Sah
Cover Design: Ratna Desai
Cover Photograph: Amish Desai (Featured dancers: Iva Fafková, Jana Floriánová and Jana Tomášková [Ta-Natyam])

To Bollywood dancers around the world

Thank you for choosing a SAGE product! If you have any comment, observation or feedback, I would like to personally hear from you. Please write to me at contactceo@sagepub.in

—Vivek Mehra, Managing Director and CEO,
SAGE Publications India Pvt Ltd, New Delhi

Bulk Sales

SAGE India offers special discounts for purchase of books in bulk. We also make available special imprints and excerpts from our books on demand.

For orders and enquiries, write to us at

Marketing Department
SAGE Publications India Pvt Ltd
B1/I-1, Mohan Cooperative Industrial Area
Mathura Road, Post Bag 7
New Delhi 110044, India
E-mail us at marketing@sagepub.in

Get to know more about SAGE, be invited to SAGE events, get on our mailing list. Write today to marketing@sagepub.in

This book is also available as an e-book.

Contents

List of Photographs

Foreword

Bollywood is unique in world cinema. What differentiates its films from those around the world is the way it integrates songs and dances into stories, whatever its genre–romance, drama, comedy, action, even horror. It is a convention which has never been questioned by anyone other than some Westernised Indian critics who think the Sun rises in Hollywood. Song and dance is expected, nay demanded, by hundreds of millions of fans across the world, impatient for Bollywood's highly entertaining razzmatazz. Its creation of sublime, emotional or foot-stomping escapism is unmatched anywhere in the world.

For decades, Bollywood was known as the "the Hindi film industry," since the language spoken by most of the actors was Hindi. It could not be called Indian cinema because that would have included films in eight regional languages, with six different scripts, seen by over a billion people. However, all Indian films follow the song-and-dance format of Bollywood, where it all began in the 1930s with the introduction of sound in films. Somewhere in the early 1990s, the word "Bollywood" replaced "Hindi films" and since then it has spread fast. It outraged old-fashioned purists who thought it sounded like a bad rip-off of "Hollywood." Right or wrong, "Bollywood" is now a worldwide brand, growing in popularity day by day. British royalty, taxi drivers in Rome, or hair dressers in New York, all want to know more about Bollywood, even if they have not seen any of its films. And Bollywood dance routines have been its most successful export ever, with dance classes in Kent, fitness routines in Los Angeles, and "Jai Ho" being performed at the Oscars. Sangita Shresthova's book, *Is It All About Hips? Around the World with Bollywood Dance*, highlights this phenomenon brilliantly.

India, the biggest film industry in the world—a thousand films a year or more, with almost six songs per film—creates thousands of melodies every year, generally filmed with stars. That is a prodigious amount of singing and dancing! As a singer, no one has been more prolific than Bollywood's Lata Mangeshkar, "the nightingale of India," who has recorded over 40,000 songs over her fifty-year career, a Guinness World Record unlikely ever to be surpassed. Indian films are unique in another remarkable way: it is the only film industry in the world that gives a nation almost all its pop music and its modern dance forms.

Sangita Shresthova, a classical dancer herself, has been an ardent advocate of Bollywood for years. I first met her when she invited me to the Prague Bollywood Festival, which she organized brilliantly in 2007, showcasing some of my Bollywood films, and, as a special honor, my epic Italian TV series, "Sandokan." She then moved to California, but did not lose her focus. This brilliant and entertaining book is the product of Sangita Shresthova's twin passion—Bollywood and dance. It illuminates the unique phenomenon that defines Bollywood films, its spectacular song-and-dance routines, while giving us a fascinating insight into its incredible international impact.

It is ironic that I have been asked to write this foreword since I am probably the only Bollywood actor who refused to sing or dance. (Psst! I did try it in a few films, but it was not my scene.) But I am delighted to write this because Sangita has written such a fine book. But, I confess, there is another reason. I love watching and listening to great Bollywood songs. When theater lights dim, and Bollywood song-and-dance numbers begin, I feel as if I am in heaven. Never mind the logic of fifteen different locations, with fifteen costume changes, all in one song. For me, Bollywood songs and dances rock, and all those who create them are real rock stars. Sangita's book tells us the whole story as never before.

Kabir Bedi

Preface

"So why are you studying Bollywood dance?" Shabina Khan, a young Hindi film dance director looks at me with undisguised curiosity. We are sitting in her private room in a rehearsal space located in Andheri, a suburb of Mumbai, India. The room opens into a dance studio, where an all-female group of dancers practices dance movements in front of a mirror. Shabina Khan has just returned from leading them through a movement sequence in their rehearsal for the Hindi film *Ek Vivaah Aisa Bhi* (2008). I smile and take a breath as I prepare to answer her question.

Over the course of my research, I encountered this question often. Sometimes it was filled with genuine curiosity, sometimes it was inflected with amusement, sometimes it was filled with excitement, and sometimes, it even bordered on mild disdain.

My decision to dedicate years of my life to understanding Bollywoood dance was not inevitable. But over the years, it became a logical outcome of the overlapping events and circumstances that defined my personal and professional interests, which eventually shaped the contours of my interest in Bollywood dance.

My first introduction to Hindi cinema took place many years ago at my cousin's pirated video rental store in Kathmandu (Nepal) where I would, on occasion, watch anything that was playing on the VCR. Most of the time, it was some Hindi movie. As the plots and stars slipped by me, it was the dances that were etched in my memory. As a product of a Czech–Nepali mixed marriage, my childhood was defined by a constant, at times painful, cultural negotiation. Born in an era that preceded the current more tolerant approaches to interculturalism, my life was littered with constant reminders of my outsider status in both Nepali and Czech societies. Looking back, I think it was in watching Hindi film songs and dances that a world of cultural mixing first welcomed me into its

midst. In the remorseless blending of movement sources and costume styles, I found a messy, yet appealing, reflection of my own scattered cultural identity.

My desire to dance led me to the study of modern dance (at Princeton University) and the South Indian dance, Bharat Natyam. Though I dabbled with Nepali classical dance forms (including the Buddhist Tantric practice of Charya Nritya), I felt a need for more structure, complexity, and, perhaps even, discipline. After many years of Bharat Natyam training, I completed my Arangetram under the strict instruction of Smt Malathi Srinivasan in Chennai, India, and went on to dance with several Indian contemporary dance companies.

But I was never only a dancer. I was always fascinated by film (and other media), particularly in non-Western contexts. I began to explore the power of media in reproductive health strategies through the Development Studies Institute at London School of Economics (LSE). It was, however, the Master's program in Comparative Media Studies at the Massachusetts Institute of Technology (MIT) and because of Professor Henry Jenkins that I finally got the courage to articulate my interest in the intersections between media and dance. Given my specialization and background in South Asian popular culture, Bollywood dance was the next logical next step. It was not long before I began asking questions about dances in Hindi films and their live performance on stages around the world. I was able to continue my research into Bollywood dance through the PhD program in Culture and Performance at the Department of World Arts and Cultures at UCLA under the guidance of Professor David Gere. On a more hands-on tangent, I became a co-founder of the Prague Bollywood Festival and forayed into film direction with *Dancing Kathmandu* (2007), a documentary about the dance and globalization in Nepal.

This is the story of how I chose to research Bollywood dance.

I have made every effort to allow the readers to encounter Bollywood dance in film and performance in this book. But Bollywood dance is, by definition, a live and filmed movement style that cannot always be adequately described on paper. Respecting this, I have created a companion web page located at www.books.bollynatyam.com to guide readers on this journey.

Acknowledgments

A project of this scale and scope would not have been possible without the support of many people, groups, and organizations.

I am grateful to many people in each city where I conducted research.

In Mumbai, I want to thank the Mr and Mrs Lulla and their lovely daughter Mumta for sharing their home with me. On an earlier visit, the same thank you goes to Mr and Mrs Pradhan. Our discussions greatly influenced the initial thoughts in this project. I also acknowledge the ongoing support from Karan Bali (Upperstall). In the Hindi film industry, I thank Shyam Tellamraju, Sumit Kumar, members of the Cine Dancer's Association (CDA), and Satyajit Gazmir. I am also grateful to all the dancers and choreographers who took the time to speak to me.

My biggest thank you, of course, goes out to everyone at the Shiamak Davar's Institute for the Performing Arts (SDIPA). I am grateful to all the dancers at the Institute who took time out of their busy schedules to speak to me. Thank you to Glen D'Mello and Rajesh Mansukhani for coordinating all my visits to SDIPA. Last and foremost, I thank Shiamak Davar for his time and permission to conduct this research.

In Los Angeles, I want to thank everyone who took the time to discuss, read, and comment on my dissertation in all its different phases. I thank Peter Sellars for his inspiration in thinking through the aesthetics of Bollywood films, Anuradha Kishore for her thoughtful commentaries, and members of the Post Natyam Collective their sensitive perspectives on Orientalism. I am also very grateful to Viji-auntie Prakash who opened her world of Bharat Natyam to me when I moved to Los Angeles. My biggest thank you goes to Nakul Dev Mahajan, NDM Productions, the NDM dance troupe, and students who made me feel welcome at all times.

In Kathmandu, I thank Sushila-fufu Badan Shrestha, who supported my research for many years and in so many ways. I wish I had told her this more often when she was still with us. I miss her terribly. I am also forever indebted to my Sherpa family (Renate and Pasang) for giving me a home in Kathmandu. I am grateful to Kiran Ngudup for facilitating the initial meetings for me. My work in Nepal would have been impossible without the support of the following organizations: Save the Children (US), STEP (Shanti Gurung and all field staff), and the Blue Diamond Society (Sunil Pant, Kumari and Rajesh). I also acknowledge support from Rajendra Shrestha, Beena Joshi, Nabin Subba, Binod Manadhar, Sunil Thapa, Deeya Maskey, Tulsi Ghimire, and Sarita Shrestha. I am grateful to Basanta Shrestha and everyone at the National Dance Center for their time, help and support. I am grateful for all their insights and observations shared over many cups of tea.

Along the way, I was helped by many people in Prague. First, there are Hanka Havliková Nedvědová and Radim Špacek, with whom I co-founded the Prague Indian Film Festival. Organizing the Festival for eight years, dealing with distribution and observing audiences respond to the films helped articulate my views and perspectives on Hindi cinema. I am grateful to David Čálek for bringing his artistry to film that was inspired by my work on Bollywood in Nepal. I am also forever grateful to the founding members of Bollynatyam: Iva Fafková, Jana Florianová, and Jana Tomásková. Together we experimented, danced and otherwise worked through many definitions of Bollywood dance. Their dancing and friendship continues to inspire me.

In Mumbai, Kathmandu, Los Angeles, and Prague, I thank all those dancers who took the time to speak to me and who chose to remain anonymous.

I did much of the research in this book while I was in the PhD program at the Department of World Arts and Cultures at University of California, Los Angeles (UCLA). As such, I recognize the support of all the members of my Doctoral committee. I am thankful for the long-term contributions of Professor Uttara Asha Coorlawala. She has supported me in my research on dance ever since I first encountered her at Princeton University years ago. I also

thank the late Professor Teshome Gabriel for opening my eyes to the world of Third and Third World Cinema. He always encouraged me to turn my dissertation into a book and the Kathmandu chapter in this book really owes its existence to his ongoing guidance. At every juncture, Professor Haiping Yan pushed me toward a deeper understanding of post-colonial theory. Professor Judy Mitoma's dedicated work greatly influenced my research and ongoing work in Nepal. Professor Christopher Waterman has been a crucial pillar of strength and intellectual support for me from the moment I arrived at UCLA. A very big thank you deservedly goes to my Committee Chair Professor David Gere whose hard work, intellectual inquiry, honesty, and thoroughness were crucial in every step of this dissertation process.

Though this project came to fruition at UCLA, the process began long ago. At MIT, Professor Henry Jenkins first encouraged me to think through Bollywood dance as reception. His work on participatory cultures greatly influenced my thinking on Bollywood dance. Joseph Houseal (Core of Culture) always encouraged me to pursue this project. Professor Joan Erdman provided suggestions throughout the journey.

This project could not have been completed without the committed support of Zhan Li who took time to review and re-review this material while it was a work in progress. His intellectual inquiry helped shape this book.

Most importantly, I want to thank those closest to me—my parents and Amish—for their ongoing and unflinching support. They stood by me and helped me through all the research travel and endless revisions.

Finally, I thank the editorial team at SAGE Publications, especially Ashok Chandran, Elina Majumdar, Rekha Natarajan, and Swati Sengupta for their guidance, persistence and patience in bringing this book project to its completion.

1

Introduction

Two silhouetted female figures in Indian ethnic clothing face each other. They heave their chests in time with the music. Their veiled faces mirror one another's to communicate a shared secret. The camera cuts to seated Rajasthani folk musicians tuning their instruments. Then, another woman enters. Face obscured, she is dressed in a bright orange backless blouse and knee-length full skirt. She balances two stacked water pots on her head and walks toward the camera. Every four beats she swings her hips. The camera lingers on her chest and bare midriff, exaggerating her hip movements. A turbaned flute player urges her on. When the woman finally lifts her veil, she looks into the camera playfully, but breaks her gaze at the last minute, to look away. She entices her audience to keep watching. These are the opening moments of the "Choli Ke Peeche Kya Hai?" (What is behind the Blouse?) song-and-dance sequence from the Hindi film *Khalnayak* (1993).

Suddenly, the screen goes black and stage lights burst into action. An uncertain twitter ripples through the audience of the Royal Opera House in London. Then, out of the wings, a veiled figure emerges and a gasp of pleasant surprise runs through the audience. The heroine from *Khalnayak* has come alive on stage! Complete in movement and costume, she brings a film dance performance to life.

Without missing a beat, she gestures and spins, and executes intricate rhythm-based combinations alongside her sexually suggestive gyrations. She is clearly a very skilled dancer. Her playful skips and innocent coyness undercut the sexual innuendo of the lyrics. The memory of the film lingers in the air as this live performance sends the audience into an enthusiastic ovation. The performer bows, laughs, and waves happily to her audience. She is Kavitha Kaur, a dancer who lives in London, and she has just finished performing "Choli Ke Peeche Kya Hai?" at Frame By Frame, the Bollywood dance symposium in the UK (*see* Photograph 1.1).

During the course of Frame By Frame—organized in 2009 by Akādemi, a foundation in the UK that supports Indian dance— soloists and dance companies took to the stage to perform live Bollywood dances. Some of the performers were primarily classical dancers "on loan" to Bollywood dance. Others, like Nutkhut, and Karan Pangali and KSPARK dancers, were formal dance troupes dedicated to the live staging of Bollywood dance in the UK. Unprecedented in its scope and inquiry, Frame By Frame brought scholars and practitioners together to share their views on Hindi film dance. Punctuated with film and live performances, and attended by film and dance experts from all over the world, the event tied "Bollywood glamour" with "salon sophistication." It highlighted the connection between film and live performance in the world of Hindi film dance. Held in one of London's most prestigious performance venues, Frame By Frame proclaimed the arrival of Bollywood dance as a live performance style.

Generally speaking, "Bollywood dance" is a term used by film professionals, amateur performers, and audiences to describe dances choreographed to songs in Hindi films. The film industry based in Bombay/Mumbai and colloquially referred to as Bollywood, has enjoyed a large global distribution for more than fifty years.[1] But, it is not just Bollywood films that are being shown all over the world. It is also their dance sequences that are performed live around the world. Bollywood dance classes have increasingly sprung up in India and abroad in response to the enthusiasm expressed by Indian and non-Indian audiences for dance movements they may have seen in Hindi films. In Germany, instructional DVDs

extol the cultural authenticity and health benefits of Bollywood dance.[2] Andrew Lloyd Webber's musical production, *Bombay Dreams*, brought Hindi film dance to the stages of London's West End and New York City's Broadway.[3] In the US, staged versions of Hindi film, (and some other Indian film) dances dominate South Asian and Indian cultural shows, where these dances become opportunities for the performance of immigrant and diasporic cultural identities.[4] In India, cultural activists lament the inability of other performance traditions to defend themselves against the popular Hindi film.[5] As the Frame By Frame UK symposium demonstrated, Bollywood dance is now really a global dance form. The proliferation of Bollywood dance through media, classes, and performances provides a powerful testimony to the current popularity of dances in Hindi films, while simultaneously suggesting that Bollywood dance allows audiences to not only watch, but also experience firsthand, their favorite song-and-dance sequences.

Live Bollywood Dance

By the early 1990s, Bollywood dance as something that was taught and learned, emerged as a popular activity amongst Indian and other South Asian communities living outside India. As the decade also brought important distribution changes to the world of Hindi film, pressure mounted on Indian film companies to exploit the commercial potential of newly accessible foreign markets, while continuing to respond to the shifting demands of urban domestic audiences. The pace of change, and expansion for producers and distributors was particularly accelerated with the introduction of new media technologies such as satellite, cable TV, as well as the Internet which helped bring a much greater range of Bollywood film dance-moves to the home audience as well as to professional and amateur live performance stages around the world. It is also this technology that brought Bollywood dance onto professional and amateur stages around the world.

Bollywood dance classes and live performances are now offered in many major and not-so-major cities around the world.

In India, specialized schools and fitness centers bring film-inspired dance classes to members of the growing middle class. Outside India, in cities like London, Berlin, Chicago, and Melbourne, Bollywood dance instructors—often only marginally connected to the film industry—have set up classes to meet the demand of South Asian and other audiences to learn and perform movements they have seen in Hindi films. In London, schools like Honey Kalaria's Dance Academy, bring Bollywood dance to the country.[6] In Los Angeles, Nakul Dev Mahajan's Bollywood Dance Studios (NDMBDS), the self-declared, "first Bollywood dance school in the nation," enthusiastically claims, that Hindi film dancing has finally arrived.[7] As the popularity of Bollywood dance grows, a new group of students—those who may not have not seen a film yet, but are aware of the trend—also seek out dance classes in their local area. Driven by local demand, Bollywood dance classes are on offer even in cities like Prague and Geneva where South Asian diasporic populations are rather small.

Live Bollywood dance is, in effect, a participatory culture based in Hindi film fandom.[8] In the process of learning Hindi film dances, students around the world have an opportunity to act out scenes from Bollywood films. But in doing this, they also begin to discover their own local and community-based meanings for these movements. In the process, they meet other people who share their interest. Through this shared mixing of the image and the imagined with the local and the experienced, live performance of the Hindi film dance becomes a participatory form of active and creative film reception. Imagination allows fans to infuse live dance performances with content that combines film content and local realities. Through this mixing of the filmic and the local, Bollywood dance becomes a performance of an actively engaged, participatory, and at times critical, film spectatorship (*see* Photograph 1.2).

As it is practiced today, Bollywood dance grows out of a symbiotic relationship between globally circulating Hindi film dances and the live performances they inspire. On the one hand, ongoing Hindi film dance productions fuel the live Bollywood dance culture. On the other hand, changing global live dance trends feed into new

film dance choreographies. A dance created for Hindi film dance can, and often does, travel around the world in many localized live interpretations, some of which may, in turn, eventually influence Hindi film dance production.

Alongside the growing popularity of Bollywood dance as live performance, changes are also underway in the Mumbai-based industry responsible for the creation of dances in Hindi films. Somewhat maligned for its commercial mixing of styles and erotic subtexts previously, the film dancer's profession is now gaining continued social respect among audiences and dancer communities. Responding to market pressures and changes in the dance industry, choreographers or dance directors continuously increase their technical demands for choreography, and dancers not trained in a particular style may suddenly find themselves sidelined in the next film. Reflecting these current dance trends, frontline dancers in big budget Bollywood films are often brought in from outside India. Recruited by agencies in their home countries, dancers from countries such as the UK, Iceland, and Ukraine arrive in Mumbai on film dance engagements. Several dancers from Russia have made this city their home. Bollywood film dance directors like Saroj Khan, Vaibhavi Merchant, and Farah Khan now enjoy celebrity status among the film industry's elite, as they jet from movie set to movie set within and outside India.

Bollywood dances in films and live performances raise questions about why these dances emerged as key ingredients of films; how their production, choreography, and cinematic content relate to film narratives; and, most importantly, how these dances are received and reinterpreted by audiences around the world. Specifically, the symbiotic migration of film dance—from a form that mixes dance traditions to a style taught and performed around the world—raises questions about the relationship between these dances in films and their performances as live Bollywood dance. What drives the popularity of Bollywood dance? Are we witnessing the rise of a new global dance form? How do we reconcile the technologically-enabled global travels of dances contained in Hindi films against local realities lived by those who perform and teach live Bollywood dance? How does Bollywood in performance

relate to the global circulation of Hindi films? In short, how do we begin to define Bollywood dance as it travels around the world?

Hindi Film Travels

The narrative use of song-and-dance, and the use of movement and lyrics to communicate are part of the global appeal of Hindi cinema. Song-and-dance sequences from films like Raj Kapoor's *Awaara* (1951), Ramesh Sippy's *Sholay* (1975), Aditya Chopra's celebratory *Dilwale Dulhania Le Jayenge* (1995), and more recently, Sanjay Gadhvi's slick and glamorous *Dhoom 2* (2006), have acquired a life of their own that spans far beyond the films themselves.[9] Through the decades, song-and-dance sequences have been a major driving force behind the global travels of Hindi cinema.

As Manjeet Kripani points out, Hindi films have enjoyed popularity in many regions of the non-Western world for many years.[10] In fact, it is very likely that Bollywood dominates the cinema of the world in terms of audience numbers in some regions of the former non-West.[11] In early postcolonial India, songs and dances in films often transcended Indian geographic and linguistic divisions. Dance also enhanced the accessibility of Hindi films to large audiences outside India, including other newly postcolonial countries, as well as those in the Communist world. While statistical data on film distribution in these regions remains scarce, the anecdotal popularity of Indian films in the Near and Middle East, Eastern Europe, the former Soviet Union, Africa, and many parts of Southeast Asia suggests that Hindi films resonated with audiences in these, often recently independent countries.[12] Songs and dances were quite central to this appeal, and aging audiences in those regions still sometimes hum along to old-but-gold melodies like "Awaara Hoon" (I am a Tramp) and "Mehbooba" (Darling) as Hindi films provided an alternative to the Hollywood fare in Asia, Africa, and the Middle East throughout the Cold War years.

While still largely undocumented, several detailed studies reveal at least some extent of Hindi film popularity in the non-Western world. Through her analysis of Indian cinema in the former Soviet

Union, Sudha Rajagopalan offers one of the most detailed analyses of non-Western Hindi film fandom and distribution. As Rajagopalan observes, the vast majority of the roughly 210 Indian films distributed in the Soviet Union from 1954–1991 were commercial Hindi films. Early films like *Awaara* and *Mother India* (1957) were enthusiastically received and honored at Soviet film festivals. Notably, Rajagopalan observes that the popularity of Indian films persisted even in subsequent decades when government support for them began to ebb, and critics scorned the "regrettable influence of Hollywood cinema in India's commercial films."[13]

In some similar ways, Brian Larkin's discussion of Hindi film consumption in Nigeria illuminates the ways in which Hindi films were received in the Nigerian local context. Observing that Indian films have been popular in northern Nigeria for several decades and exist alongside their domestic film industry known as Nollywood, Larkin argues that song-and-dance sequences are a crucial component of this popularity.[14] Seen as more closely related to local culture than Hollywood films and other media, Hindi films have, in fact, inspired local filmmakers who "borrow plots and styles from Bollywood cinema."[15] In Larkin's account, the distribution of Hindi films within the so-called Third World provides viewers with the opportunity to actively engage notions of modernity as Hindi cinema offers an alternative medium to explore postcolonial realities.

Hindi films become images of negotiated modernity that contributed to a shared imagination for emerging nations grappling with modernity issues in the postcolonial era. As Jiotika Virdi points out, Hindi films are replete with imagery reflecting upon India's postcolonial condition. For example, the Indian peasants' struggle with modernity lies at the center of the *Mother India* epic, ultimately placing the burden of nation building on the mother figure. While only one (albeit dominant) part of India's cultural linguistic film identity, Hindi cinema remains undoubtedly connected to India's national struggles. At the same time, we cannot conflate Hindi films as synonymous with Indian nation building.

Though international distribution of Indian films began back in the early days of Indian Independence, a widespread commercial

distribution of films to the West is a relatively new occurrence driven by both the growth of South Asian diasporic communities globally, as well as, general international neo-liberal policies.[16] Since the early 1990s, the Indian government implemented a series of economic reforms, which directly impacted the Hindi film industry, as lucrative and previously unavailable Western markets with their large diasporic populations with potential audiences for Hindi films became legally accessible. As India began its drive toward capitalist reforms, its ambition became increasingly clear—to claim a cultural superpower position in the post-Cold War world.[17] The Hindi film industry, increasingly known as Bollywood, races to make its mark on a globalizing world.[18]

These expansive tendencies marked a significant shift in film content, including song-and-dance sequences, which are now often integral to a film's marketing strategy.[19] In an effort to capture non-Indian audiences, many films are now edited twice—once for the Indian market and once for foreign markets. Global satellite channels like ZeeTV and B4U regularly bring Bollywood content to audiences around the world. Indian national news carefully tracks any hint of Hollywood–Bollywood "crossover" success. To cut down on piracy and increase global reach, Eros Entertainment, a Hindi film distribution company, makes select content from its films available through YouTube. The International Indian Film Academy (IIFA) awards held outside India and in a different location every year, celebrates the global reach of the Hindi film industry. At the same time, Reliance Big Entertainment Limited (RBEL), the entertainment division of the Anil Dhirubhai Ambani Group, now has a stake in Hollywood.[20] These trends suggest that we may be seeing more Bollywood in Hollywood and vice-versa.

Commercial Hindi film production and distribution structures continue to change rapidly as the industry poises itself to claim its new place in the world.[21] Producers increasingly reach for foreign investment possibilities to finance films. Film directors and screenwriters adapt film content to meet the perceived preferences of geographically dispersed audiences. New sponsors set stringent deadlines. New narratives call for new actors in new costumes. And new settings require new extras.

Dances in Hindi films are part of this process. In fact, dances in Hindi films have also become the subject of a debate as some critics argue that digressions like song-and-dance sequences are holding the film industry back. Today, many young Indian filmmakers, as they strive for international recognition, question whether dancers are necessary in Hindi films. Others argue that song-and-dance sequences are a defining characteristic that is, in fact, responsible for both the historical influence and ongoing appeal of Hindi films.

Traveling with Bollywood Dance

Today, Bollywood dance straddles a border between film and dance. On the one hand, choreographers in Hindi films still value varied choreographic arrangements to complement specific narratives and character requirements. On the other hand, the popularity of Bollywood dance as live performance clearly identifies what is an authentic Bollywood dance movement. This leads to competing definitions of Bollywood dance, both as set and fluid; codified and changing; created and interpreted.

New media technologies have been crucial in encouraging the global circulation and popularity of Bollywood dance. Of the more than 325,000 videos of Bollywood dance uploaded on the popular online video site YouTube, many document live, mostly amateur, performances set to Hindi film songs.[22] Uploaded by dancers and audiences, these performances offer some glimpses of where, why, and by whom they were performed. These videos also offer a wealth of information about the choreographic relationship between film and live performance in Bollywood dance. As with the staging of "Choli Ke Peeche Kya Hai?" at Frame By Frame UK, many dancers retain some elements of the filmed version of the dance while changing others. Bollywood dance on YouTube as a key, perhaps a defining aspect of Bollywood dance becomes apparent. Live Bollywood dance performance is expressed through, namely, the body, inevitably raising questions about the dancers themselves.

Where are these dancers located? What motivated them to dance? What meanings do the dances take on in their lives? If Bollywood dance lives between film and performance, then the meaning of this dance phenomenon can only be understood well if we follow its journeys around the world. In other words, we need to travel with Bollywood dance to understand it.

My methodological approach to understanding how Bollywood dance travels is best defined as participant observation, carried out over a period of eight years (2001–2009). Specifically, the chapters in this book trace Bollywood dances as they are interpreted, created, and produced in three locations—Mumbai (India),[23] Kathmandu (Nepal), and Los Angeles (USA).[24] In each location, a dance school becomes our entry point. My own observations and experiences combine with interviews and discussions to explore the meanings created by Bollywood dance and its associated locations.

In each location, live Bollywood dance emerges through dance schools where Hindi film dances are taught and performed. In Mumbai, the journey begins at Shiamak Davar's Institute for the Performing Arts (SDIPA). Created as a response to the increasing professionalization of the film dance industry and the rise of a new body of awareness in middle-class India, Davar's institute meets a popular demand for Bollywood-inspired dance classes as it simultaneously helps shape current trends within the film dance industry itself. In Kathmandu, the National Dance Centre becomes the initial stop for understanding the controversy of Bollywood in Nepal. Here, Bollywood dance intermingles with Nepal's troubled relationship with India, further complicated through cultural assumptions relating to dance and sexuality. In Los Angeles, we enter the world of Bollywood dance through Nakul Dev Mahajan Bollywood Dance Studios (NDMBDS). Catering to a predominantly Non-resident Indian (NRI) clientele in his dance classes, Mahajan has also become a key player in mediating Hollywood's recent increased interest in Bollywood dance.[25] In these travels, we encounter the local and global dimensions of contemporary Bollywood dance through live performances, classes, and close readings of dances in films.

In each city, Bollywood dance comes alive through live performance, classes, film spectatorship, and personal narratives. We ask: Who dances? Who watches? What is the symbolic and narrative function of the performance? Who decides what gets included? What is omitted? How does dance content change as it moves from film to stage? In what ways do performers allude to the dance in a film? What local meanings do the dances take on in each location? And, what do those meanings teach us about the relationship between live Bollywood dance and dances in Hindi films?

2

Dancing through the Decades: A Bit of Theory and History

She jumps. Her body moves, almost involuntarily. Unable to resist the percussive contagiousness of the music any longer, Rosie (Waheeda Rehman), the troubled young heroine in *Guide* (1965) breaks into a passionate dance during her touristic visit to the snake charmer in rural India. Surprised, some villagers look on. Her feet beat and skip to the beat. Her arms move with ease as they alternate between fluid movement and precise gestures. The dance is unexpected from a married woman of her class. In a frenzy, she circles faster and faster, giving into the song's stunning climax. Her dance, like the dances in other Hindi films, becomes a crucial moment to the film's story and character development.

Although the use of Bollywood dance is fairly recent, song-and-dance sequences—filmed dance sequences accompanying film songs—have been an important part of popular Indian cinema for a long time. Dances as choreographed movements set to music appeared in films soon after the introduction of film technology in India during the late 1800s. Of the roughly 1,300 silent films produced in India between 1912 and 1934, the ones that still exist suggest that rhythmically choreographed sequences existed

even in those early experiments.[1] It was, however, the introduction of sound to cinema—heralded by *Alam Ara* (1931)—that confirmed the importance of visually depicted songs in Indian films, ultimately establishing song-and-dance as a key storytelling characteristic of Hindi cinema.[2]

Song-and-dance sequences are important storytelling elements in popular Indian cinema. For example, the "Choli Ke Peeche Kya Hai?" song-and-dance sequence plays a key narrative role in *Khalnayak*, a film that loosely echoes the Hindu epic, Ramayana. In the film, Ganga (wife of Ram), the high-ranking police officer, tries to rescue her husband from public disgrace. A policewoman herself, she goes undercover as a dancing girl in an entertainment troupe to capture a felon, Ballu Balram, who escaped her husband's police custody. In the song, Ganga, masquerading as a dancing girl, dances for, charms, and ultimately lures Ballu Balram who asks her to accompany him on his escape. Ballu's affection for Ganga eventually leads him to voluntarily denounce the world of crime and surrender to the police—an act that ultimately also saves Ganga's honor. In *Khalnayak*, the song-and-dance sequence is thus a crucial moment in the plot.

Dances in Hindi films also serve other narrative functions. They may give expression to otherwise concealed secrets and desires. They allow heroines undulate in wet saris in men's fantasy sequences without compromising their reputations. They make it possible for star-crossed lovers to waltz in dreamy duets in exotic locations far away from the public, and at times difficult, circumstances of their everyday lives. They may become moments of celebration as conflicted communities escape the desperation of their everyday reality through dances reminiscent of folk festivities. They may stand in as a metaphor for sexual encounters otherwise restricted by India's norms of propriety represented by Indian censorship policies. In other cases, dancers perform a song only tangentially related to the film narrative—as a momentary boisterous release of narrative tension. In short, dances have been an important aspect of storytelling methods deployed in many Hindi films through the decades (*see* Photograph 2.1).

The narrative roles of song-and-dance sequences in popular Hindi films vary a great deal. On the one hand, spectacular "item numbers" featuring guest performers seemingly unrelated to the main narrative break the tension and provide a transition in storytelling.[3] For example, Czech model Yana Gupta's sexually charged performance to the song "Babuji Zara Dhere Chalo" (Sir, Please Walk Slowly) in *Dum* (2003) provided a moment of release in the narrative. On the other hand, specific characters perform dances that relate directly to the central plot in the film.[4] In the case of Sanjay Leela Bhansali's remake of the film *Devdas* (2001), a crucial meeting between the film's two female protagonists takes place in the midst of a shared dance. On both ends of the narrative spectrum, song-and-dance sequences often allow hidden emotions (like love, celebration, or sexual desire) and information (perhaps about a mysterious past, an illicit affair, or a secret pregnancy) to surface.

Indian film scholars argue that it was Indian theater (and its various forms), which particularly influenced commercial Indian film narrative structures through the inclusion of dance.[5] Supporting this view, Ravi Vasudevan fundamentally defines popular Hindi films as complex systems that include song-and-dance sequences and comedic subplots.[6] Building on Vasudevan's hypothesis, Lalitha Gopalan argues that songs and dances need to be recognized as parts of an alternative narrative system that defines Hindi cinema, a "cinema of interruptions."[7] Gopalan suggests that unlike the more linear storytelling common to Hollywood films, Indian popular cinema features more narrative digressions emerged from the intermixing of Indian approaches to performance and film technology. Following this reasoning, song-and-dance sequences cannot be defined simply as haphazard digressions but are crucial to telling stories in Hindi films.

In effect, many songs and dances often provide moments of what Madhava Prasad calls "temporary permission."[8] Distinguishing between the private, the public, and what is acceptable in Hindi films, Prasad proposes ways in which dance sequences provide public glimpses of the otherwise private. Focusing on the sexually charged moments in the context of India's history of censorship, Prasad

points to the charged song-and-dance sequences as moments that bypass these restrictions.[9]

This mechanism of temporary permission is particularly relevant for the three historically key female stock characters in Hindi cinema—the heroine (whose sexual innocence often approximates that of the ingénue), the vamp (whose Westernized sexual forwardness contrasts the wholesome character of the heroine), and the courtesan (a woman trained in the refined traditional art of dance and seduction). The heroine's innocence and chastity differentiates her from the vamp. Seen as morally corrupted, vamps could not become heroines. The courtesans were defined by their tragedy. Refined and skilled, courtesans are usually not able to marry and dedicate their lives to entertaining men who eventually return to their wives. Though these characters changed in response to evolving social norms of acceptability (and the vamps have faded from the scene as the roles for heroines changed), they still provide a useful analytical framework for understanding the narrative functions of dances performed by female characters in Hindi films.

The cabaret dance numbers performed by vamp characters in the 1960s are central to the temporary permission afforded by the dance. Typecast femmes fatales, Helen and Cuckoo, undulated in many dance sequences to balance out the morally restrained behaviors of the heroines of that period. In these contexts, female dancers' sensual performances existed outside conventional social boundaries.

Beyond the femme fatale performances, the temporary permission created by the song-and-dance sequences also allowed the characters to reveal otherwise hidden emotions, desires and acts. In the midst of song-and-dance, illicit love affairs may surface and lovers declare their love as the sequences make public what would otherwise remain unexpressed. As Anna Morcom observes, the changing scenery, or virtual travel allowed by song-and-dance sequences also provides a private communicative moment (within the film's narrative).[10] Of course, these private travel scenes also become opportunities for virtual tourism for film audiences.

The narrative space created by song-and-dance sequences may also give temporary permission to the character (often the

female protagonist) to behave in ways that would normally lie outside the scope of social acceptability. In "Choli Ke Peeche Kya Hai?" this temporary permission is set up through a narrative strategy that Asha Kasbekar calls "noble sacrifice."[11] In this plot device, the heroine (or hero) crosses the lines of respectability to perform a salacious dance to save a specific person (usually a loved one) or community. Through its noble aims, this potentially scandalous performance is absolved of blame for any social transgressions. One of the most popularly known examples of a noble sacrifice through dance takes place in the film *Sholay* (1975), where the heroine, Basanti (Hema Malini), dances on shattered glass to save her loved one's life. If she stops dancing, the villain, Gabbar Singh (Amjad Khan), will kill them both. In this way, the narrative creates conditions for a "respectable" woman to dance without compromising herself.

In "Choli Ke Peeche Kya Hai?" the notion of sacrifice becomes crucial as Ganga, the heroine, tries to rescue her husband from public disgrace by going undercover as a dancing girl in an entertainment troupe. Through her performance in disguise, she successfully walks a fine line between respectability and moral compromise, as she only mimics a dancing girl without actually becoming one. In an interview shown in Nasreen Munni Kabir's short documentary on the dancing in *Khalnayak*, choreographer Saroj Khan explains that she consciously incorporated this fine line in her choreography in this dance. For one, Ganga never looks directly into the camera. A direct gaze would have been too confrontational. Rather, she had her gaze coquettishly off to one corner of the frame. Khan also took great care in differentiating Ganga's movements from those of the chorus line dancers to underscore her dancing skills and professional status. This strategy, cited in the final decision not to censor the film, allowed the song-and-dance sequence to transgress and simultaneously uphold perceived cultural norms within the safe social acceptability of a dance performance within a film narrative.

The sacrifice plot device is also implicitly linked to the notion of dance as potentially dangerous—and potently sexual. This is evidenced through the recurring courtesan character in Hindi films. The courtesan in Hindi films represents women trained in the dance

of refined seduction, destined to live on the outskirts of society. Actor Rekha created a timeless rendition of the courtesan character through her performance in the film *Umraojaan* (1981). Kidnapped at a young age, Umraojaan grows up to become an artistically skilled courtesan. Yet, her unhappiness grows with her skill and her soulful dance performances are rooted in a desire for a normal and respectable life. Her dream remains unfulfilled. As the film ends, she is alone and destined to remain a courtesan for the rest of her life. Sumita Chakravarty describes the courtesan as the most mysterious historical and cinematic figure in India's public imagination.[12] A courtesan commands a certain power. She is respected for her mastery of singing and dancing, yet her profession as an entertainer and association with prostitution places her on the outskirts of society. Unlike the courtesan who is compromised by her dance, a heroine in Hindi films carries out a "noble sacrifice" through dance, and does so without ultimately compromising herself.

Song-and-Dance Connections

Historically overlooked by film and media scholars, commercial Hindi films have received more prominent attention in the last two decades. Considerable work has now been done on the relationship between Hindi commercial cinema, Indian popular culture, and more specifically Indian nationalism.[13] Similarly, several scholars have begun to investigate dances in Hindi films.[14] V.A.K. Ranga Rao and Arundhati Subramaniam paved the way with general overviews of the historical evolution of dances in Hindi films. Ajay Gehlawat forged a comparison between Hollywood musicals and Hindi film sequences to illuminate the narrative and emotional complexity of Bollywood song-and-dance sequences. Ann R. David focused on the current popularity of Bollywood dance among South Asians in UK. Kai-Ti Kao and Rebecca-Anne Do Rozario investigated implications of the imagined space created by Hindi song-and-dance sequences for diasporic audiences. More recently, Pallabi Chakravorty initiated work into the links between the Indian classical dance form of Kathak and Bollywood dance.

Anna Morcom's ethnography explored Bollywood dance in Tibet as a form that complicates China's approaches to multiculturalism. Rooted in their particular disciplines, these studies point to the historical impact, social relevance, and cultural significance of song and dance. In particular, many of these studies point to live Bollywood dance as an important aspect of Hindi cinema's domestic and global appeal.

Even as studies begin to carve out a space for Bollywood dance in academia, dances in Indian popular films are yet to be systematically analyzed. Their content, history, cultural influence, and migration remain largely unexplored.

Over the decades, recurring themes of particular periods have translated into movements, and established themselves as Bollywood dance repertoire echoing India's audience preferences at that time. At any given time, commercial Hindi films juggle profit pressures and audience preferences against national and global production values. This constant negotiation within Hindi films is captured brilliantly in the work of Ashis Nandy, who proposes a metaphor of the urban slum as a lens for understanding Hindi commercial cinema. As Nandy explains, the slum's uneven joining of the modern and traditional, the urban and the rural, the Eastern and Western is mirrored in Hindi films, which often assume a similar, conflicted rendering of the world.[15] This slum perspective provides a unique insight as it replicates the rural experience in a new context while simultaneously generating new experiences. Indian commercial films occupy the in-between position on current social realities, rooted in the past and entrenched within an imagined future. As Nandy aptly observes, "studying popular film is studying Indian modernity at its rawest." Bollywood dance in film and live performance lies at the center of the world created by Hindi cinema.

Just like Hindi films, film dances are inherently hybrid in their content and intention as they juggle national priorities with social, political, cultural, and perhaps, most importantly, profit considerations. Hindi film dances are perhaps best described as pastiche—mixing of borrowed movements to generate content. The mixing and remixing of movement in Hindi film dance evolved over time in ways loosely reflecting various changes in film content.

From their inception, the content of Indian film dance drew on a variety of Indian and non-Indian performance traditions, ranging from various folk styles like vernacular theater, including the Ram Leela, Krishna Leela, Tamasha from Maharashtra, and Parsi theater, codified Indian classical dances, and Hollywood musicals and, much later, MTV.[16] Indian elements adopted in Hindi films linked indigenous storytelling with song-and-dance.[17] Simultaneously, liberal appropriation of non-Indian dance elements linked Hindi film dance and its audiences to the outside world.

One of these influences was, and is, Hollywood. Hollywood musicals provided inspiration on several levels including method of narrative integration and interruption. At times this borrowing led to a literal adaptation of Hollywood techniques, music, choreography, and camera. Several early films further exemplify the myriad of influences and functions that have helped define Indian film dance. As V.A.K. Ranga Rao points out films like, "Modhu Bose's *Ali Baba* (1937), *Court Dancer* (1941), and B.V. Ramanandam's *Kacha Devayani* (1938) were at least in part inspired by Hollywood musicals of that time."[18] V.A.K. Ranga Rao further stresses, "Even a [Tamil] film like *Shakuntala* (1940) directed by an American, Ellis R. Dungan, deployed Anglo-Indian chorines scantily dressed in the dance of the wood nymphs."[19] Another early example of borrowing from Hollywood is S.S. Vasan's *Chandralekha* (1948), which impressed audiences with its spectacular dances, and is most often remembered for its spectacular drum dance.

As Indian film dance choreographers drew on both indigenous performance traditions and non-Indian movement, they encouraged an open, constantly evolving, and permeable popular dance culture that mirrored Hindi cinema's responses to market preferences.[20]

Throughout their existence, Hindi film dances remained inextricably tied to film music. As Nasreen Munni Kabir points out, it is impossible to speak about dance in Hindi films without speaking about the Hindi film song.[21] Music and lyrics influence movement quality as dance directors often set their dances to prerecorded soundtracks. Choreographer Farah Khan explains, "I first get the music and listen to it.... I get ideas of possible movements that will

fit the music and the character in the film."[22] These soundtracks work in tandem with the film's narrative context and help determine or alter meanings of dances. While skilled choreographers may interpret the lyrics of the song through nuanced multilayered choreography, the centrality of music, and literal interpretation of lyrics to Hindi film dance is undeniable. This close relationship between dance and music makes a fundamental understanding of the Hindi film song crucial for any investigation of film dance.

Several scholars rooted in different disciplines (most prominently film studies and ethnomusicology), have mapped the evolution, production, and distribution of Hindi film songs.[23] A pioneer in this field was Alison Arnold, who identified several defining features of Hindi film songs in her PhD dissertation:

> Among the constant and identifying factors of Hindi film song is the accompanying orchestra: prominent use of violins, the adoption of particular Indian instruments to evoke specific moods or cultural references (sitar for classical music/dance or sadness/yearning, rabab for folk or Muslim gatherings, shehnai for marriage ceremonies, etc.) and the inclusion of Western Instruments.[24]

This mixing of styles in the Hindi film song over time influenced dances in Hindi films. In-depth studies have attempted to capture the historical trajectory of Hindi film songs. Although these analyses often reveal strongly inflected taste preferences, they tend to agree on a timeline that follows key personalities and various musical styles and traditions.[25]

In his analysis, Sen identified the years between 1931 and 1955 as a key historical period for the development of Hindi film music.[26] Recorded film music that first appeared in Hindi films with the introduction of sound in the early 1930s, drew heavily on both Indian folk and non-Indian music traditions.[27] *Alam Ara*, the first Hindi "sound film" translated a Parsi theater play— itself a form defined by fusion—into film. Arnold noted that the musicians responsible for early Hindi film music generally drew on their training through Parsi and Marathi theater as well as the Bengali *Jatra*.[28] Gregory Booth pointed out that even these early

sound recordings already included sounds created in Hollywood reflecting stereotyped, orientalized versions of non-Western music.[29] As such, musicians of this era borrowed from the different music traditions and styles they encountered including "Indian and foreign folk, classical, and popular musics," their own foundations in local theater, and the "latest British or American film."[30] Technological innovations of the 1930s brought in pre-recorded sound,[31] which eventually encouraged the development of more complex choreography in films. In the 1940s, playback singing allowed movement to become even more of a staple in film songs.

Significantly, the early decades of Hindi film song occurred during the "studio era" in which many crewmembers, including actors, directors, and music directors worked only within their respective studio structures.[32] Recounting specific allegiances between music directors and studios, Biswarup Sen's analysis of this period suggests particular stylistic and narrative foundations that developed within these somewhat protected organizational structures. Later, these foundations influenced further development of music in Hindi cinema.

The 1950s saw even more experimentation with Western sound. Anna Morcom observes the clear influence of Hollywood, as melodies and musical compositions demanding large orchestras became more common.[33] This trend continued to grow in the 1960s with the entry of sounds like jazz and later rock and roll.

The 1960s and 1970s India witnessed the rise of two key music composers: Kishore Kumar and Rahul Dev Burman. These two composers, who did not grow up with Indian classical music training, defined what some have called the "second revolution" in Hindi film music.[34] Characterized by "multicultural influences," "frenetic pacing," "youthful exuberance," and "upbeat rhythms," their compositions reinvented the sound of the Hindi film song.[35] With the rise of these composers came singers such as the two sisters, Lata Mangeshkar and Asha Bhonsle, Geeta Dutt, Mukesh, Mohammed Rafi, and Kishore Kumar who came to largely dominate the industry until the late 1980s.[36]

The 1990s brought more electronic sound mixing, world music, and hip hop, most prominently defined by A.R. Rahman, India's

current film music composer superstar.[37] It is also this period that foregrounds the commercial priorities of Hindi film song. By astutely asking, "Do songs sell films or films sell songs?"[38] Anna Morcom points to the symbiotic relationship between songs and profits in Hindi cinema. Enabled by technological innovations, the film song is today both a separate commodity and a marketing mechanism for film releases. While by no means a new development (songs in Hindi films were always by definition commercial), the scope of commercialization of the Hindi film song has increased over time.[39]

Throughout the decades, with their various mixings of musical styles and the ebb and flow of musical personalities, one aspect of the Hindi film song remained constant: the songs have always been embedded in the narratives in Hindi films. To compose a song for a Hindi film, the composer and lyricist need information about the characters, narrative context, and situation involved.[40] As Anna Morcom observes, "If a character is Westernized, urban, disco-loving, and so on, then it would be incongruous for them to sing a traditional folk or classical style song."[41] The song needs to fit within the general mood and narrative moment of the film as well. A tragic moment cannot be expressed through an upbeat song. A nightclub scene cannot be set to a lyrical love song.[42]

Hindi Film Dance Histories

Reflecting the changes in Hindi film songs, dance movements in Hindi films were never, by any means, ad hoc; neither are staged reinterpretations of film dances. At every historical juncture they correspond to social expectations, narrative needs, and market demands. Hindi film dance directors continuously keep their eyes and ears open to new dance trends. As dance director Rekha Prakash explains, "I am always watching to see what is popular."[43] Bollywood dance is not simply a school of specific dance moves, it is more importantly an ongoing process of content borrowing, or more aptly, appropriating dance moves to keep up with latest trends.

Appropriation is not simply the act of taking and using without authority or permission. It is often a sophisticated process of

borrowing, claiming, and adapting content to meet one's own needs. In media studies, appropriation takes on a more specific meaning as it describes a process akin to what Henry Jenkins has called "textual poaching."[44] By appropriating in this sense, Hindi film dance choreographers not only adopt specific content as their own, but also transform associated meanings through the process. To create dances for Bollywood films, choreographers borrow from dance traditions, older films, and current global and local trends. Like the songs in Hindi films, these practices date back to the early days of Hindi cinema.

The appropriation of Indian performance traditions into early films was supported by the migration of performers and other artists from Indian performance traditions that had fallen into disrepute during British colonial rule.[45] By the time *Alam Ara* appeared on the market in 1931, the reclaiming of Indian dances as Indian traditions, crucial to India's nationalist and anti-colonial movement, were well underway. Dance scholar Purnima Shah explains that dances, in particular those considered to be classical, played a significant role in a larger political movement that valued tradition.[46] Avanthi Meduri, in her historical analysis of this revival, identifies a paradoxical situation: the fact that these dances had undergone significant transformation through social and cultural change, largely brought on by colonialism, was largely ignored by artists eager to claim them.[47] Thus, the notion of authenticity in classical Indian dance in postcolonial India was, by definition, constructed.[48] Authenticity in Indian dance became, at least in part, a "modern myth of an ancient heritage."[49]

In the case of Bharata Natyam, a dance originating from Tamil Nadu, a key controversy centered on approaches to *sringara* (or erotic desire) and *bhakti* (or devotion expressed through dance) and revealed how classical dance was appropriated into Hindi film dance. At the heart of this controversy was Rukmini Devi Arundale, a Brahmin dancer who played a key role in reclaiming Indian dance as part of India's national anticolonial awakening. In her support for the Indian dance, Rukmini Devi also encouraged their socially conservative reform—exalting the devotional aspects and downplaying the potentially secularly erotic elements of the

dance.[50] Though the work of Balasaraswati, a dancer of the *devadasi* lineage and a contemporary of Rukmini Devi, has received considerable attention in recent decades, Rukmini Devi's perspective prevailed in the public consciousness of early postcolonial India. Dance scholar Uttara Asha Coorlawala explains that at that time most hip movements were strongly discouraged and effectively edited out from the dance styles altogether. The body was repositioned to express devotion rather than erotic sensuality.[51] To be culturally and socially authentic, Indian dance had to be respectable.

This respectability was tied to a normative understanding of the respectable Indian woman.[52] To be publicly respected, dancers had to conform to a contemporary middle-class ideal of a well-behaved and sexually contained female. To accommodate this ideal for female dancers, the dance of Bharata Natyam had to be separated from any potential sexual subtext so that it could then assume the respectable role of a national dance of India.[53] Uttara Asha Coorlawala labeled this process "Sanskritization," drawing from the sociologist M.N. Srinivas.[54] Paradoxically, the process of "Sankritization" of Indian dance resulted in a loss of livelihood for many traditional dancer communities who found their profession defamed.[55]

Through a process that began with Bharata Natyam and later spread to other Indian traditional dance forms (including Kathak, Odissi, and Kuchipudi), India's classical dances re-emerged in the public as refined, bourgeois art forms. Following a similar path to classical dance, folk dance forms became associated with colorful costumes, group formations, gestures, and body positions.

As India's dance traditions underwent this systematic cleansing and change, Hindi film dance directors laid no claim to such notions of a traceable precolonial cultural authenticity. Rather, they focused on dance as part of character and narrative development as they simultaneously responded to the requirements of creating engaging entertainment. Dances in Hindi films drew on various movement styles including classical dance (thought of as religious, pure, and refined), folk dance (as communal, rural, and innocent), and non-Indian (as foreign). As they carried out their work, these film dance directors probably somewhat unknowingly participated in the creation of vernacular culture of Hindi film dance which

appealed to audiences precisely through its ability to selectively deploy, evade, and sometimes transgress moral and social boundaries.

Looking back at this period in Indian dance provides useful guidelines for thinking about the movement content of Hindi film dances. In particular, the values associated with particular dance styles allow us to engage with how movement functions in Hindi film dance and how meanings associated with particular movements shift over time. In *Madhumati* (1958), a film set in what Vijay Mishra call the "Indian gothic"[56] the quintessentially Indian simplicity and innocence of the heroine of the film, Madhumati (played by the South Indian actor/dancer Vyjayanthimala), are underlined through her dancing a folk dance with the other villagers. In *Guide* (1965), the choice to intercut between several dance styles ranging from Manipuri to Bharata Natyam, establishes Rosie's virtuosity as a pan-Indian professional dancer.[57] Stances associated with Bharata Natyam connote artistic achievement and conservative values. Much later, these connotations return in *Kabhi Khushi Kabhi Gham* (2001) "as chorus line dancers dressed in Bharata Natyam costumes execute *adavus* (set abstract movement sequences)" to accompany the hero (Hrithik Roshan) upon his arrival in London.[58] Their presence helps reaffirm his connection to Indian culture and values. In the same sequence non-Indian dancers in short dresses in the colors of the Indian flag execute several stereotypical Indian dance gestures in unison with Roshan, underlining his simultaneous global cosmopolitanism.[59]

Reflecting ongoing musical and dance trends, film dance canon—associated with particular stars, decades, characters, choreographers and contexts—emerged by the early 1990s.[60] These include Shammi Kapoor's rock and roll imitation, Waheeda Rehman's snake dance, Amitabh Bachchan's step-together-step, Madhuri Dixit's "Ek Do Teen" (One, Two, Three) routine, and Govinda's folk dance interpretations. In effect, each decade of Hindi film dance contributed its own trends to the body of movement we now call Bollywood dance. This adaptability enabled Indian (and most prominently Hindi) film dance to emerge as popular culture. As film scholar Vinay Lal points out, the fact that dances in films continued to thrive is, at least partly, because of their ability

to evade and even transgress upon strict rules imposed on other Indian performance traditions.[61] Indian film dances grew out of, and continue to thrive on, diverse movement histories and trends. A brief discussion of salient historical instances on the Hindi film dance timeline follows.

The post–Independence years and the 1950s

The involvement of acclaimed dancers including Gopi Krishna, Sitara Devi, Lacchu Maharaj, Roshan Kumari, and Uday Shankar's student Madame Simkie in the film industry linked Hindi film dance to debates surrounding dance in pre-Independence and post-Independence India.[62] In the 1950s, traditionally inflected and staged dances in Indian films sought to boost India's national confidence. Simultaneously, the influence of the Hollywood musical was felt in the editing and theme, reflecting a newly independent India's search for a postcolonial identity. The dream song and dance from Raj Kapoor's *Awaara* (1952) is a revealing example from this period. Here, Raju, the vagabond hero of the film played by Raj Kapoor himself, has a dream about Rita, the heroine played by Nargis. Choreographed by Madame Simkie, the dream sequence draws on Indian dance traditions as much as it looks toward Hollywood musicals and expressive dance techniques of the 1930s' early modern dance era in the West. The linear configurations and complementary shapes created by the dancers nod toward Busby Berkeley's attention to symmetry in his musicals. At the same time, attention to facial expression through use of the close-up on the heroine's face respects emotive or *abhinaya* elements of India's classical dance. Complimenting this interplay of tradition and contemporary, the majestic statues of Indian deities settle next to opulent art deco columns to create a mysterious, dream space.

As dancers like Madame Simkie forayed into Indian cinema, they brought their classical dance training with them. Released in 1955, R.V. Shantaram's *Jhanak Jhanak Payal Bhaaje* openly honors this legacy through classical Indian dance. The film was choreographed by the Kathak virtuoso Gopikrishna who is also cast in a leading

role in the film, which is set in a dance school that is struggling to preserve India's classical dance traditions. Respecting the dancers' movements, the camera angles in the film work in long shots and cuts to close-ups in order to highlight particular movements including footwork, facial expressions, or gestures.

1960s

In this decade, film dances continued to draw heavily on India's traditions as dancers like Vyjayanthimala rose to stardom. Though men admittedly took on a secondary role when it came to dance during this period, Shammi Kapoor's rock and roll shimmy set the fashion for dancing heroes in Hindi films.

At the same time, the hip thrust became a signature move of the vamp character in the 1960s. Given the public demands for sexually-charged content on the one hand, and behavioral constraints placed on film heroines by film censors and social norms of that period on the other, Hindi filmmakers responded through a dualization of the female role. Embodied most memorably by the Anglo-Burmese dancer, Helen, the vamp character was a woman of questionable moral standing whose sensual appeal made her almost irresistible. Simultaneously shunned, admired, and desired she dazzled audiences and heroes alike with her worldly dancing abilities.

The vamp lived outside the codes of social propriety, and often outside the narrative as well.[63] Morally suspect, Westernized and scantily clad, the vamp became synonymous with transgressive sexuality. Often her role in the films was marginal. She appeared and then disappeared, sometimes through death brought on by her moral decay. Dances performed by prototypical vamp characters demonstrated the characters' sexual forwardness, confirmed through "titillating" dances accentuated by revealing costumes, hip rotations, pelvic thrusts, chest undulations, and seductive expressions.[64] The sexually explicit dance movements were complemented by habits like smoking, drinking, and sexual promiscuity. Through her, an intensely objectifying *sringara*, or erotic meaning, claimed its space in Hindi films.

In the "Mukabla Humse Nakaro" song-and-dance from the film *Prince* (1969) we encounter the hero, the heroine, the vamp and their dances. Against the backdrop of a friendly dance competition between an Indian princess in post-Independence India (played by actor Vyjayanthimala), an incognito prince (played by actor Shammi Kapoor) and a friend visiting from abroad (Helen), this sequence becomes a brilliant display of Hindi cinema's interpretation of Indian and non-Indian dance movements for specific characters in the narrative.

It is interesting to note how rhythm plays out between the two female characters. Vyjayanthimala's movement is defined by restraint as she stamps her feet and moves in percussive, contained steps. With Helen, as the foreign visitor not constrained by local norms, it is all about the hips as she undulates, and pulses through the movement. With his twists and arm swings, Shammi Kapoor weaves between the two female dancers. These differences in movement quality came to define the boundaries of respectability for vamps, heroes and heroines in that period.

1970s

In the 1970s, soulful tragic dances glorified the courtesan character in Hindi films even as Amitabh Bachchan's strut became synonymous with the joys and travails of the frustrated young Indian man. A previously mentioned recurring character in Hindi films, the courtesan is a female entertainer deeply trained in India's performance traditions generally characterized through nuanced facial expressions, rhythmic footwork, and gestures in dances that often approximate the north Indian dance of Kathak. In a role that connotes sexual services, she generally uses her skills to entertain men. Inspired by a romanticized version of the *tawaif*s (courtesans) of northern India, the film courtesan dedicates her life to her art only to be denied the respectability of marriage. Often both revered and maligned, the courtesan in Hindi films is often destined to live in the social margins.

In the song-and-dance "Chalte Chalte," from the classic courtesan film *Pakeezah* (1972), we encounter the mourning and sorrow of a courtesan in the character Niraz, performed by Meena Kumari.[65] Unlike many other courtesan dances, here the background dancers execute most of the steps. Niraz's minimalist gestures, captured in close-up, contrast against the dancers movements shot in wide angle. Niraz only joins the dancers briefly and exits before they complete the dance phrase. Through this, the audience senses her hesitation in performing the dance. Finally, the lights dim, and a train whistle interrupts the performance, bringing it to an abrupt end. The tragic aura of the performance is amplified by the fact that this was Meena Kumari's last role as she passed away before the film was released.

1980s

Hindi films in the 1980s responded to a country frustrated with the slow pace of progress and change in the decades following India's Independence in 1947. Reflecting this stance, this decade brought a definite shift in Hindi film dance as choreographers took bolder steps to move away from the previous era of filmmaking. One such step was a more radical separation from Indian dance through an almost brazen flaunting of Western pop culture, albeit infused with the Indian style. Mithun Chakraborty's performance in *Disco Dancer* (1983), choreographed by Kamal and Suresh Bhatt, took India by storm. Unapologetically inspired by disco, the film dance responded to a demand for fresh and different content by audiences. But beyond the clearly borrowed disco movements— the jump cuts and sharp angles—we can still discern traces of Indian folk dance movements that defined a previous generation of Hindi film dance. Inspired by dancing heroes in films outside India, this period also saw the rise of Govinda, a quirky hero known for his easily imitated dance moves, who starred in the film *Ilzaam* (1986).

It was also this decade that introduced a new sensuality to Hindi film heroines as filmmakers developed several narrative and

choreographic strategies that allowed heroines to perform seductive dances without compromising their on- and off-screen respectability. Film dance choreographer Saroj Khan's nuanced, yet sensual dances became crucial to this trend. Khan's choreography of the sultry blue sari dance in *Mr. India* (1987) became legendary for its portrayal of female desire. Two years later, Khan's choreography in the film *Chandni* (1989) further established Sridevi—an actor trained in Bharata Natyam— as a sultry, yet innocent, young woman. In the "Mere Hathon Me" song-and-dance sequence we see Sridevi (in her role as Chandni) perform at a *sangeet*, a ladies-only event that usually takes place before a wedding. The dance is filled with gesture and expression, accentuated through close-up shots. Unlike the thrusts of the vamps, Sridevi's hip movements are more contained and inwardly focused. Any potentially overtly sexual movement is undercut by her innocently playful expression. At the same time, Rohit, Chandni's fiancé-to-be looks on secretly— affirming her sensual appeal. Through the work of choreographers like Saroj Khan and films like *Disco Dancer*, the 1980s saw the loosening of previous constraints on the acceptable dance movements for movement constraints for both the heroes and heroines in Hindi cinema.

Colloquially referred to as the "Oscars of India," the Filmfare Awards are generally recognized as one of the most prestigious honors in popular Hindi cinema. The awards are distributed based on a poll by the readers of *Filmfare* magazine and were launched in 1953. A testimony to the growing influence of choreographers in popular Hindi cinema in the late 1980s, the Best Choreography Award was first awarded in 1988 and that year Saroj Khan took home the prize for her choreography of "Ek Do Teen." While choreographers like Saroj Khan, Farah Khan, and Chinni Prakash have been recipients of this award on a regular basis since then, recent years have witnessed the emergence of other choreographers like Vaibhavi Merchant and the choreographic partners, Bosco and Caesar. It is notable that the Best Choreography Award came into existence in the late 1980s, right around the time when Bollywood dance began to come into its own as a taught live dance style.

In the 1990s, dances in Hindi films began to more actively engage the changing Indian urban diasporic and non-Indian audiences. Masculine, athletic movement became the staple of the hero of the 1990s, even as heroines claimed movements previously reserved for vamp characters. Salman Khan's athleticism in dance rapidly raised him to heartthrob status. Heroines like Madhuri Dixit no longer shied away from sensual performances. This decade also brought progressively increasing demands for enhanced skills on all dancers in the industry. By the time Shiamak Davar's choreography in *Dil To Pagal Hai* (1997) hit the theaters, audiences were watching the chorus dancers as much as they were watching the frontline heroes and heroines. Trained in various dance styles, but most extensively in studio jazz, Davar's dance troupe jump-started a popular dance trend in India that allowed Shiamak Davar and his company to become a large global dance enterprise. Alongside Davar's success, choreographer Farah Khan brought a new level of mastery to the interplay between dance and film through her simple yet catchy and effective choreography for the song "Chaiyya Chaiyya" in *Dil Se* (1997).

The end of the 20th century opened up new directions for song-and-dance as choreographers built on a century of Indian filmmaking. In 2000, Hrithik Roshan's dances in *Kaho Na Pyar Hai* (2000) raised the standards for male hero dancers in Hindi films and created a still increasing demand for athleticism and versatility. The film's choreographer, Farah Khan, recalled that she actually reworked all the dances after her first rehearsal with Roshan to better showcase his physical skills. In his fluid execution of fragmented up-tempo movements, Roshan exudes a masculine energy and lithe physicality. His dancing is now the gold standard in Hindi film dance.

Over the decades the notions of what constituted acceptable movement for characters changed. Men became more physical in the execution of their movement. The earlier separation between the heroine and the vamp diminished. The distinctions between dances created for heroes and those created for heroines shifted.

Dances for heroines expanded to include movements previously reserved for vamps. Dances performed by heroes became increasingly technically demanding. In addition to set recognizable movements, film dance practitioners developed conventions ranging from gestures, camera angles to costuming choices that became the staples of particular song-and-dance sequences. These movements and cinematographic conventions form a loose body of gestures and movements that contributed to the rise of Bollywood dance.

On the production side, the 21st century has also seen a continued increase in professionalization in Hindi film dance, or what is today increasingly referred to as the Bollywood dance field. Hrithik Roshan now sets a high bar in dance for male actors. Technically trained heroines like Madhuri Dixit and Aishwarya Rai are now the models of dance excellence among female dancers in Hindi films. Hindi film dance is increasingly redefining itself as a global commercial phenomenon in its own right. A film dancer summarizes her perspective on this as follows:

> Bollywood dance and music has become a way of promoting the movies. Now it's become very popular. People may remember the film because of the songs and dances. Not the song because of the movie.[66]

Dances in Hindi cinema, then, are no longer limited to their existence within a film's narrative. Instead, they increasingly live under the umbrella label of Bollywood dance, which describes Hindi film songs, movements set and imagined to these melodies, and the bodies shaped through these dance movements.

It is well known that all dance, including Bollywood, engages the body and the meanings the body in motion creates. [67] The way people move and train their bodies to dance tells a lot about how they want be perceived. For example, the strict codes of movement and costume applied to many Indian classical dances suggest a premium placed upon individual discipline and ultimately control. By contrast, the more loosely interpreted dance movements of a folk dance routine place less importance on the individual even as they privilege the group's identity. Subject to extensive analyses in the field of dance studies, the moving bodies of dancers comment

on many aspects of our lives including individual desires, cultural norms, and political priorities. In dance, the body, its training, and ultimately its performance create meanings that comment upon and influence societies and cultures.[68]

In the Indian context, explorations of the body and the meanings it creates still often grow out of postcolonial examinations of the East–West encounter. For instance, they may draw upon the influential theoretical foundations laid down by Edward Said who critiqued how the non-western body was represented under colonialism to help affirm the assumed supremacy of the colonizing West over the inferiority of non-western societies. Said observed that positioning the non-"Western" bodies as dirty, feeble, immature, and/or in need of assistance, helped justify imperializm.[69]

Informed by Said's work, several other scholars have explored the meanings associated with the body in modern India.[70] More contemporary in focus, Shoma Munshi explores the rise of the middle-class body in urban India. Munshi engages with the "Indian Cosmo Girl who goes to the gym, diets, and buys the right cosmetics," whilst critiquing the national and global mechanisms that help define sexualized female bodies within normative boundaries.[71] In the field of dance, other scholars have examined the ways in which idealized physical attributes of classical dancers (curvaceous bodies, large breasts, and round hips) became linked to nationalizm in India.[72]

Drawing on these and other studies raises many questions about the bodies of Bollywood dance. How and why are these bodies shaped? What do they communicate? And, inevitably how have these bodies changed over time? The bodies of heroes and heroines in Hindi cinema changed substantially over the past few years. The coveted voluptuous shapes of the vamps and heroines of the 1960s bear little resemblance to the gym-toned bodies proudly displayed by contemporary heroines. Similarly, the heroes of yesteryear sported less muscular physiques than the male stars of today. As we plunge deeper into understanding these bodily ideals, we need to ask what drives these changes? Who responds to them? Based in Mumbai, the next chapter explores the live and filmed bodies of Bollywood dance and how their idealized shapes and meanings have changed over time.

3

Bombay and the Bodies of Bollywood Dance

She walks down the street with her head held high. She does not hesitate or waiver. Her hip-hugging sweatpants and form-fitting t-shirt accentuate her figure. She is lean, toned, and confident. Her long hair is pulled back in a high ponytail. In her sneakers, she looks ready to move. She could strike a dance pose or break into a sprint at any instant. Her poise and confidence cut a stark contrast to the dusty hustle and bustle of Bombay's Matunga street market around her.[1] She stops and surveys her surroundings with purpose. She has a reason to be here. She flips open her mobile phone and sends a quick text message. Then, she sets out again with renewed urgency. As she pushes forward to cross the congested street, heads turn in admiration. Her name is Aneesha and she is a lead dancer and instructor at the Shiamak Davar's Institute for the Performing Arts (SDIPA).[2] She grew up in Bombay and has already danced in many SDIPA productions. She has appeared in all the Hindi films choreographed by Shiamak Davar, dancing beside the heroes and heroines. As a recognizable featured dancer, she is something of a demi-heroine herself.

Aneesha walks toward the entrance of a large hall, past the security guards who step back respectfully. She passes through the bomb detectors and enters the sharply air-conditioned lobby of

Shanmukhananda Hall. The walls are lined with stalls sorted according to the different Bombay regions—ranging from trendy Bandra and historical Churchgate, via Borivalli to the suburb of Powai. Hundreds of parents and students crowd the stalls to register for summer session classes as dancers of all ages titter with barely contained excitement. Some practice their movements in clusters; others take a few minutes to adjust their costumes and props. Still more students and their parents crowd the hallways. Other dancers supervise the scene. Shiamak company dancers dressed in identical "SHIAMAK" shirts organize the students around them with planned efficiency. They pause and wave to Aneesha as she drifts past them. She waves back but does not stop. Like the other staff, she is busy ensuring a flawless execution of the 2008 Winter Session presentations for the SDIPA's classes in Bombay. Over three days, all Bombay area SDIPA students will assemble here to present what they have learned in their classes over the last months, in addition to signing up for the upcoming season of instruction.

In neat formation, the students line up and prepare to enter the auditorium. Behind the closely guarded door, muffled music pounds. The imminent reality of performing sends a palpable shiver of excitement through the air. As the music fades, the door opens and the students file into the darkened space. They take their places in the audience and wait for their turn to perform. On stage, fast-paced remixes of Hindi film and Western pop songs pulse as students march, jump, punch, shimmy, and slide through symmetrical formations waving flags, small drums, ribbons, and banners as props. Synchronized bodies execute rehearsed rhythmic configurations with precision. Some audience members give in to temptation and dance along in the aisles. Others gesture along as they mouth the words to songs they know well. The atmosphere is of performance, competition, and party. Generous applause ripples through the room as students fall, jump, or turn into a final spectacular tableau-like pose.

Throughout the performances, the cameras roll and a judging panel of senior dancers carefully assesses the students' progress. The performers are scrutinized for how they look, move, and relate to others. Aneesha assumes her place among other judges at the

observation table. She is attentive to her task as she taps along to the beat; she circles numbers, and scribbles notes on printed evaluation sheets. Perhaps the jury will single out a performer for recruitment into one of SDIPA's junior companies. Perhaps somebody's life will change tonight.

This chapter enters the world of Bollywood dance in Hindi cinema's hometown, Bombay. A commercial hub, historically Bombay/Mumbai served as an in-between space for Indian and foreign influences. These influences, in turn, informed Hindi film content and presented them to audiences in India and beyond. Live Bollywood dance becomes a physical display of experiencing Hindi films. Here, we also encounter Bollywood dance in the context of India's current global aspirations. Between SDIPA and other locations in the city, we explore the gentrification of Bollywood dance in Bombay. This is the first stop in our mapping of live Bollywood dance around the world.

Entering SDIPA

Through SDIPA, we enter the world of Bollywood dances as they are filmed, danced, and taught in Bombay. SDIPA is active in creating choreography for Hindi films and teaching classes inspired by Hindi film dances. Their constantly expanding enterprise has grown out of, and in part, informed a new glamorous, and lean body image for India's urban populations eager to be part of India's current globalizing aspirations. Driven by Shiamak Davar's intercultural approaches to choreography, SDIPA has exerted significant influence on dances in Hindi films and the bodily images propagated through them. This influence has also informed a new mode of dance instruction in India.

Founded in Bombay in 1992, SDIPA is an umbrella organization for the work of singer, choreographer, and dancer Shiamak Davar. The Institute engages in a broad range of activities including stage shows, film choreography, and dance instruction, as well as singing and acting. It also provides employment to hundreds of dancers in several Indian urban centers. Every year, SDIPA dancers

perform Davar's choreography at many film-related extravaganzas, including the Bollywood industry's Filmfare and International Indian Film Academy (IIFA) award ceremonies. SDIPA dancers also perform in a wide range of other events, from non-profit events that feature its Victory Arts Foundation charitable trust to commercial events for major corporate clients. Sanjana, a lead dancer in Shiamak's dance company explains:

> Our shows are very varied. We do product launches, shows and Shiamak shows which are very, very glamorous with huge sets. The music varies from Bollywood songs to Western songs.... We did a show for IBM, where we showed the speed of the car...[3]

While its live performances, film choreographies, and philanthropic projects increase SDIPA's visibility in the media, it is the dance classes that make the Institute accessible to anyone interested in dance. One of the largest (if not *the* largest) dance institution in India, SDIPA organizes regular dance classes in sixteen locations in Bombay. SDIPA also runs multiple classes in twelve other Indian cities including Delhi, Chennai, and Bangalore (now Bengaluru). SDIPA launched operations in Vancouver and Toronto in Canada as well as in Melbourne, Australia a few years ago. As SDIPA consolidates its position as a global multinational dance enterprise, the Institute's managers envision a future when, at any time of day or night, "there will be a Shiamak dancer dancing somewhere in the world."[4]

With the "Have Feet, Will Dance" slogan, SDIPA makes its classes accessible to new students without prior training. "Anyone, any age, any physical level can join the classes," explains Pratap, a senior dancer at the Institute. Joining the ranks of SDIPA dancers, a select group selected to teach and perform SDIPA choreography, however, is extremely competitive. SDIPA generally promotes from within. Potential SDIPA dancers enter the organization through a beginners' class and work their way up through the Institute's hierarchical structures. Students become entry-level members in the SDIPA community. Many advanced students dream of a company contract with SDIPA. "I think about getting noticed all the

time," confides Deepti, one such student. Subtly, the Institute encourages this sense of possibility through the messages it sends to its students. As Shiamak speaks about his future project—the *Unforgettable Tour*, an international dance extravaganza featuring Indian film stars including Amitabh Bachchan—on a prerecorded message projected through video at Shanmukhananda Hall, he mentions that he may use SDIPA dancers for the show. He turns to the camera and speaks to his students directly, "Maybe it will be you!" A ripple of excitement runs through the auditorium. He advises the students to work hard in their dance classes. SDIPA holds the promise of success and stardom (*see* Photograph 3.1).

The students at Shanmukhananda Hall gush about their experiences with SDIPA. Shanti, a female student, exclaims, "Shiamak made everybody dance.... He made me dance!" Prema, a female dancer in SDIPA's company, saunters up to us. Prema begins to reminisce about how her dance career started through being inspired by Bollywood films. "I wanted to do every move that the film stars were doing". Prema relates how access to a Shiamak Davar class allowed her to learn to dance movements that she saw Aishwarya Rai perform in Hindi films. Today as a member of the Institute she gets to teach these movements to her students.[5] Prema laughs and Shanti looks at her with deep admiration. Prema embodies her dream of becoming an SDIPA dancer.

Throughout the event at Shanmukhananda Hall, similar stories are told and retold. Almost all the students express a desire to somehow participate in the world of Bollywood, and learning to move like the stars becomes an entry point into their dance encounters. "Bollywood is definitely the biggest thing in India," Pratap observes. Deepak, a male SDIPA dancer, acknowledges that many students report first encountering SDIPA dances through the media. For many of them, the television becomes their primary or at least initial source of dance content. Sunita, a female dance instructor, notes a related change in her younger new students who are starting their classes already more skilled in their movements. She compares what she sees now to her experiences five years ago when students could not even bounce to a beat on the first day of class; today

they come to class armed with dance movements they have learned practicing Hindi film song-and-dance sequences on television.[6] When asked about these developments, Chandrika, a SDIPA instructor, observes that current Hindi film dances often encourage audiences to try them, while sending a clear message that dance lessons may be helpful in mastering particular movements through professional instruction.[7] Trained in Bharata Natyam when she was young, she becomes wistful about what she perceives as the decline of classical dance as an element of Hindi films:

> I wish there was more freedom for classical dancers to be in movies. In India, if you don't see it in movies you don't even think about it.[8]

As Chandrika refers to the polarization of Bollywood and Indian classical dance, she also emphasizes the power of the media in popularizing dance beyond Hindi films through television programs and dance competitions. Deepak explains that seeing Hindi film dance acts motivates people to join particular dance schools, preferably those associated with a particular choreographer.[9] Audiences scrutinize the choreography executed by dancers and stars in Hindi films, which indirectly provide advertising benefits to the classes taught by the choreographers that created the dances.

Though SDIPA instructors insist that given his broad-ranging repertoire, Shiamak Davar's work cannot be labeled as purely Bollywood, most of SDIPA's students and many of its company dancers referenced Bollywood film dance sequences choreographed by Shiamak Davar as a key draw for them in joining SDIPA.[10] A large portion of the material taught at SDIPA in Bombay is set to Bollywood songs. As one instructor puts it, "Definitely, Bollywood is it."[11] Hindi films create a demand among their viewers to look like their film stars, and SDIPA's classes cater to this demand (see Photograph 3.2).

At SDIPA, dance becomes both an entry into experiencing movement showcased in Hindi films and a window to the world beyond.

Between India and the World

To a newcomer, finding the headquarters of SDIPA is no simple feat. "We are right by the Mahalaxmi bridge," Shameera had explained. But there do not seem to be any buildings by the Mahalaxmi bridge. It takes a while to realize that SDIPA is not by the bridge, but quite literally *in it*. It is nestled amid a row of car repair shops on a road that meanders through the *gully* (alley) before leading out onto the perennially traffic-choked main street. But all the noise of the street and the traffic fades away upon entering SDIPA. The guarded door opens into a brightly lit, mirrored and air-conditioned dance studio. The walls are lined with pictures of Shiamak Davar in various dance positions. A door at one end of the studio opens into a busy, cubicled office space. Dancers bustle between the office and the studio where a rehearsal is now underway.

Several dancers stand in front of the mirror in the dance studio. They count out eight fast beats of the music playing through the speakers. Their legs stretched out wide, feet facing toward the front, they bend forward. They lunge out to the right and hold the stretch for eight counts. Then they stretch out to the left. They allow their heads to hang even as they press themselves closer to the ground. They count out loud. In unison, the dancers roll up and jump into a closed position, their feet together and arms at their side. The techno-remix song pounds on relentlessly. The students move through their choreographed sequence eight times. "This is our time," Vinay, a male dancer, explains as he wipes the sweat off his forehead, "Shiamak expresses our India."[12] From its headquarters under the Mahalaxmi bridge, SDIPA lays claim to its unique position in the globally-oriented city of Bombay. This claim places SDIPA in a particular geographical and historical situation as a cultural juncture, economic center, and a key part of Bombay's not quite realized aspirations toward becoming a global city.

The subject of the city is a key topic of inquiries into modernity.[13] In India, no city captures the cultural imagery of the urban landscape like Bombay, the country's commercial film capital and a city of starkly differentiated spaces and dense places. Today, Bombay is also one of the leading centers of the Indian business

community's frantically paced desire to capture global markets. While the global focus of business in Bombay in the early 21st century is a product of the pro-market reforms of the 1990s, Bombay was an important trading post even before the British Raj.[14] Under British rule, modern Bombay further solidified its position as a city driven by trade and manufacturing. Simultaneously, Bombay's links to the rest of India in terms of ethnicity, worship and exchange tied the city to the domestic questions and challenges. Bombay's heritage is that of a town that served and continues to serve as an interface between India and the world through its prospering as a commercial hub with a significant, vibrant, cultural, and intellectual life.[15]

In early postcolonial India, Bombay was often seen as a metaphor for both the challenges and opportunities of urban modernity and industrialization.[16] Simultaneously outward-looking, entrepreneurial and nationalist, post-Independence Bombay experienced burgeoning growth complicated by the questions posed by the formal end of colonialism.[17] In the 1990s, injections of international capital fueled by liberalizing economic reforms, skyrocketing real estate prices, and the suppression of labor union power began to propel Bombay to aspire to the ranks of global cities like New York, London, and Tokyo.[18]

Yet, even as Bombay shifts toward a focus on finance and services and builds its membership in global capital networks, it remains, in Aparna Vedula's terms, a conflicted "global city in the making."[19] On the one hand, Bombay's inhabitants staunchly support its worldliness characterized by liveliness, lavishness, tolerance, and openness to change.[20] On the other hand, the city's population grapples with sectarian politics such as that characterized by the Shiv Sena, a political party founded in the 1960s and gained prominence in the 1980s and 1990s. In many ways, the violent eruption of communal tensions in 1992–1993 might be seen as marking what Varma labels as the "provincialization" of Bombay.[21] Bombay is caught between these simultaneous and at times conflicting views. This struggle is perhaps most tellingly symbolized by the city's renaming as Mumbai. Indian media studies scholar Parmesh Shahani notes that although "Bombay was renamed Mumbai in November

1995 by the BJP–Shiv Sena coalition government in power," many chose to continue to use "Bombay", thereby "aligning themselves with the notion of the city that is dynamic, intensely commercial, heterogeneous, chaotic, and yet spontaneously tolerant and open-minded."[22] Pitting the name of Bombay against Mumbai thus becomes a political statement. Today, Bombay occupies the border position between local and global pressures, and aspirations. Even as we witness the construction of nationalist discourses of Mumbai as a "Hindu city,"[23] Bombay maintains its openness to new ideas and social change.

Portrayals of Bombay in films are as conflicted as the city that generates them. On the one hand, directors associated with Bombay's art cinema movement grapple with the city's stark, apparently irreconcilable contrasts. In the film *Black Friday* (2004), director Anurag Kashyap delves uncompromisingly into the communal riots of 1992–1993. In *Mumbai Cutting... A City Unfolds* (2008), ten film directors come together to interpret their understanding of the city through realism. On the other hand, Bollywood films systematically erase the city's harsh realities steeped with overcrowding, extreme poverty, the desperate fight for survival and competition whilst showcasing "an assortment of landscape and tourist spots, malls, neon signs, and global brand names".[24] Replete with wealth and spectacle, these renditions of Bombay superimpose a glamorous sheen over the city. Hindi films provide a prismatic, conflicted, and, at times, selectively distorted, portrayal of Bombay.

As a key dance institution in Bombay linked to the city's film industries, SDIPA responds to—and even perpetuates—a particular cosmopolitan view of Bombay as it is imagined and experienced through Bollywood cinema (*see* Photograph 3.3).

Shiamak Davar's persona and vision drives SDIPA. Hailing from a Parsi family that runs the Davar's College of Commerce, Davar trained mostly in non-Indian dance styles including jazz and contemporary. He received his dance education mostly abroad at London's Pineapple Dance Centre and the London Contemporary Dance School (part of the dance complex known as The Place), which was founded by former members of the Martha Graham Dance Company.[25] Influenced by these styles, Davar's philosophy

of movement grows out of non-Indian approaches to the body, particularly studio jazz dance. When he speaks about his choreography and movement choices, Davar stresses the mixing of Eastern and Western styles as integral to his approach to movement creation. By this he means that his Western dance training allows him to fuse Indian elements with non-Indian forms of expression.

Although not extensively trained in any single type of Indian classical dance, Davar states that he aims to bring new interpretations to India's classical dances through his approaches to movement, rhythm, and staging:

> I think that people have always thought of India as classical, that there is nothing in it that's modern. It's old-fashioned, with typical classical dances—people riding on an elephant and doing Bharata Natyam and those classical forms.[26]

Here, Davar distances himself from the 'timelessly exotic' perception often imposed on India and aligns himself with contemporary trends.

Davar uses two distinct labels to describe his choreography: Bollywood Jazz and Indo-Jazz. Bollywood Jazz describes the choreography he has created for Hindi films. Indo-Jazz is the label he applies to his dance movements that are not based on film. Both styles draw on studio jazz dance movement and incorporate Indian dance elements including gesture, rhythm, and facial expression as they strive toward a more contemporary and athletic kind of dance content that has greater appeal for cosmopolitan populations in India and abroad. Taught in dance studios around the world, studio jazz dance is culturally eclectic and influenced by Hollywood's early 20th century, admittedly Orientalist, views of the Eastern world.[27] Although its history can be traced back to the US dance halls of the 1920s and 1930s when the Camel Walk, the Charleston and the Lindy Hop reached their peak, studio jazz dance today generally refers to movements and techniques traceable to 1940s and 1950s Broadway and Hollywood musicals.[28] Later, as dancers and choreographers continued to borrow from these dances, they began to alter movements as they moved toward more athleticism, with more leg extensions and leaps, and less hip swinging and

pantomime.[29] These adjustments constituted the foundation of what is today known as studio jazz dance.

Although several dancers contributed to its development, Jack Cole, an American dancer and choreographer, engaged in developing Broadway and Hollywood musicals, is often recognized as a key figure in developing studio jazz dance.[30] Open to borrowing dance movements from other cultures, Cole drew liberally on various movement styles, including Indian dance, most prominently Bharata Natyam.[31]

This history of studio jazz dance presents an interesting paradox for Shiamak Davar's Bollywood and Indo-Jazz styles. When Shiamak Davar infuses, or rather re-infuses jazz dance with Indian moves to arrive at his creations of Indo-Jazz and Bollywood Jazz, he may in fact be reintroducing these influences to a form previously shaped by Indian elements. This appropriation of movement completes jazz dance's circular journey—from a Western hybrid style influenced by Indian classical traditions to an Indian hybrid style that today sets new standards in Bollywood dance.

To Davar, his appropriation of studio jazz dance translated into his two signature styles of Bollywood and Indo-Jazz. These styles mix East and West to promote a "new" presentation of India.[32] As proof of the appeal of this vision of India, Davar's dancers are often invited to represent India at international events. In 2006, Davar choreographed and staged a performance featuring 800 dancers at the Closing Ceremony of the 18th Commonwealth Games in Melbourne, Australia. Davar also staged the presentation of India at the World Economic Forum in Davos, Switzerland in 2006; the Indo-Japan Friendship Year 2007 inaugural event in Tokyo, Japan; and the Indian Economic Forum in Rome, Italy. With the current popularity of the Institute, Davar feels the time has come for his choreography.

Mediated Bodies of Bollywood Dance

In an interview, director and producer Yash Chopra explains that he was looking for a "new and fresh look" for the dances that

would frame his film *Dil To Pagal Hai* (1997), a love story set in a dance school. Shiamak Davar was invited to create the choreography. Today, his choreography in the film is recognized as a turning point for Hindi film dance.

> When Shiamak choreographed Dil To Pagal Hai..., [he] had a free hand and his... style was seen all around the world. Before that there were dancers who were not in shape. It was a very down-market, raw kind of dance. Suddenly people saw fit bodies on screen and suddenly people were noticing the dancers behind the stars. Whereas earlier they saw the star and they didn't look at the dancers. This was a very distinct style—very clean and classy.[33]

With its release, *Dil To Pagal Hai* ushered in a new period for Hindi film dance—a period of changed movement and new idealized dance bodies.

Set in an upscale dance/theater company, the *Dil To Pagal Hai* film narrative revolves around the production of a staged show. The school's director, Rahul (played by Shah Rukh Khan), has a clear vision of what the performance should become. When his lead dancer is unexpectedly injured in rehearsal, Rahul desperately searches for a replacement. He finds his heroine, who turns out to be the love of his life, in Pooja who had never before thought of pursuing dance seriously but who nonetheless possessed natural dancing talent. As is typical of Bollywood films, the narrative is interspersed with song-and-dance sequences.

The spectacular, direct, concerted entry of dancers in the opening scene of *Dil To Pagal Hai* is in itself a metaphor for the dawning of a new era in Hindi film dance. Marching feet echo across an open space. Twenty-two female dancers dressed in form-fitting costumes emerge, arm in arm, against a blue background. They march forward to stand in an immaculate line. They raise their right arms above their heads, look down over their left shoulders, and snap their right hand fingers: "One, Two, Three, and Four!" Black leotards with golden trim and high black boots accentuate the unified clarity of their movement. They turn away, their right arms gesturing toward the right diagonal in invitation to a thunderous beginning for the music. As the music begins, the female

dancers strike dramatic poses—setting the stage for the performance to come.

Media scholar Sangeeta Datta observes that the plot of *Dil To Pagal Hai* is a casually fashionable negotiation between traditional and modern perceptions of India.[34] Datta investigates the film's two lead female characters: Nisha, a modern dancer played by actor Karishma Kapoor, and Pooja, a classically trained dancer portrayed by Madhuri Dixit.[35] An outgoing and independent woman, Nisha is athletic and sporty and belongs in the gym as much as in the dance studio. She loves to show off her dance and thrives when performing publicly. Pooja, however, is introverted and dreamy. She is almost secretive about her classical dance and does not actively seek out the stage. Although Pooja ultimately wins the boy, it is really Nisha's modern style of dancing that captures the Indian imagination (*see* Photograph 3.4).

Shiamak Davar's choreography in the film contributed greatly to the film's success. The film's athletic, synchronized, and technically demanding movements impressed Hindi film audiences. *Dil To Pagal Hai* marked Davar's entry into India's mainstream entertainment industry and established his place in the history of film dance. Manoj, a SDIPA dancer, recalls:

> In the 50s, they used to move their neck and eyes [in the films]. In the 60s and 70s, they used small lyrical movements with their hands and maybe they are sitting in the garden. In the 1980s with Mithun Chakraborty, came the whole disco thing, but people were not glamorous.... In Hollywood, with Liza Minelli and stuff, the dancers were really fit. But in Bollywood the dancers would be fat and you would see all the mistakes in the chorus lines. The major change came after *Dil To Pagal Hai*, for the first time, Shiamak used professional dancers, who were good looking and had life.... I was in the theater and people would be shocked at the change. Even my mother was shocked.[36]

Rohit makes a similar observation when he states:

> Earlier it was more the actors [boy and girl] a lot of dancers, and not correct bodies, unfit bodies.... Shiamak came and brought perfect

bodies and then nobody wanted imperfect bodies. Now Bollywood is more about class.[37]

The bodies created by Davar formed the basis for a new ideal body image. It was also thought that the new bodies could represent India abroad and not embarrass Indians. The perfection of the chorus line dancers makes them comparable to the stars:

> Now the dancers look just as good as the hero and heroine, if not better.... Background dancers today are more like models and very highly paid.[38]

Shiamak Davar's entry into the film industry with *Dil To Pagal Hai* coincided with a general trend away from traditional Indian movements in Hindi film dance, a trend that began almost two decades earlier. While SDIPA is one dance school among many in Bombay, its phenomenal success is evidence of a widespread desire among Indian audiences to participate in a contemporary dance fashion that mixes Western (predominantly the US and the UK) influences with Indian themes, often privileging the former.[39] A senior Hindi film dance choreographer, Rekha Prakash, explains that the film dance business is like a pendulum which oscillates between preferences for Indian and Western movements. This latest Western movement wave coincides with the renewed idealization of the toned body as an apparent prerequisite for achieving glamor and stardom in India.

Historically more geared toward audiences in rural villages, Bollywood films today often explicitly focus on pleasing urban Indian, as well as foreign audiences. A leading example of this tendency, *Dil To Pagal Hai* did much better in India's cities and abroad than it did in the country's rural regions.[40] Responding to this trend, several recent prominent recent box office blockbusters, like *Kabhi Alvida Naa Kehnaa* (2006) and *New York* (2009), set their narratives outside India with stories shaped by their setting and interspersed with English words or even sentences in their dialogues.[41] Even as she acknowledges that some films do continue to focus on telling wholly Indian stories, especially for rural audiences, film

scholar Shakuntala Rao notes an increasing division between films made with rural audiences in mind and those made for movie-goers in the cities. Films like *Dhoom* (2004) or *Kal Ho Naa Ho* (2003) make the predominant proportion (around 80 percent) of their revenue through urban Indian and international distribution.[42] An anecdotal drop in rural film theater attendance further supports this observation.[43]

Many smaller rural cinemas closed with the proliferation of television sets. Overseas profits, driven by NRI enthusiasm for Hindi films, also make increasingly important contributions to the bottom line. In its October 3, 2003 issue, the *TIME* magazine questioned Hindi film director, Ram Gopal Varma, about the future of Bollywood films:

> *TIME*: What's the future for Bollywood?
> Varma: There's going to be a massive change. A lot of old filmmakers are going to go out of business. Anyone who looks at a film as a formula of one song, two comedy scenes and three action scenes, who doesn't look at the totality of the film, is lost now. Anyone who follows the old prudish traditions, of showing a bush shaking leaves when they mean people are f—ing behind a tree, is gone. And anyone who doesn't follow the West is gone. For many people in the business, their pride won't let them. But following the West is not surrendering. Following the West, the best of the West, is following originality. Western innovation is superior, and I think we're just beginning to understand that. With my films, I'm targeting the urban multiplexes, the sophisticated media-savvy young crowd. Frankly, I couldn't give a f—for the villages.[44]

Although Varma later partially retracted his strong statement, he nonetheless stuck by the general attitude of his response.[45] According to Varma, Western notions of innovation become superior to indigenous notions of creativity in Bombay cinema. Shiamak Davar's dancers in *Dil To Pagal Hai* support this perspective.

Trends in Bollywood dance suggest a deeper change in what is most valued when it comes to Hindi film choreography. Dancers and audiences alike describe Davar's choreography as sparse, classy, and elegant. Older film dances often get labeled as

unpolished, the chorus line dancers as low class. *Dil To Pagal Hai* is seen as a pivotal moment in the evolution of the Hindi film dance. Here is a brief list of terms that SDIPA dancers use to describe the world of Hindi film before and after *Dil To Pagal Hai* world of Hindi film dance:

Before	After
low-class	classy
fat	lean
mistakes	correct
poor	highly-paid
unrefined	modern/synchronized

What we can see here is a shift from unrefined to sophisticated, from fat to lean, from low-brow to classy (*see* Photograph 3.5).

The words dancers use to describe the before and after *Dil To Pagal Hai* worlds of Bollywood dance are strikingly similar to the language that surrounded the reconstruction of Indian classical dances in late colonial India.[46] Traditional practitioners of the classical dance arts in India, once respected as high-class entertainers and mediators of the divine, by the late 1800s had become associated with social marginalization. To reclaim Indian dance as a respectable art, India's intellectual and social elites reformed it with middle-class notions of nationalism and respectability.[47] To achieve this, they worked to remove any content they perceived as morally impure or corrupted.[48] In some cases, explicitly erotic content was purged and replaced with devotional themes (or *bhakti*).[49] In others, the dance form was adopted by the elites and implicitly disassociated with its historical and less respectable practitioners.

The reform of the South Indian dance Bharata Natyam became a blueprint for the reconstruction of dance in post-Independence India. Stressing the link between Bharata Natyam and spirituality, an upper-class Indian woman, Rukmini Devi Arundale, and other contemporaries established Bharata Natyam as a respectable—and not merely secular—art. This process, informally determined the key technical and aesthetic standards needed for a dance to be recognized as classical in India. These include dance education,

costuming, facial expression, gesture, rhythm, and theme.[50] As dance scholar Avanthi Meduri explains, this process tied Bharata Natyam up with middle-class moralities and values.[51]

These efforts had profound implications for Indian dances and their practitioners. Once they became a recognized national art, instruction in dance forms like Bharata Natyam appeared on the formal curricula of well-established schools. These schools, attended by the self-consciously culturally aware middle and upper classes, continued to ensure that the content of the dances adequately presented Indian culture. Too often, traditional practitioners of these dance forms found themselves (once again) on the margins. Slowly but surely, dances in these traditional dance communities and the livelihoods associated with these practices continued to fade even as new teachers, often foreign to these communities, assumed responsibility for the teaching, maintenance, and survival of Indian classical dances. The new teachers inevitably brought their own aesthetic preferences and moral views to this process and eventually re-sculpted the dance forms, and the dancers who practice them, to reflect these, rather than those of the traditional communities.

Current trends in Hindi film dance echo what happened to India's classical dances. As SDIPA dancers, trained in Davar's dance schools, enter the film industry, they introduce their physical standards and aesthetic ideals relating to dance in films. Fueled by India's new middle-class aspirations, these aesthetic and physical standards endeavor to validate dance in general, and film dance specifically, as a respectable, even exclusive, profession worthy of modern Indians. Similarly, the dances they create and perform present India—a contemporary global India—in a positive light. In a proud testimony to the success of these endeavors, SDIPA dancers today often represent India abroad alongside performers drawn from the ranks of the Indian classical dance. These changes to Hindi film dances share another similarity to the processes that affected Indian classical dance. As dancers from India's emerging middle-classes, like those in SDIPA, take increasing interest in Hindi film dance, they may begin to slowly displace less affluent chorus line dancers, in ways that reminds one of the struggles of the *devadasi*s and courtesans.

Of course, differences between Bollywood dance and post-Independence Indian classical dance continue to exist. Unlike the largely codified classical dances, Bollywood dance still responds to Hindi film narratives and the dancing skills of films stars.[52] A romantic song would call for slow flowing movements. A wedding celebration may need to be expressed through boisterous movements that draw on folk dances. A nightclub scene calls for energetic choreography. Similarly, the social perceptions of Bollywood dancers (particularly at SDIPA) differ significantly from that linked with classical dancers. Classical dancers strive to be deeply rooted bastions of the ancient arts. They are stable and almost timeless presentations of India's cultural riches. In contrast, Bollywood dancers need to be versatile and globally knowledgeable, yet culturally specific. They need to move easily between Indian themes and non-Indian movements. They need the skills to adapt, learn quickly, and execute professionally. Bollywood dancers need these skills of adaptation, learning, and execution to continuously create new, innovative, and trendy dances.

Despite these differences, the current efforts to make dances in Hindi films more professional, sophisticated and acceptable echo the processes that surrounded Indian classical dance in the colonial and postcolonial era. These parallels suggest that a process of gentrification may be underway in the world of Bollywood dance in Bombay.[53] The transformation of Bollywood dance from being considered vulgar to being considered refined reflects a prevailing interest among some prominent commercial Hindi film directors and producers eager to present India as modern and global.

On Bombay's Film Sets

Dance aesthetics and physical requirements of Bollywood directly impact dancers who work in the industry but are not part of SDIPA. Most of them are members of the Cine Dancers Association (CDA). All Indian dancers who appear in Hindi films need to be members of the CDA, which guarantees them a minimum wage

and a few other benefits in return for a one-time membership fee of Rs 51,000 (equal to US$1,101).

Radhika has been a Hindi film dancer for three years. She explains how important CDA is to what she can expect to earn:

> We earn thirty-to-forty thousand [per month] or something like that. If you do not register, you cannot get the work. As a [CDA] member, they give you more work. They refer you to a member, who gets you work and charges like five hundred rupees extra for that. That is the system.[54]

The CDA estimates that there are approximately 750 dancers making a living in Hindi films, though dormant membership numbers are much higher. Although no formal age limits exist, dancers mention that their ability to continue dancing depends on their appearance and dance skills. This is particularly true for female dancers. How much a dancer earns differs from dancer to dancer, but Radhika estimates that their income is typically better than if they were working in a call center.

Most of the CDA dancers on the sets of *Ek Vivaah Aisa Bhi* (A Marriage Like This Too, 2008), *Love Story 2050* (2008), and *The Race* (2008) do not take regular dance classes. "I have no time and no money," one dancer named Poonam explains. "Each choreographer teaches you something," another dancer says. When they get a chance, dancers also keep up with the latest trends by watching television, particularly for examples of non-Indian dance movements that are in increasing demand in the Hindi film dance industry. Some dancers become attached to specific choreographers who may maintain several dancers that specialize in particular movement vocabularies; others continue to freelance and wait for calls for shoots. Regardless of whether dancers freelance or become attached to one choreographer, their schedule can get very hectic as dancers often agree to several filming engagements at one time to maximize income and increase their visibility.

Poonam often travels extensively for filming. This means that she is often away from home for days, even weeks. Poonam explains that even when the filming is in Bombay, she usually returns

home late at night or early morning. As a female film dancer returning home at unusual hours, she lives outside socially-accepted norms of propriety for young women in India, even for cosmopolitan Bombay. Radhika blames the negative connotations of her job to the revealing costumes that she has to wear on set. In particular, she feels that skimpy attire reinforces existing stereotypes of film dancers as lewd and morally reproachable. These rumors date back to the early days of cinema when the ranks of chorus dancers were associated with socially-maligned communities.

Most members of Radhika's family do not know that she is a chorus line dancer. When I ask her whether she worries that they might see her in a film, she laughs and says, "Sometimes." But I have a hard time recognizing myself." With a few exceptions, the chorus line dancers of Hindi films remain anonymous to their audiences. They are often anonymous to the crew on the film set as well.

With the development of a category of wealthier, extensively trained dancers like those from SDIPA, being a film dancer has become a much more respected profession. Nonetheless, Poonam feels some people judge her when they hear about her work.[55] The dancers on film sets in Bombay insist that film dance is not a viable long-term career option. As Radhika explains, she does not think of film dance as a long-term career:

> Because in this [film dance], there is no future.... There is too much competition. If you are good looking and maintain yourself then you can dance maybe ten or so years. But that is it.[56]

Radhika is applying for flight attendant positions. Poonam tells her parents she is an actress, rather than a dancer. Shreya plans to eventually transition into a lower paying call center job when she ages and dancing becomes too difficult. Vipul hopes that dance will become a stepping stone to an acting career.

Dancers explain that it is best to lie about one's age to avoid disqualification as thirty is generally the high end unofficial age cutoff for chorus dancers. Many dancers move on to different jobs. Some become extras in films. Very few become choreographers themselves.

In the studio, an all-female group of dancers clusters around the mirror while the assistant choreographer leads them through a repetition of the sequence for the Hindi film *Ek Vivaah Aisa Bhi*, which is being produced by Rajshri Productions. Male dancers sit on the sides of the room, waiting for their turn. They chat among themselves and intermittently glance at their female colleagues. Shabina Khan, a young and rising Hindi film dance choreographer, supervises the instruction process as she emerges from her room.

As we talk, Shabina narrates her own story. Raised in a conservative family, Shabina began dancing secretly without her family's knowledge.[57] Eventually she made her way to performing in stage shows where film choreographer Ganesh Acharya noticed her and invited her to dance in his films. She worked her way through the dancer hierarchies and eventually became a choreographic assistant to several choreographers including Ganesh Heggede (well known for his MTV-style movements) before venturing out on her own. With several important film dance achievements, Shabina is looking to consolidate her reputation in the industry. Shabina understands that the industry is an extremely competitive environment where one has to constantly fend for oneself and be aware of the latest trends. She keeps up with the latest movements in Hindi films and is on a strict diet to regain the body shape currently highly valued in Bollywood films, which is epitomized by the SDIPA dancers.

Back at SDIPA headquarters, Shamira, a young female dancer, is in a hurry. She is late for a salsa workshop organized for all SDIPA dancers. The workshop is part of an ongoing series that SDIPA organizes to introduce its dancers to new movement styles. The series includes classical Indian dance, salsa, tap, hip-hop, and other styles that may be useful for SDIPA dancers. Shamira explains that the dance workshops do not just "train" bodies; they "open minds."[58]

The lives of Hindi cinema's chorus line dancers seem far removed from the lives of SDIPA students and dancers. Though they live in the same city and move in the same general professional field, they exist on different rungs of Bombay's social hierarchies. Most film dancers do not come from a wealthy and educated background.

Though dance may indeed be their passion in life, their work in the film world is a way to earn a living. Unlike these dancers, SDIPA dancers generally progress through dance classes offered by the Institute. They pay for their dance training and actively seek out possibilities to join SDIPA's handpicked dancer ranks. Their participation in SDIPA often develops alongside their non-dance education and professional training. Many SDIPA dancers possess college degrees. To them a dance career is a choice, rather than a necessity. "Shiamak Davar dancers are different from most film dancers," a commercial film producer explains. "They are the kind of people you will see partying in swanky nightclubs like Poison. You will not see most film dancers there. Why? Because, they are at home somewhere in the suburbs, taking care of their sick mothers or marrying off their sister. They remain anonymous as they dance behind stars like Shah Rukh—behind him being the operative word here."[59] Notably, Shiamak Davar's dancers speak about dancing *with* the stars rather than *behind* them.

Through his deployment of studio jazz dance in and outside Hindi films, Davar shifted the norms of acceptability associated with Hindi film dance. This shift further fueled the emergence of practicing Bollywood dance as a popular pastime in India's urban centers. Indian female and male dancers in social groups historically averse to public performance outside the classical dance realm now flock to SDIPA classes both in India and abroad. Davar's choreography in *Dil To Pagal Hai* also signaled a shift in the choreographic and bodily demands placed on dancers in Hindi films. Consequently, new demands are now being placed on chorus line dancers who may or may not possess the financial means to acquire the necessary skills.

New Bodies for a New India?

In September 2007, more than 400 preselected students gather at an accelerated learning SDIPA audition one early Sunday morning.[60] Upon arrival, SDIPA dancers meet the selected students. Audition participants fill out forms and are allocated numbers. The

audition begins on time and the students are asked to enter the studio in groups of twenty. Students initially perform the dance sequences they learned in class. Shiamak and his dancers scrutinize their performances and take notes. As he recognizes some students for their talent, Davar asks them to dance with more energy. Later, Davar asks the men to take off their t-shirts; the women are asked to lift their tops to reveal their midriffs. Nobody refuses. Davar assesses some students as "great dancers but too fat." He stresses this to the female dancers: "You need to lose weight. I cannot put you on stage like this." Davar tells the male dancers to develop a lean body like Hrithik Roshan, a Bollywood star that Davar recently choreographed in *Dhoom 2*. "Don't overdo to it with the weights. Walking and running are better for you," he explains. Several company dancers stand tall as they observe the audition. Their tight-fitting athletic wear accentuates their toned bodies, exemplifying the SDIPA ideal physique. After three hours, Davar selects four students out of more than four hundred.

The body shape advocated by Davar and embodied by his dancers reflects a "fat is out, fit is in" mindset increasingly prevalent among the middle and upper classes in urban India.[61] As Shoma Munshi recounts, this change in body consciousness began in the early 1980s and was motivated, at least in part, by public discussion around India's hosting of the Asian Games in 1982.[62] Preparations for the event publicly highlighted how out of shape many Indians were, and the danger of being overweight became an increasing concern for India's predominantly physically inactive affluent urban dwellers. A public fitness trend was jumpstarted by a government-run Sports Authority of India public information campaign in the 1980s. Today, the vast majority of Indian urban centers have at least one, if not more than one, fitness center and going to the gym has become an encouraged activity among India's middle classes. Paradoxically, this class-specific health consciousness developed in a context where almost half of all Indian children under the age of five were reported to be malnourished![63] As many people in India continue to live in poverty, more affluent Indians now face problems associated with obesity. An article in the *The Times of India* published in 2008 grimly observes, "India too is slowly heading for

an obesity and diabetes epidemic" and urges parents to make their children, and themselves, exercise more.[64]

Many students at SDIPA come from these middle classes. Students in SDIPA classes generally include school and college students, young professionals, and housewives. Indian film scholar Rachel Dwyer highlights sustaining physical fitness, particularly in terms of appearance, as a key consideration for many members of the middle classes in Bombay.[65] These days, Indian fashion lifestyle magazines like *Femina* regularly feature articles on healthy living and exercise, reflecting increased awareness of fitness and exercise. Dwyer observes:

> Sports and fitness may be practiced at home as yoga or on fitness machines but more usually in clubs, which have only western sports— tennis, golf, swimming—and are beginning to build gyms. The oldest clubs, some with British origins (the Bombay Gymkhana and the Wellington), are almost impossible to join because of their waiting lists and vastly inflated prices and remain the haunts of the professional middle-classes and new corporate sponsorships.[66]

Recently, gyms and fitness centers have sprung up throughout the Bombay area.

SDIPA becomes an accessible entry point into fitness training for many students as we can see exemplified in this interview question posed to several students:

> Question: Why do you take classes at Shiamak's?
> Answer: Fitness. To get in shape. I don't want to go to the gym.
> Answer: It is a new way to dance.
> Answer: It makes me feel so free. I never got a chance to dance before.
> Answer: Today people look at the way you look. Any profession. It is very important. It is the first thing they notice.
> Answer: I got so much more confidence. Before I used to feel so shy. I don't know how, but now I am more confident.
> Answer: Makes me fit. So you can be more confidence [*sic*]. Confidence is most important today in India.
> Answer: Shiamak's classes make you feel good about yourself. You feel that you are successful.

Answer: I get to be closer to Shiamak. One day he may notice me. I dream about that. [laughter]... but for now I become stronger and get respect.

Answer: You are dancing with other successful people.

Parent: If my son chooses to dance, I am ok. But he has to be successful. He shouldn't just be a dancer. He should be a star. [laughter]

Answer: Shiamak's class is a good workout. Nowadays, being in shape has become important, not only for young people but also for older ones. People judge you by how you look. [67]

The physical training gained at Davar's school signifies confidence, success, and even stardom. Most students speak about gaining self-belief, attractiveness, and even fame through better bodies as reasons to attend SDIPA classes. Feminist scholar Suparna Bhaskaran links this kind of awareness of ideal body types as India's economic liberalization, which brought with it new ideal imagery of women in particular through broadened access to Western media.[68] The same applies to men.

In the early 1990s, a beauty pageant mania swept through India as girls and women signed up and participated in local, national and even international beauty contests. The beauty frenzy intensified in 1994 when Sushmita Sen won the international Miss Universe beauty pageant and Aishwarya Rai was crowned Miss World in another international pageant.[69] Celebrated by audiences and media alike, the dual victory was hailed as proof of India's global visibility.[70] The victories also ushered in a period where beauty contests are often lead features in the Indian newspapers and magazines as female beauty concerns in general became the focus of much attention.[71] Feminist scholar and activist Madhu Kishwar shares her critical perspective on this trend:

> To the inferiority complex ridden Indian elites, the Indian beauties who won international crowns gave them a hope, that if they continue to ape the West in its mannerisms, lifestyle, consumption patterns, fashion designs and what have you, they will one day make it to world class, just as Sushmita Sen and Aishwarya Rai did by learning to walk, talk, dress, smile and wear make-up like Hollywood stars.[72]

This climate encouraged the founding of many new beauty contests that grew in popularity and has now reached the point where it seems as if almost every town, school and college has its own beauty contest. As Kishwar aptly observes, the new prominence of Indian beauty in international arenas sent a clear message: the shape and sexual appeal of bodies are of crucial importance to female validation.[73]

Offering an alternative, historically rooted perspective, Vanita Reddy analyses this recent popularity of beauty pageants as a phenomenon that grows out of a much earlier focus on women as symbols of India's national identity.[74] These older national ideals combine with the present day globalized aspirations to create a dual ideal concept of the Indian woman as both Indian and global. Using *Femina* magazine articles and editorials, Reddy documents the ways in which Miss India organizers consciously select women who will garner international interest by encouraging women to aspire to be both Indian and international in their appeal.[75] For example, contestants may need to show that they are just as conversant in global issues as they are in India's cultural heritage. From this example, we can see how Indian beauty ideals today can be driven simultaneously by both national and global agendas.

A SDIPA dancer explains, "Before, how many boys danced? Now boys can dance too." According to students, it is increasingly acceptable for men to dance because of actors like Hrithik Roshan who prominently display their masculinity through dance. Akram, a male SDIPA dancer, explains, "if they [students] see Hrithik dancing, it's cool; if they see Shah Rukh dancing, it's cool; if they see Salman dancing, it's cool."[76] Though they did dance before, hero dance moves are increasingly defined by agility and athleticism. Standards for heroes in Bollywood cinema have also undergone substantial changes and are now quite distinct from the physical look associated with them in the pre-1990s period. Back then, Hindi film heroes depended less on their looks and more on their social stature, a situation aptly described by Sanjay Srivastava as the "Five Year Plan (FYP) Hero." Influenced by the political and economic climate of early post-Independence India, the FYP Hero was typically an engineer or other such technically trained

professional associated with furthering the country's development.[77] For example, in *Madhumati* (Madhumati, 1958), the hero (Dilip Kumar) is defined by his technical training. In a complex plot involving death and reincarnation, he first presents himself as an engineer only to discover that he was a timber estate manager in his former life. Technical expertise, rather than any physical attribute, was the distinguishing characteristic of the FYP Hero of the early post-Independence period.

Unlike the heroes of the early postcolonial period, Hindi film heroes of today display their trained and toned physical virility and sexual appeal. Sudhanva Deshpande teasingly identifies the 1990s as the decade of the biceps. [78] A look through Hindi cinema magazines like *Cineblitz* and *Stardust* suggests that she is indeed correct about what matters when it comes to the look of the Hindi film heroes. Interestingly, even Shah Rukh Khan and Govinda—the two notable untoned exceptions named in Deshpande's article—have since followed the trend and reshaped themselves according to the new masculine body ideal. The film *Partner* (Partner, 2007) featured Govinda flexing his newly strengthened biceps alongside Salman Khan. That same year, in *Om Shanti Om* (2007), Shah Rukh Khan emerged from the water shirtless, proudly bearing his hard-earned abdominal "six-pack." With few exceptions, Hindi commercial films have now entered what Deshpande calls the "age of the consumable hero" who uses his body to advertise global brands.[79] For the Hindi film hero, physicality is now a key criterion for success. Expressed through the body, these qualities are much more obvious (and easy to assess) than the less visible talents of FYP Heroes of yesteryear.

Body shape, finesse, dance skill, and sexual appeal are a frequent topic of discussion on Karan Johar's *Koffee with Karan*, a popular television talk show on StarPlus, a satellite channel (owned by the global media conglomerate, News Corporation). The show features chat sessions with celebrities from the film world. As a director and industry insider himself, Karan Johar invites his guests to speak candidly (or at least, that is the show's claim) about their personal and professional lives. Much of the show's appeal rests in Johar's ability to coax at least marginally controversial statements from

his guests. Notably, many questions asked on the show relate to physical appearance and sexual attractiveness. In an episode featuring former Miss Universe Lara Dutta and rising star Katrina Kaif, Johar first asks Dutta:

> Johar: Who is a stud?
> Dutta: Salman Khan.
> Johar: Hot 'bod'?
> Dutta: Hrithik Roshan.

Johar then turns to Kaif:

> Johar: What do actresses mean when they say, 'I don't exercise. This body is just God's gift'.
> Kaif: Yeah right, what a lot of nonsense. She [the actress] probably sleeps on a treadmill, lives on a treadmill, does not eat anything at all and probably is very good friends with Rakhee Sawant's surgeon.

In her response, Kaif alludes to an earlier episode of the show where Rakhee Sawant, an actress known for her relatively sultry roles, states boldly: "What God doesn't give you, the doctor can." Despite being laughed off, the comment is significant as it alludes to the perception that one's body is within one's control. Financial means can solve perceived imperfections. As the comments of these guests on *Koffee with Karan* reveal, body image is of crucial importance to male and female Bollywood stars today. Just as films respond to, and influence fashion and other consumption trends in India, so the body portrayed in films now becomes a commodity to be owned and desired.

Educated, multilingual and fashion savvy, many SDIPA students belong to a generation which grew up amidst India's pro-market political and economic reforms. They are characterized by capitalistic attitudes, a faith in social mobility and consumerism.[80] Knowledgeable about brands and media, most students frequently watch youth-oriented channels such as MTV and Channel V. Bombay itself is today a city permeated by corporate media.[81] Like advertised brands and products, the successful body becomes a

tangible aspiration. For dance students at SDIPA, the journey toward this successful body begins in the dance class.

Training Bodies at SDIPA

Students assemble for the Friday class at St Andrew's school in Bandra, a suburb of Bombay. The class is taught in an auditorium with large windows that overlook the school's sports field. Vinay, the class instructor, plugs in his iPod MP3 player while students wander into class and assemble their props. His assistant converses with the students. At 6:05pm precisely, Vinay starts the class with a short silent non-denominational prayer. The class stands quiet. Vinay then asks the class to "scatter," or stand in alternating formations—one of the terms that SDIPA students are expected to master. The students assemble themselves in a staggered formation and begin their warm-up exercises.

Vinay leads the class through a warm-up. Stretches begin with the head, move through the body, and end with the feet. Students look from side to side, bend back and forth, and stretch their feet, to a medley of Bollywood and Western pop songs. Because of the influence of Davar's previous training, most classes at SDIPA draw on movements from studio jazz dance. Vinay explains that he teaches the basic stretches and jazz-inspired sequences to build physical fitness and dance skill.[82] SDIPA classes emphasize posture, muscle toning, musicality, flexibility, and confidence in executing movement.[83] Dance training at SDIPA focuses on toning and tuning the body to become flexible, strong, and versatile. According to SDIPA instructors a body trained well through dance presents itself with new confidence. This, in turn, translates into inner strength.

The dances are generally set to songs popular at that given time, and range from the latest Bollywood songs to international MTV chart hits. Over the past five years, the instructors have observed a trend toward faster, predominantly techno-remixed rhythms. "They [the students] like everything to be fast. I guess that is what they like nowadays," an instructor explains. Students bend forward and stretch their hamstrings. Then they roll up on a count of eight.

After their initial warm-ups, the students sit on the floor, spread their legs, and bend forward. Many look uncomfortable and strained. Several students groan. Then they lie on their backs and proceed to do a series of sit-ups. Some students persevere through all sets; others moan in mock agony. Vinay urges them on. "Sir, I can't, sir," one female student exclaims. "Yes you can, just keep going," Vinay urges her on. "This is the way to become strong." After the warm-up, the class takes a short break as students assemble their props. They are ready to rehearse for their presentation in two weeks. They are once again in their scatter formation, now holding their props: cardboard shields covered with DVD and CD discs, shiny side up. The song begins. The students march, gyrate, and swing their hips to the beat. Their movements are angular, jumpy, and jerky. They move through a series of formations. They form two lines, then a forward-facing V. Then they split into smaller groups. They perform in unison. They look ahead with determination. Generally, the students fumble through some of the movements. The assistant steps in to help at a few points.

The song ends and Vinay appraises their performance. "That was good, but it all needs to be bigger. You need to make everything big. What is the point of moving small? Bigger! Everything bigger." He demonstrates his point by executing a movement. He steps to the side, hooks his leg and turns and steps into an open position. His arms are stretched out, his legs stretched with toes pointed. He then repeats the movement, demonstratively exaggerating every step. Several students giggle. "See? You need to move big and proud. Then people will look at you. Even if you are not tall, you need to look tall." The students assemble to do the movement again. Several look intimidated. Others look ahead again with determination. They want to "move big." Here, the desire to participate in the success promised by the mediated bodies of Bollywood dance translates into the physical training of the body.

After the class, several students linger to speak to the instructor and other students. They are very excited about their upcoming final class performance. Some of the students make plans to meet up before the performance for a last minute rehearsal. Slowly they pack their bags and leave. As they walk down the evening street,

a billboard advertising, *Heyy Babyy* (2007), a Bollywood block-buster mostly set in Australia—towers over them.

Back on Set and New Exotic Bodies of Bollywood Dance

"This film is going to be a big hit. It has all the right ingredients." Bosco, of the Bosco and Caesar film choreography duo, raises his voice to carry above the grinding rhythms of an on-set rehearsal of *The Race* (2008). Bosco sits in the director's chair and scrutinizes the monitor as his assistants work through four counts of choreography with Bipasha Basu and Katrina Kaif, two fashionable Bollywood stars. Now and then, he mutters camera angle instructions into his microphone. His voice echoes through the set—a tunnel with a smoke machine and fan—but is drowned out. After several unsuccessful attempts to make himself heard above the commotion, Bosco sighs and walks over to the cinematographer standing next to the camera. The film directors continue to sip their tea and watch all the activity through the monitor. Allowing the dance choreographers to take over, they do not interfere with filming of the dance sequence.

"Bollywood dance has changed." Bosco says on return. "You see the songs are more fast-cut, more racy." Scantily-clad chorus line dancers begin to file in along the peripheries of the set. Indian men and foreign, predominantly blonde, women arrive together. The Indian female dancers arrive last and stand off toward a corner and chat as they adjust each other's costumes. The chorus line dancers take their positions on the set. Blonde dancers are assigned to the front rows behind the stars. Indian dancers fill up the background. "Do you think we have a post-colonial hang-up?" Bosco's manager comments, "You should write about that."[84] The stars take their positions and the call for "quiet on set" resounds through the tunnel.

The last few years have witnessed the arrival of foreign—mostly white, blonde, and female—dancers in Hindi film chorus lines. The first waves of these dancers came from countries of the former

Soviet Union. Many foreign dancers rotated in and out of India every six months to avoid visa complications as agents coordinated their local contracts and visas. Today, several of these dancers, who initially arrived on short-term contracts, settled more permanently in Mumbai. "There is so much work here," says Nadya, a Russian dancer.[85] Trained in ballet in Moscow, Nadya first arrived in Bombay three years ago. She works on film shoots almost every day. The money is good. She and her friends now rent an apartment in Bombay where she feels she gets to enjoy a lifestyle that would not have been possible for her in Russia. She has danced in over a hundred Hindi films but says that she "is not learning much in terms of dance."[86]

More recently, dancers from other countries, like the UK, Spain, Iceland and South Africa have arrived to meet the demand for foreign dancers in Hindi films. The initial demand for foreign dancers in Bombay was driven by logistics. Choreographer Feroz Khan explains, "it was cheaper to bring the dancers here than to take the whole crew there..." when shooting a dance sequence set abroad. But the appeal of foreign dancers in Hindi films now goes beyond these early considerations.[87]

The fascination with Anglo-Indian and foreign performers in Hindi films may reflect some cultural constructs of desire and female sexuality prevalent in India.[88] In his analysis of sexuality in India, for instance, Sanjay Srivastava observes that the covers of racy novels and comics sold at roadside stalls in India's urban centers often center around sexualized images of European or Westernized women.[89] These sexualized portrayals of the body pre-date the current wave of media globalization.

Azoori and Kuldeep Kaur introduced Cuckoo, a dancer of Anglo-Indian origin, to the Hindi film scene in the 1940s.[90] Cuckoo appeared in many Hindi films including *Andaz* (Style 1949), *Awaara* (1951), *Mr. and Mrs. 55* (1955) and *Chalti Ka Naam Gaadi* (What Moves is Called a Car: 1958). She usually took on secondary, at times even anonymous, roles that featured her flexibility and dancing, quite often in the sexualized environment of the cabaret. Cuckoo's roles paved the way for the emergence of the outsider Anglo-Indian character in Hindi films.

The fearless characters embodied by Nadia Wadia, a stunt artist and actress of Greek–British descent, also provide powerful examples of the space occupied by a foreign female star in early Indian cinema. Born in Australia, Wadia moved to Bombay in 1913 when she was five years old.[91] In her biographical account of Wadia, Dorothee Wenner argues that in spite of, or perhaps due to, the fact that she was European, Wadia became a pioneer in Hindi films.[92] Wadia challenged typical Hindi film female character tropes through her startling stunts and daring roles.[93]

Although women like Cuckoo and Nadya paved the way, it was really Helen, a dancer of Anglo-Burmese origin that claimed the vamp character in Hindi films. Thinking back to his encounters with Helen in Hindi films, Vikram Kapadia recalled:

> Helen was a 'pretty Indian [film] dancer who looked like a foreigner and thus represented 'a relief from the Indianness of the rest of the film. She looked Caucasian, spoke with an accent, wore enticing costumes and showed her stuff, which was far more exciting than watching the sati savitri attempt amateurish Bharata Natyam in a mangalsutra and sari.[94]

Speaking about the 1960s to 1970s era of the femme fatale in Hindi films, epitomized by Helen, Geetanjali Gangoli observes that the often Anglo-Indian and Westernized female vamp stood in for the forbidden, even amoral sexuality that would have been unseemly for Indian heroines of that period.[95] Their most popular Hindi film juxtapositions of the heroine and vamp allowed for a separation of chastity and sexuality, propriety and promiscuity, and, to a certain degree, Indianness and foreignness. The distinct character type of the vamp faded from Hindi film by the late 1970s, and Hindi films typically deal with the distinction between both India and the outside world as well as morals and sexuality differently.[96] The current deployment of markedly Caucasian European dancers in Hindi films may provide new continuities to the sexualized gaze encouraged by the vamp of decades past.

This continuity was prominently established when Yana Gupta, a Czech model, managed to establish herself as an "item girl"—that is, a woman who appears in sexualized dances in Hindi films that

are sometimes only peripherally related to the narrative—through the "Babuji Zara Dheere" song-and-dance sequence. At the IIFA awards ceremony in 2007, Gupta also performed the song "Mehbooba" from the film *Sholay* (1975), a dance originally performed by Helen, an actress famous for her vamp character roles. Gupta's performance connects the female vamp characters of the 1960s with the foreign dancers currently employed in Hindi films. When I ask the Russian dancer Nadya, why she and her colleagues are in such high demand in Bollywood, she laughs and explains:

> Because it's exotic, I think. [smile] First of all its [about] white skin. When I came here for the first time it was only white skin....[97]

Nadya and her colleagues estimate that at any given time there are at least twenty Russian female film dancers based in Bombay. There are even larger numbers of dancers from elsewhere in the former Soviet Union. Although Hindi film productions mostly demand female foreign dancers, there have been instances in which male foreign dancers have been brought in to perform. Svetlana recounts that a group of sixteen Russian male dancers came for a film shoot that she worked on in the Indian city of Lucknow. Similarly, Jorge, a Bollywood dance agent also observes that choreographers increasingly demand male hip-hop performers when they contact him for dancers. Still, foreign dancers are overwhelmingly female.

On the set of the film *The Race* (2007), Sarah, a dancer from London, recounts her first dance engagement in India:

> I was here for one month and we went from Delhi, Bangalore, Mumbai, and Goa as well. It was a hotel show. Everyone else was dark and I was the token white girl [laughs]. Indian people seem to really enjoy that. In the Hindi section, I had a solo cause I was the only blonde girl, which I found very strange.[98]

Sarah expresses surprise at being selected to perform a solo in a Hindi film dance. Yet, her experience is not that unusual. Kaushi, an event organizer in Mumbai, recounts a Bollywood-themed party her company organized in Mumbai:

Like this one party, I had this [Russian] girl and she was supposed to go into a solo and this actor Vivek Oberoi was there at the party. His film *Omkara* had just been released a few weeks earlier and this Bidi Jaliye song was very very popular at that time. I was waiting with her back stage and she is one person who could speak English. She turned to me and said, you know I know his song and she's pointing to Vivek Oberoi. She liked the dance so much, she went and learned it. So I called my DJ and said play Bidi Jaliye right now.... Just play it. So we changed the track last minute. She started dancing on Bidi. I tell you people went mad to see a foreign girl.[99]

Kaushi values the "novelty factor" of using foreign dancers for her routines. She attributes the appeal to their appearance and dance training, which she uses to justify the price premium paid for non-Indian performers in Bombay today. Generally speaking, if Kaushi's clients can afford it, they prefer to use foreign dancers.

Back on the set of *The Race*, the filming finishes for the day and an industry insider turns to me to explain the interest in foreign dancers:

Basically it's about this: Indian men want to watch white women dance. It is pure Indian prejudice.[100]

Listening in on this exchange, Bosco's female assistant elaborates that audiences today "want to see half-naked skimpily-clad white women" as this is something that is not often seen in Indian films. She laughs and says, "Here people are fascinated with white skin." Another choreographic assistant chimes in, "Notice the white dancers wear the skimpiest, smallest costumes.... You will not see Indian dancers in those costumes so often. Ever wonder what that's all about?"[101] Later that day in the film set dressing room, Nadya laughs when I ask her about this, "They give us costumes to show more skin."

The current popularity of foreign dancers in revealing costumes in Hindi films needs to be distinguished from India's well-documented preference for fair skin.[102] India's obsession with fairness may partially grow out of both pre-colonial and colonial cultural histories in which fairer skin color connoted higher caste

status.[103] Research suggests that some pre-colonial bias based on skin color existed.[104] Yet, fairness arguably took on new meanings in colonial and later postcolonial India. British colonial legacies encouraged a continued valorization of fairness. In contemporary India, fair skin is still perceived to be a great asset for women.[105] Ads for fairness creams, including for men, reinforce the Indian cultural idea of the supposed connection between fairness and success.[106]

Fairness, however, is not simply equitable with whiteness.[107] White is a term most often reserved historically in India for the British colonizers, and more recently for Caucasian foreigners. In contrast, the term "fairness" is used to describe pale-skinned Indian beauty.[108] White is considered foreign. In the Hindi film industry, heroes and heroines are perceived as *fair*; foreign Caucasian chorus line dancers are identified as *white*.

To understand this distinction, it is helpful to return to Frantz Fanon's crucial work on questions of race in colonial contexts. Fanon identifies the colonized man's envy of the white colonizer.[109] To Fanon, the colonized male's desire for white women is tied to the desire for power in a colonized situation. Fanon summarizes the desire for the white woman thus:

When my restless hands caress those white breasts, they grasp the white civilization and dignity and make them mine.[110]

Several researchers have pointed to the ways in which such displaced fantasies play out in India's urban red light districts where clients often pay premiums for women who appear western in dress and demeanor. As Geetanjali Gangoli suggests, these demands invert well-known orientalist erotic perceptions of eastern women as Indian men live out their fantasies about western white women.[111]

To what extent do fantasies like these drive today's appeal of foreign dancers in Bollywood films? The answer to this question is not simple. While it is clear that the appeal of Caucasian complexions does indeed explain some of this popularity, it is also true that foreign dancers also fill a niche demand for foreign dance styles not easily filled by the Indian chorus line dancers. Reflecting on

her experience in the industry, Nadya observes a shift in Hindi films toward choreography based in non-Indian dance, including hip-hop.[112] "They [foreign dancers] have a training that is hard to find in India," an assistant choreographer observes. Simultaneously exoticized and revered for their movement abilities, these predominantly white female dancers may join SDIPA-level dancers in forming the front row of elite chorus line dancers in Hindi films.

The increasing number of foreign dancers in Hindi films have put an additional pressure on the Indian film dancers. An atmosphere of quiet antagonism permeates the dressing room shared by the female dancers on the set of *The Race*. Russian dancers sit off to one side as they speak softly to each other. Indian dancers stand in front of a mirror adjusting their makeup and costumes. Distinct borders emerge in the geography of the dressing room. Very little unnecessary interaction happens between the different groups of dancers in the hours that I spend in the studio. "I would be upset too," choreographer Feroz Khan observes. "They [Indian dancers] are now stuck in the back rows." This observation is especially significant as moving to the front rows is generally the only way to get noticed and move upward as an Indian dancer in the film industry. Between the new dancer standards introduced with Shiamak Davar's entry into films, changing dance styles, and most recently, the preference for foreign dancers, the chorus line dancers now find themselves relegated to even farther peripheries within an industry where proximity to the spotlight matters more than anything.

SDIPA plays an important role in Bollywood dance in film and performance. The lean, toned bodies of *Dil To Pagal Hai* were admired by Indian audiences. Drawn to these role models, students from social classes that historically scorned film dances now want to master the dance movements from the latest Hindi film blockbuster in classes offered by SDIPA. The body—its images and moving, shape and performance—becomes crucial to this process. Bollywood dance is changing in the city where these dances were first created as older chorus line traditions give way to new gentrified practices for live and filmed song-and-dance sequences.

4

Under Bollywood's Big Umbrella?
Bollywood Dance in Kathmandu

It is 7:30 am and the morning class at the National Dance Centre (NDC) in Kathmandu (the capital city of Nepal) is in full swing. Eight students, all in their late teens, struggle to master the steps. "You need to move your body like this," says Mohan, a junior instructor at the Centre, as he lifts and lowers his shoulders, steps side to side, and bounces his knees.[1] The eight students, grouped into four mixed gender pairs, execute their versions of the step. "Then the boys reach and grab the girls like this," Mohan uses his left hand to reach out and grasp the right hand of his eight-year-old teaching assistant, Sushant. Mohan pulls Sushant closer and swoops to pick him up, holding him to his chest as he whirls around. The studio fills with shrieks and giggles. A female student collapses on the floor as her shoulders convulse in hysterical laughter. "I cannot do it, sir," says Dipika gasping and clutching her *dupatta* (scarf). "Yes, you can," Mohan retorts briskly, "they do it in films, don't they?" Sushant runs into position as the instrumental introduction of the Hindi film song "Rock and Roll Soniye" (Hear the Rock and Roll) fills the room. But Dipika does not rejoin her class. She moves toward the wall and exits the room. Her partner walks through

the steps without her. Dipika returns at the end of the class to join her classmates in their concluding prayer. She smiles uncertainly. Beyond the windows of the studio, Kathmandu awakens.[2]

The film *Kabhie Alvida Naa Kehnaa* (2006), directed by tearjerker master Karan Johar, is a prime example of the new, globetrotting, opulent, and cautiously risqué face of Bollywood. The story, set in New York City, revolves around Dev and Maya, who are married—but not to each other. The "Rock and Roll Soniye" song-and-dance sequence takes place at an extravagant birthday party where Dev and Maya stand on the sidelines as their spouses enthusiastically lead a large ensemble of Indian and foreign dancers. Maya and Dev's simultaneous disengagement from the celebratory dance around them suggests a bond between them. Their mutual attraction eventually leads to an extramarital affair that speeds the demise of their faltering marriages. At the NDC, the memory of this film conjures up images of affluence—resplendent with expensive clothes, lavish sets, and foreign locations—and permissiveness as the characters in the film work through their questions regarding marriage and love. The NDC studio's peeling pink walls and linoleum-covered cement floor provide a stark contrast to the film's glamorous imagery.

In his interpretation of the song, Mohan adopts many of the steps contained in the film. Like the dancers in the film, his students step sideways, slap their hips and move their pelvises side to side. They shimmy forward and back. They twist and flick their hands above their heads in a bhangra-esque gesture.[3] The lift, however, is Mohan's addition and may have provoked Dipika's reaction. Did she respond to the memory of the film, or to Mohan's choreographic adjustment? Did she laugh because of another association conjured by the movement, the film, and the song? Was she afraid of ceding control to a male classmate? Was it an issue of trust? Why could not she allow herself to be lifted?

After the class Mohan, and several other senior students sit in the reception, drink tea, and chat about the latest film and other news. Everyone is up to date on latest developments in the Hindi film industry. Mohan admires Hrithik Roshan's performance in *Dhoom 2* (2007). Sushma speaks about how Nepal's thriving

music video culture brings new employment possibilities and recounts how she recently danced in several videos for Nepali singers. Lalita dreams of pursuing a career in Mumbai. "But it is just a dream," she laughs. The morning post-class chat is interrupted as a mother and her teenage daughter arrive to inquire about classes. The daughter, clearly excited, remains silent as her mother runs through her list of questions. Her initial questions come as no surprise. How often do classes take place? How much do they cost? How many students to a class? Then her line of questioning shifts abruptly. Is the studio safe? Are there boys in the classes? Can she watch the first few classes to make sure everything is ok? Mohan seems slightly annoyed by her questions but maintains his composure as he responds. He tells the mother that she can come and watch any class at any time; the classes are mixed enrollment; and there have never been any problems. After the newcomers leave an uncomfortable silence descends upon the group.

Through the study of the NDC, we encounter the realities of Bollywood dance in Nepal. An economically-impoverished country, Nepal exists on India's periphery. Set against the backdrop of Nepal's cultural and political dependence on India, this chapter reveals the painful national cultural borders drawn through Bollywood dance in this former Himalayan Kingdom. From our point of departure at the specific field site of the NDC, the research then transitions to a broader understanding of Bollywood dance, Hindi cinema and its role in the construction of Nepal's national identity. We then explore local dance spaces, and dancer groups affected by this dance form.

Filmi[4] Dance in Nepal: Modernity and Nationalism

Owned by Basanta Shrestha, a prominent film dance director in Nepal's fledgling film industry, NDC was founded in 1990—a particularly significant year in Nepal's recent history. It was this year that saw the revolutionary culmination of the "Jan Andolan," the people's movement for democracy and human rights led by the centrist Nepali Congress political party and an alliance of leftist

parties.[5] It was also the year that marked the dawning of a new political era in Nepal. The movement formally ended the palace-centric Panchayat System instituted by King Mahendra in 1960, and claimed to set Nepal on a renewed course of development toward modernization.[6]

In the early 1990s, a freshly-elected government committed itself publicly to establishing a new democratic society in Nepal.[7] Although the euphoria of this decade slowly gave way to disillusionment as government policies repeatedly failed to deliver on their promises, the people's movement still marked an important moment for Nepal.[8] The failures of the newly-elected government in the early 1990s to deliver on its policy promises contributed to the initial stages of the violent conflict in 1996 and, eventually, to the complete abolition of the monarchy in 2008. These events, in turn, officially ended Nepal's status as the world's only Hindu monarchy and propelled it into becoming a secular republic. As a privately-owned institution that opened in the early 1990s, the NDC is in many ways a product of the increased political, economic, and cultural openness that characterized Nepal in that era.

Located in a congested part of Kathmandu, the Centre occupies two studios and has over 100 registered students at any given time. Most classes take place in the early morning and evening and are geared toward youths and young working professionals. Although dance classes are not a new occurrence in Nepal, the Dance Centre serves the newly growing demand from Kathmandu's expanding middle classes.[9] This interest in dance classes is evident from the increasing number of private dance schools in Kathmandu. Take a short walk down the city's Dilli Bazaar will encounter billboard signs advertising dance and music lessons. Basanta Shrestha explains:

> Earlier, parents did not send their children to learn dance. This profession [dance] was not seen as a good profession. Now this has changed, now they bring their seven- or eight-year-old children. It was not like this twenty years ago.[10]

This growing interest in dance is driven by the emergence of Kathmandu's middle classes as the city becomes wealthier

than other areas in the country.[11] The educated and employed Kathmandu's middle class actively debate what defines Nepali identity. Mark Liechty's ethnographic research into middle classes in Kathmandu suggests that many of their members struggle to establish a *"between space"* that allows them to identify as modern and therefore separate from the lower classes, even as they question and separate themselves from many aspects of modern life that they deem foreign to the Nepali culture.[12] This means that even as they value imported consumer goods, such as refrigerators, fashionable clothing, and televisions as signs of middle-class status, they tend to look down upon behavior associated with what are deemed to be modern social values.[13]

Prominent in the media through Hindi-dominated programming, Bollywood dance often mediates these aspects of modern life to Kathmandu middle-class audiences. Although the NDC initially offered a wide range of dance classes—including Nepali classical, folk and dance—in reality, a vast majority of classes taught at the Centre are set to popular Hindi and Nepali film songs. As Basanta Shrestha explains, "We are a school. We teach what people want to learn.... Today everybody wants to learn fast and easy dances."[14] Over the last few years at the Centre, teaching of classical dance has been abandoned for more popular "modern dances," as students see the latest film song on television or in the cinema and demand to learn how to perform the dance movements shown in the song.[15] Distinct from the recognized category of "modern dance" in the United States, dancing "modern" dances in Nepal often refers to dances set to Hindi film songs (*see* Photograph 4.1).

Hindi films have dominated Nepali cinema since the 1950s when film theaters first appeared in Kathmandu.[16] Nepali filmmaker Nabin Subba estimates that at least half of the films screened in Nepal's cinema halls come from Mumbai.[17] This dominance has only been challenged by the occasional Hollywood or Nepali surprise hit. Radio was introduced to the country in 1951, and more than fifty FM stations currently bring the latest Bollywood and other songs into homes through battery-powered radios. Nepal's first, nationally-owned television station opened in 1985. Since then several private broadcasters have launched, bringing varied television

programming to approximately 20 percent of Nepal's inhabitants. From the 1980s onwards, media technology innovations (including VHS tapes, satellite television channels,[18] privately owned FM radio stations, and digital media) further increased the accessibility of Hindi films in Nepal's urban hubs.

Today, satellite dishes and cable networks (most prominently News Corporation's Star TV network) bring several dedicated channels transmitting Bollywood film, news and music videos directly into the homes of middle-class families. Glossy posters of Bollywood stars adorn many tea-stall walls and songs from the latest Hindi blockbusters crowd Nepal's radio airwaves. Screensavers and homepages featuring Hindi film stars are a common sight in Internet cafés that dot Nepal's towns and cities. Fashion trends from Hindi films are quickly copied in Kathmandu's beauty salons and fashion houses (see Photograph 4.2).

The introduction of theatrical distribution of commercial Hindi films in Nepal was part of the country's introduction to modern development, ushered in through the ousting of the restrictive Rana regime in 1951. Never formally subjugated by foreign imperial powers, Nepal's experience with modernity has been defined largely through 20th century nationalism, as well as through foreign aid-driven social and economic development efforts. While modern development strategies have undergone significant changes and crises over the last few decades[19] their fundamental promise of progress to a better quality of life for the whole of the society is still highly regarded in Nepal.[20]

Simultaneously, the notion of lack (or inadequacy) remains central to Nepal's experience with international development efforts.[21] Ranked as one of the poorest countries in the world, Nepal depends heavily on foreign aid and loans. In 2004, Nepal received an allocation of US$320 million in foreign financial assistance; 37.7 percent were grants, the rest were loans. Even as the ratio of foreign aid to GDP decreased, Nepal's dependence on foreign assistance remains significant.[22] The prominence of foreign aid has given rise to a rhetoric of development in Nepal as journalists, government officials, and development professionals often cite well-rehearsed statistics on Nepal's woes of high poverty, impending HIV/AIDS

epidemic, low literacy, environmental degradation, and high child mortality rates. Whether it involves large-scale technical assistance or small-scale self-help non-governmental interventions, Nepal's relative economic weakness is repeatedly highlighted in many development projects. Despite recent crises in development policy discourses brought about through postcolonial critiques[23] and poor results generated by half-a-century of development interventions in many countries,[24] progress is a key word among Nepal's middle classes who continue to strive to improve their standard of living.[25]

With their increasingly global content and sleek veneer, Hindi films—which are popularly associated with economic affluence, social mobility and progress by the Nepalis—become mediators of the promises of aspirational modernity in Nepal. As Subba explains:

> Bollywood today is globalized. Today everybody wants to escape from Nepal, going *lahure* is in our subconscious.[26]

Going *lahure* is a colloquial term for returning migrants and the process of traveling abroad for work. It is historically associated with Gorkha soldiers, who work abroad for foreign armies, but today applies to all those who migrate to foreign countries for work.[27] To go *lahure* also implies the way Nepalis may fantasize unrealistically about gaining great wealth and success through working in glamorous foreign countries. The appeal of Bollywood films in Nepal can be understood partly in terms of how they can satisfy the yearnings of *lahure* fantasies. Subba's observation highlights the power of the images of wealth, foreign locales and lavish lifestyles present in many recent Bollywood films such as *Kabhie Alvida Naa Kehna*,[28] which is set entirely in New York City.

In recent years there has been a dramatic change in commercial Hindi cinema as producers look for distribution to diasporic audiences in foreign markets and cater to the shifting urban market preferences within South Asia. In particular, films often now include locations outside India. Although foreign locations are not new to Hindi films, today's heroes and heroines often reside in locations like the United States, Australia, and the United Kingdom,

adopting more Westernized fashion trends while pursuing generally opulent lifestyles filled with clubbing and dating.[29]

Dancers who are influenced by, study, and perform Bollywood dances through the NDC willingly engage the imagery of progress, success as depicted in contemporary Hindi films. In doing so, they subtly redefine what is and what is not Nepali.

Seema Gurung, a lead dancer at the Centre, explains that for dancers in Basanta Shrestha's school very little difference exists between Nepali and Hindi film dances:

> You cannot distinguish between [film] dances from India and Nepal. We are very influenced by Indian dance and songs—you will not find that much difference....[30]

Dances in Hindi films are perceived as tending toward modern, but not quite foreign presentations of culture. Mahajan, another dance instructor at the Centre explains:

> Question: Is modern the same as *filmi*?
> Mahajan: Yes, but it can be more than that, it can be Western. Western is about working physically, it's more like aerobics. When it comes to *filmi* songs it's about the expressions too.[31]

The cultural proximity of Bollywood films allows Nepali dancers to express themselves in modern ways without resorting to Western or more foreign modes. Students' familiarity with Bollywood films allows instructors to tap the popular memories of the films and deploy them in the classroom. At the same time, the hybrid mix of movements contained in the Hindi film dances themselves encourages instructors and students to add their own movements.[32] These added movements are then combined with key elements from the filmed version of dance. This means that instructors at the NDC now include steps from various styles—including salsa, flamenco and hip-hop—in their teaching.

The perceived fluidity and interchangeability between the Nepali and Indian movement at the Dance Centre contrasts with Nepal's public discourses of patriotism in which emphatically differentiating Nepal from India is a key strategy. Conscious efforts to build

Nepal's national identity in the 20th century centered on King Mahendra's slogan of "one country, one people, one dress, one language." With Nepal's former monarchy tracing its heritage to Hindu mythology, Hindi cinema's aesthetic and narrative conventions, which sometimes loosely borrow from Hindu religious storytelling motifs can appear culturally similar.[33] Sunil Thapa, a Nepali actor and filmmaker who worked in Hindi cinema, claims that these films are "closely related to Nepali sentiment."[34] Critics of this perspective view these Hindu-influenced aesthetic and narrative conventions as alien to Nepal's own unique mix of diverse traditions and cultural practices.[35]

However, the history of film production in Nepal itself is inextricably linked to Hindi films. In the 1950s, the government actively supported the growth of a Nepali film industry and encouraged the would-be Nepali film professionals to apprentice in Bombay to learn the skills of the trade including camerawork, film choreography, and editing.[36] The first Nepali language film, *Aama* (1964), was created with the support of the Hindi film industry at King Mahendra's explicit request. A few years later, the film *Maiti Ghar* (1966), which valorized village life, sparked Nepal's commercial film production.[37] The film starred Indian actress Mala Sinha and cemented Nepal's relationship to Hindi films. The dances in *Maiti Ghar* were choreographed by Basanta Shrestha and launched his career as film dance director.

The next thirty years saw a steady increase in Nepal's film production, which peaked at approximately 50 films in 2001. During this period, the film production base in Nepal strengthened as Bollywood-trained professionals like Tulsi Ghimire, Shambu Pradhan, and Kishor Pradhan brought Hindi film aesthetics and techniques to Nepal. Most films produced during this time openly borrowed narrative structures including song-and-dance sequences, fight scenes, and even storylines from their southern neighbors. Audiences, thrilled by the opportunity to watch films in the Nepali language, flocked to the cinemas.

Over the past decade, Nepal's film production has run into hard times—a consequence of ongoing political instability in the country, the Maoists stated dislike for feature films (particularly

Hindi-style films) as immoral entertainment, and the subsequent decline in a number of operating cinema halls in the country. Nepali film distributors hesitate to take on Nepali films, preferring (once again) to screen Hindi blockbusters, which once again dominate cinema halls in Kathmandu and across Nepal. This is true even though Hindi films are more risky financially as the distributors have to pay the distribution fees up front, in contrast to the wholly profit-sharing agreements used in Nepali film distribution. These distribution strategies are further supported by the popularity of Hindi films in Nepal (*see* Photograph 4.3).

Reflecting upon realities, Basanta Shrestha explains it is very difficult to choreograph Nepali dance movement into commercial Nepali cinema because audiences demand sequences that echo Bollywood films. Critical of current tendencies in Nepali film production, Nabin Subba bluntly states, "We are afraid of becoming Bollywoodized. We cannot think without thinking Bollywood."[38] In Nepal, Bollywood has increasingly become representative of the fear of "Indianization" that has grown out of the broader context of Nepal's historical and continued socio-economic dependence on India.

Although Nepal did not experience a direct colonial rule, the 1814–1816 Anglo-Nepal war effectively curtailed Nepal's freedom and subjected it to indirect supervision by the British Empire.[39] India's postcolonial government inherited these power relations. Since India gained Independence in 1947, its government has continually played an active role in Nepal's politics and has not hesitated to deploy its army in Nepal without permission on several occasions.[40]

In the late 1980s, a proposed work-permit system for Indians in Nepal met with steely resistance from the Indian government, which closed the Indo-Nepali border so causing a block on most Nepalese trade. This resulted in import starvation in Nepal. As development scholar Hari Roka observes, 'India's aggressive tactic clearly delineated how much freedom it would allow its northern neighbor.'[41]

The close and dependent relationship with India dominates Nepal's economic, political, and cultural life.[42] The question of what is or is not Indian is thus particularly potent in the Nepali

context. A Nepali development scholar, Dor Bahadur Bista, observes, "Nepal is not like India" and goes on to argue that Nepal's identity problems grow out of India's ongoing influence over Nepal's diverse cultures.[43] Bista's argument portrays Nepal's relationship with India as one defined by strife and difficulty. It also suggests that Nepal's identity is defined, at least in part, in terms of its un-Indianness.

Bombay Disease and Bollywood Dance

Nepal's dependence on India also has another dimension. Every year, millions of Nepalis journey across the Indo-Nepali border for employment in India's thriving urban centers. They tend to find work there as domestic help (cooks, servants, guards), technicians in the film industry, soldiers in the Indian army, and as sex workers and dancers in Mumbai's red-light Kamathipura district.

In Nepal's public imagination, driven by the sex trade rhetoric, sexually transmitted diseases often come to Nepal from India and most commonly from Mumbai. The popular understanding of Nepali migration patterns fuels this assumption. Sexually transmitted diseases, particularly AIDS, get labeled as "Bombay diseases" in Nepal.[44] Such perceptions are further fueled by reports of high HIV infection rates among the Nepali sex workers who return to Nepal after working in India. For example, in 2005, a study of "287 repatriated Nepalese sex-trafficked girls and women" found an HIV prevalence rate of 38 percent.[45] The popular narrative of HIV/AIDS in Nepal describes "innocent" women trafficked to Mumbai against their will, and who subsequently return to Nepal with a possibly incurable "Bombay disease."[46]

The notion of Mumbai as a source of infection is particularly potent in discussions that surround the trafficking of the Nepali women to India's urban centers, in which forced prostitution becomes a national identity issue.[47] Sushma Joshi, a Nepali feminist scholar, defines Nepal's notion of "*maiti*" or birth home as a crucial defining characteristic of Nepali attitudes toward the trafficking of women to India.[48] Joshi's discussion reveals how the

public discourse about sex trafficking in Nepal positions girls as innocent virgins, being groomed toward marriage. Due of their innocence, these girls are easily fooled and abducted by traffickers to Indian brothels where they are exploited and brutalized by (mostly Indian) men.[49] This narrative mixes anxieties about Nepal's dependence on India with those about sex trafficking to paint a picture of innocent Nepalis being exploited by their powerful neighbor. *Maiti*, or Nepal, becomes a vulnerable place. The notion of *maiti* has been used often by the Nepali and Western non-governmental organizations to provoke emotionally charged thoughts about family. In fact, one of the largest and most visible organizations that seeks to repatriate Nepali girls and women trafficked to India is named Maiti Nepal.[50]

The victimization of women engaged in sex work also serves another purpose. In the words of Sushma Joshi, it allows Nepali society to position Nepali prostitution in India as a "Nepali *national* story" that encompasses Nepal's developmental travails and a desperate desire for genuine independence from India.[51] Perhaps most importantly, trafficking provides a unifying story that:

> ... keeps us [Nepalis] secure in the knowledge of our poverty, and the inevitability of conditions of exploitation outside the nation. It also keeps Nepal united against India and Indians, the Others who exploit and use the bodies of our women, sisters, and daughters.[52]

As they rely economically on India, Nepalis feel the need to reassert the existence of borders. The clients become "evil, exploitative Indian men" as the women, like Nepal, assume the role of the victims.[53] The narrative of sex trafficking and HIV in Nepal thus becomes a metaphor for Nepal's dependent relationship with India.

Notably, the narrative of Nepali women as victims persists as a major issue despite uncertainty over how many women from Nepal are in India as sex workers. The frequently cited figure of 200,000, which originates from a UN report published in 1998[54] contradicts other studies that estimate that Nepali prostitutes make up approximately 40 percent of the 15,000 sex workers in Mumbai's

Kamanthipura, and that there are no more than 25,000 Nepali commercial sex workers and victims of commercial sexual exploitation in the red light areas of India in total.[55] As one Nepali fieldworker explains, "reading the reports of some NGOs you would get the feeling that there are hundreds of thousands of Nepali women in India who make up the majority of sex workers in India. That is just not true. Also, it is not true that all women are taken to India against their will."[56] She elaborates, "When I went to the red-light district in Calcutta, some Nepali women working there did not want to talk to me. They told me, 'We don't need to be rescued.' It was very confusing for me".[57] Despite these critiques, the narrative of Nepali women as victims of forced trafficking to India persists and begins to systematically erase any possibility for other explanations in this, admittedly difficult, situation. Perhaps most importantly, trafficking also provides a narrative that unifies Nepal against Indian exploitation—sexual, economic or political—while blaming poverty for the country's many other problems.[58] Joshi argues that such anti-India attitudes reinforce Nepali unity.

Occasionally, Bollywood films themselves perpetuate the imagery of this unequal relationship through negatively stereotyped portrayals of Nepali characters—a tendency evident in director Dev Anand's *Hare Rama Hare Krishna* (1971), which was ironically honored by the Nepal Film Association in 2005. Nepalis are portrayed in these offending Hindi films as awkward, comical tricksters out to swindle the unsuspecting ordinary Indian. When I interviewed Nepali professionals working in the Hindi film industry in Mumbai, all of them mentioned anti-Nepali slander as a common occurrence. "Oh you're Nepali—you must be a prostitute, a guard, or servant" was how one of them mimicked the most common prejudice.[59]

Hindi cinema is also seen as having significant political power in Nepal. Bollywood films are considered to be so influential that they were singled out in the list of forty demands publicized by the Maoist United People's Front in 1996 during the violent conflict that had gripped Nepal over the previous ten years. Specifically, the demand states:

The invasion of colonial and imperial culture should be banned. Vulgar Hindi films, videos, and magazines should be immediately outlawed.[60]

There is an even longer history of official political opposition to Hindi films in Nepal. In 1981 Nepal's one-party Panchayat government moved to ban Hindi films after *Kranti* (1981), with its portrayal of India's pro-Independence struggle against the British, was deemed to be a pro-democracy propaganda.[61] The ban, however, succeeded only in fueling black market demand for the film and after the popular revolt in 1990, the newly-appointed democratic government lifted all restrictions on Hindi films. The proliferation of Bollywood films gains an ever-more momentum. As Nabin Subba explains, "Bollywood is sweeping the subcontinent, with all the new cable channels."[62]

In 2000, anti-India riots erupted in several rural and urban regions in Nepal when rumors surfaced about Bollywood superstar Hrithik Roshan's slandering of Nepalis in a TV interview.[63] Covered by most Nepali newspapers, the rumors were immediate headline news:

> Numerous comments are constantly flowing in from various organizations across the country criticizing the comments made by Indian film star Hrithik Roshan in an interview to an Indian TV channel, aired on December 14. The Indian teenage heart-throb, who sky rocketed to stardom with his debut film, had during the interview reportedly commented that the people he hated most were the Nepali people.[64]

Nepali government officials were also quick to make public statements condemning Roshan. Spontaneous demonstrations erupted in parts of the country. Although Roshan denied the allegations and no evidence supporting the claim ever surfaced, the people's outrage took a violent turn when businesses and persons associated with India were attacked in Nepal.[65] The subsequent mass boycotting of Roshan's Hindi films in Nepal demonstrates that little is needed to sting Nepal's national self-confidence.

Notably, Roshan's fall from grace in Nepal was only temporary. He later regained his popularity in Nepal when he became a

brand ambassador for John Players, exclusive fashion label owned by ITC and licensed in Nepal by Surya Nepal. Today, Hindi, English and Nepali language tabloids full of gossip about the lives of Bollywood's celebrities, including Roshan, are sold at many newspaper stands and street shops in Nepal, often against a backdrop of billboards featuring Hindi film stars promoting a wide range of products from Lux Soap to Pepsi Cola.

New *Filmi* Dance Professionals?

At the NDC, many students dream of dancing in Nepali films and eventually moving on to work in Bollywood. As Basanta Shrestha explains, "Today everyone's children are dancing, but are they dancing classical? No. They are practising to dance like Hrithik Roshan."[66] The NDC bustles with the new students that enroll almost every week, drawn by the Nepali fashion for Bollywood films and their dances. The teachers and dancers at the Centre now speak of a new, voluntarily chosen, *filmi* dance profession.

Although many dances exist in Nepal, the notion of dance as a voluntarily chosen and economically viable profession is fairly recent. Now in her sixties, Beena Joshi belongs to the first generation of dancer professionals not linked to traditional dance communities. Initially, her desire to dance as a youngster met with quiet family disapproval. She later trained in Bharata Natyam in India and Pakistan and returned to Nepal in the 1970s eager to do something for Nepali dance. Driven by a sense of urgency that echoed the reconstructivist impulses that led to the codification of Indian dances, she dedicated several years to documenting Nepali dances, and archiving dance scriptures and sculptures that she encountered.[67] Frustrated by the lack of Nepali public support for recognizing dance as cultural heritage, she has now withdrawn from the public sphere and is now focused on finalizing her research on Nepali dance for publication.

Among the various dance scenes that exist in Nepal, the situation of dancers in Kathmandu is markedly mixed. On one end of the spectrum, Beena Joshi exalts the role of dance as living history

and links dancers to high, and economically secured, social status. On the other end, dancers, from poorer backgrounds often speak about the economic imperatives of survival. "Most dancers in Kathmandu come from middle-class families," Joshi observes. "They need the money. So they dance in hotels, schools, films.... Dancers have a very tough life here." Even as government-run dance institutions like the Naach Ghar and the Royal Dance Academy strive to support dancers, urban-based dancers often find employment in shows set up for tourists and in film-inspired commercial performances for local audiences in various venues, including the dance bars.

Yet, the popularity of film-inspired dancing increasingly influences the situation of dancers in Nepal. At the NDC, dancers speak proudly about the emergence of a new kind of dance profession in Kathmandu. Basanta Shrestha observes that the biggest shift in the profession relates to female dancers:

> Before, no girls would come to dance on the stage. The boys would have to perform the girls' roles.[68]

Shrestha's observation suggests a significant shift in the perception regarding dance as a career for men and women. Dance was previously seen as an unprofitable and disrespected career in general, and for women it was also socially compromising. Dancers at the Centre assert that since the prestige of dance has improved, they can now pursue their profession without compromising their reputations.

It is true that female dancers at the Centre now can become financially independent through employment in films, stage performances, music videos, and modeling. In addition, the demand for dance performances by Nepali communities living outside Nepal encourages the perception that dance can be a financially rewarding career. One such dancer is Seema, a lead dancer at the NDC who assists Basanta Shrestha in his film choreographies while also dancing in films. Seema sees herself as a member of a new generation of professional dancers.[69] She is open about her profession as a dancer and proud of the fact that it earns her a steady income. She feels

comfortable participating in public dance shows and traveling to perform abroad.

Yet, the idea of the new Nepali female dance professional remains controversial. In another part of Kathmandu, Rajendra Shrestha,[70] a teacher of the Kathmandu Buddhist Tantric dance known as Charya Nritya, discourages female dancers from continuing to dance beyond their teenage years. He is adamant about his dancers keeping out of the *filmi* dance world. Rajendra Shrestha explains that Nepali parents are today often happy when their daughters dance as children, but try to stop them from dancing as they get older to protect their reputation.[71] In his comments, Shrestha alludes to gendered differences in the perceptions of dancers. Female dancers are perceived as particularly vulnerable to sexual exploitation when pursuing a professional career in Kathmandu today. Rajendra Shrestha's observation directly contradicts Basanta Shrestha's assertion that dance is now perceived as a good middle-class profession, and that the rising popularity of dance among Nepali girls is a respectable phenomenon.

Beena Joshi further illuminates some of the challenges for female dancers in Kathmandu. Joshi sits in her living room, sips tea and reminisces about her experience of dancing. "What was the problem for your family with dancing? Why have you stopped?" Joshi recalls people asking her. "Well, when you are a dancer, people will not treat you well. They think dance is something very near to prostitution," Joshi had responded then. "How is dance so close to prostitution in Nepal?" was often the follow up question. Joshi does not elaborate any further. She just smiles and rearranges her sari. Her demurely silencing gesture connects dance and the idea of sexual pollution—an expression of the desire to keep the "body (physical and social)" intact and define social boundaries of acceptable contact—in Nepal.[72]

In his exploration of Kathmandu's middle classes, Mark Liechty observes that sexual pollution is crucial to defining what is or is not acceptable behavior.[73] Through its direct engagement with the body, dance latches onto these notions of pollution, in very gender-specific ways.[74]

Despite the country's unique and diverse cultural aspects, gender roles in Nepal are often highly influenced by ideals of Hindu womanhood upheld by the upper-class castes. Cultural differences between these elite city castes and lower class rural populations were institutionalized in the Muluki Ain, a legal çode that until recently remained rooted in upper-caste Hindu shastric rule and its ideals of womanhood.[75] Women were defined through their male family ties—their fathers, brothers, and later through their husbands. They were able to inherit their birth family's property only if they remained unmarried until thirty-five. They could not pass citizenship rights onto their child without his father's signature. These laws often came into conflict with the norms of minority cultures whose social organization was more equitable. Conservative ideals of Hindu womanhood also impose specific Hindu gender-based expectations of sexuality on diverse cultures subsumed under Nepal's national identity.[76]

As South Asian scholar David Mandelbaum points out, one gender assumption endows women with uncontrollable sexual powers of attraction that are irresistible to men.[77] Posed against a notion of the vulnerable female body, dance becomes a potential threat to exposing women to pollution. According to Nepali beliefs, some dances, in particular those intended for secular entertainment, have the potential of revealing the performer in ways that make her vulnerable to pollution. The cultural meanings of how men watch women, and what women feel about being watched is crucial to this potential.

Laura Mulvey's notion of the gaze taken together with the Indian classical dance notion of *darsán* (briefly, the act of seeing and being seen) are helpful in unpacking this relationship between the act of watching and the position of being watched in Nepal. In her seminal essay "Visual Pleasure and Narrative Cinema," Mulvey analyzed the relationship between the performers in a Hollywood film and their audience. She described the act of watching (the "gaze") as "male" and correspondingly, the object of the gaze as "female." According to Mulvey, the gaze of the camera has an objectifying effect on female performers. The gaze translates into erotic pleasure for the male spectator who identifies with the camera.[78]

In contrast, dance scholar Uttara Asha Coorlawala, in writing about Indian classical dance, proposes that *darsán*, the notion of the gaze in Indian classical dance, challenges the objectifying dynamics of voyeurism by transforming the act of watching into an act of religious significance.[79] As the potentially sexualized gaze becomes an act of devotion to the sacred, the power positions of the gaze are reversed.[80]

Bollywood dance in Nepal can be usefully interpreted through both the notion of the gaze and that of *darsán*. Beena Joshi's comments point to the power of the gaze in the context of Nepali dance:

> Women dancers have a very hard time. If you want a family life and you are a woman, it is even more difficult. Your mind and body is involved and your husband might get jealous of that and of people watching you.[81]

In Nepal, as Joshi suggests, audiences assume the connection between the dancer and the dance extends beyond the performance itself. In the case of *filmi* dances, this perception links the dancer to the dance in the film. But as Joshi's observation also suggests these associations sometimes invert the performer–spectator power relationship, resulting in an exploitative practice of viewership that has the potential to disempower the performer in everyday life beyond the performance itself. The position of being gazed upon compromises the dancer's respectability. Rajendra Shrestha specifies that at times the act of dancing itself, if performed with a specific intention, can compromise the character of the performer. In combination, the western feminist theory of the gaze and the idea of the inverted Indian *darsán* is a revealing pair of conceptual tools for approaching the relationship between female dance in Nepal and cultural notions of pollution.

The potentially polluting nature of dance affects women more than men; girls more than boys. Rajendra Shrestha observes that a woman's reputation is fragile in the Nepali society, and the social judgment against her is typically harsh—her status cannot be restored once it has been compromised. Shrestha also suggests that the situation of women in Nepal today is undergoing new changes

and tensions due to the proliferation of modern media technologies. On the one hand, modern media images are enticing symbols of liberation from traditional sociocultural constraints. On the other hand, these same images increase the conflict and collide with upper-class Nepali conservative social norms that prescribe codes of propriety.

In his exploration of the construction of Nepali moral, Mark Liechty observes that sexual restraint is required of Kathmandu's middle-class females.[82] In Liechty's account, middle-class women claim the moral high ground through distancing themselves from what they perceive as the recreational sexuality of the upper classes and commercial sexual service rumors that surround the economically weaker lower classes. At the NDC, middle-class dancers protect their morality by carefully separating themselves from other, less respected (usually lower class) performer groups. Questioned about her performances, Anju, a dancer at the Centre, quickly clarifies:

> As far as I am concerned, I just perform on stage, abroad. Not in the bars or so on... There is a vast difference between them and me. They are doing [it] to survive. But me I am just doing it because it's my passion.[83]

Anju strives to create distance between her dancing and what she understands to be the highly sexualized lives of the performers in Kathmandu's 200 or so dance bars, where most of the dances are set to Bollywood songs.[84] It is in those dance bars that the notions of purity, pollution, sexuality—that shape Kathmandu's perceptions of film dance—become most apparent.

Kathmandu's Dance Bars

"You cannot go to the dance bars alone. Not if you don't know the people and the place well," warns Shanti, a fieldworker from the Society for Empowerment (STEP), a nongovernmental, nonprofit organization that works with bilateral donor agencies like USAID

on reproductive health projects. As she walks down the street in Thamel (Kathmandu's main tourist district), Shanti points out dance bars: "A few years ago, there were very few dance bars here. Now there might be fifty bars in Thamel alone." She stops in front of a partially open iron-grille door, slides through the opening and descends down a flight of stairs into a darkened room. Smelling dank, the room is filled with tables and chairs clustered around a slightly raised stage, equipped with neon lights and a shower. Shanti walks up to the bar and speaks to a man who appears to be the bar manager. He nods, and she walks toward a swinging door that opens into a small room lit by a harsh neon light. The room is filled with young women preparing for this evening's performance at the dance bar (*see* Photograph 4.4).

Prior to the most recent censorship action by the Maoist majority government, dance bars had rapidly become a key element of Nepal's nightlife, competing for clients with the Dohori restaurants (based in bantering call-and-response song traditions between male and female singers) as well as with the cabin restaurants where customers have the option of dining in private cabins. According to NGOs working in this area, the cabin restaurants are the most dangerous for female employees, with many reports of sexual exploitation. Consequently, the cabin restaurants are also subject to frequent police raids.[85] Select waitresses from cabin restaurants transition to dance bars where audiences gather to watch live, often sexually suggestive, performances set mostly to Bollywood songs. Bar dancers occupy the higher-pay position in the adult entertainment hierarchy of Kathmandu's nightlife economy.

The Nepal Restaurants Entrepreneurs Association (NREA) estimates 30,000 women are currently employed as dancers in Kathmandu's dance bars.[86] Following the banning of dance bars in Mumbai in 2005, Kathmandu became the new dance bar "capital."[87] Rumors abound regarding Nepali film stars and the occasional foreign dancers who allegedly perform in the most exclusive dance bars for a selected audience. Links to prostitution are also common as the dancers and other staff may, on occasion, provide additional sexual services to their customers.

In public discourse, the dance bars have become the new and increasingly present underbelly of dance in Kathmandu. One fieldworker at STEP explains, "Seven or nine years ago you would have really had to search to find a bar that has dancers. Today they are everywhere. All you have to do is lift your head and look for glittering lights and the telltale billboard. Look for words like sexy, X, dance, and bar."[88] While both men and women perform, female dancers are clearly in the majority. According to field staff, the girls and women generally come from outside Kathmandu, many of them displaced by the country's violent internal conflict.

Performances at the dance bar begin around 7 or 8 pm. But the evening really gets going 9 pm onward when the clientele changes. Any lingering couples out on a date disappear, and the audience becomes virtually all male. The dances then become more sexually explicit, and the clothes more revealing. "In some bars, late at night, women dance completely naked—pour beer on themselves," a STEP fieldworker reports. "The girls who do it earn twice or three times more than girls who keep their clothes on." Wages are also set according to the quality of performance and type of clothing. Manjita, a bar dancer, explains that her work is very well paid in comparison to other work opportunities: "I came from the village and was earning just a few hundred rupees. Then my friend told me to come to work as a waitress. So I came here. Later I started dancing here. I can earn a few thousand rupees in just one night. Much more than I was earning before, plus I like the people here" (see Photograph 4.5).

Backstage at the XXX dance bar one night, a lot of attention goes into getting the makeup just right and more experienced dancers give advice to the younger ones on the specifics of how it should be applied. "You need to make the bottom eye line longer. That makes your eyes look bigger. Then you can look like Madhuri Dixit," Binita advises Jyoti and they both laugh. Jyoti flutters her eyelashes. Women compare cosmetics brands and discuss which songs are their favorites. "I like romantic songs," Binita laughs. "But you cannot always dance well to them. Sometimes we need things that are a bit faster." As Jyoti reapplies her makeup, Binita watches her and becomes more talkative: "My husband is not

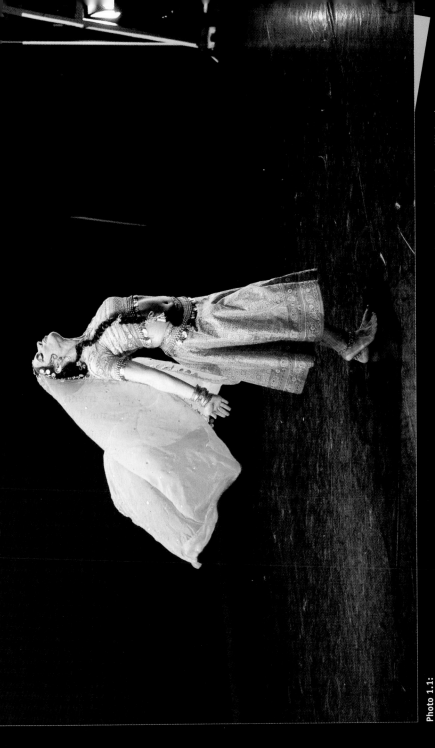

Photo 1.1:
Kavitha Kaur performs "Choli Ke Peeche Kya Hai?" at Frame By Frame. Photography by Peter Schiazza, courtesy of Akādemi – South Asian Dance UK, London.

Photo 1.2:
Dances in Hindi films, like this sequence from Partner *(2007),
are often choreographed to encourage audience participation.
Photo courtesy of Eros International.*

Photo 2.1:
Dances take on a central role in the film Om Shanti Om *(2007).
Photo courtesy of Eros International.*

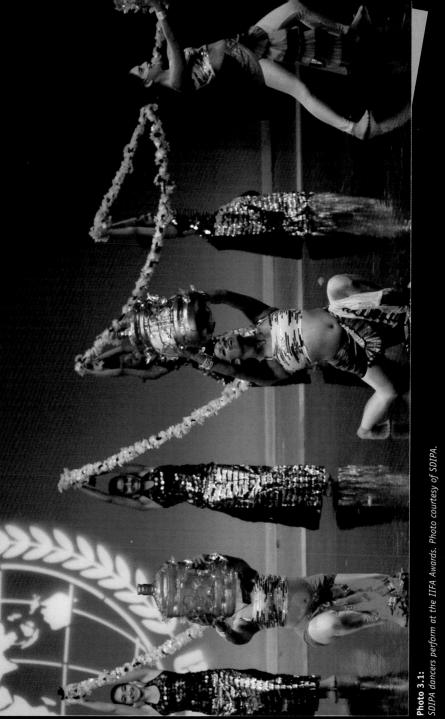

Photo 3.1:
SDIPA dancers perform at the IIFA Awards. Photo courtesy of SDIPA.

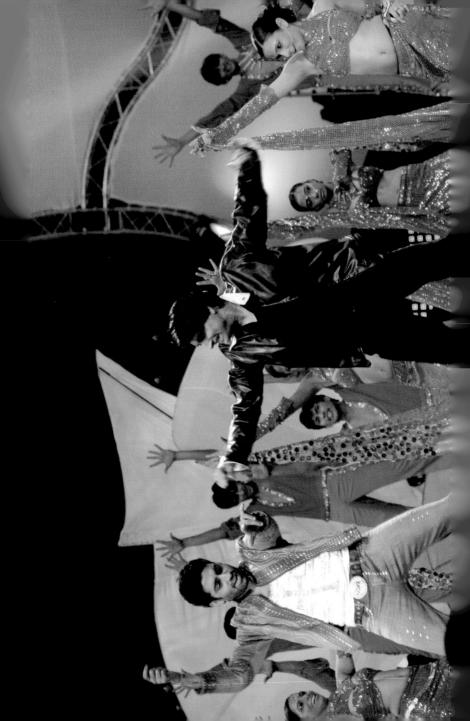

Photo 3.3:
Shiamak Davar performs with Bollywood film star Hrithik Roshan.
Photo courtesy of SDIPA.

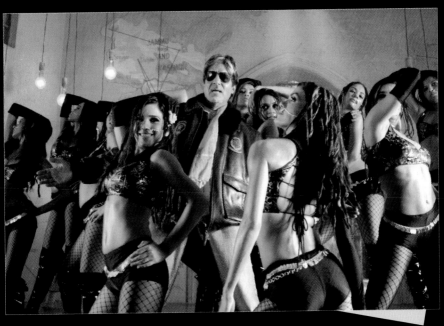

Photo 3.4:
SDIPA dancers perform with Amitabh Bachchan in the film Bunty Aur Babli *(2005).*
Photo courtesy of SDIPA.

Photo 3.5:

Shiamak Davar's choreography became a key selling point for the Bollywood film Kisna *(2005).*
Photo courtesy of SDIPA.

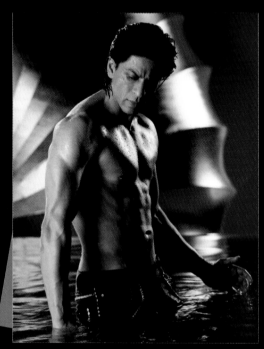

Photo 3.6:

In Om Shanti Om *(2007), Shah Rukh Khan stunned audiences by bearing*
his new and much discussed, "six-pack" abdominal muscles.
Photo courtesy of Eros International.

...eign, often fair-skinned, dancers are currently popular in Bollywood film dances. Several companies recruit and provide non-Indian dancers to

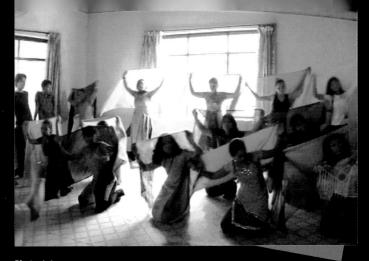

Photo 4.1:
Dance class underway at the National Dance Centre, Kathmandu, Nepal.
Photo courtesy of David Čálek.

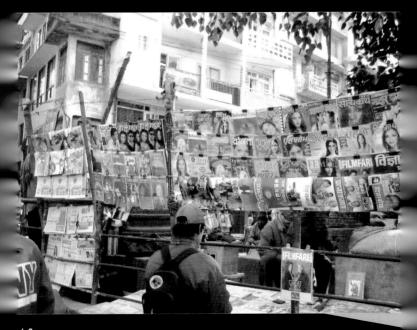

4.2:
...ood themes dominate a street-side newspaper and magazine stall in Kathmandu, Nepal.

Photo 4.4:
A sign advertises a dance bar to all passers-by. Photo courtesy of author.

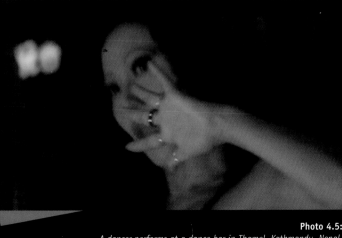

Photo 4.5:
A dancer performs at a dance bar in Thamel, Kathmandu, Nepal.
Photo courtesy of David Čálek.

Photo 4.6:
A Badi dancer demonstrates the community's traditional form of dancing. Photo courtesy of author.

Photo 5.1:
The NDM Bollywood Dance Studios is located in the heart of Little India in the Los Angeles area.
Photo courtesy of author.

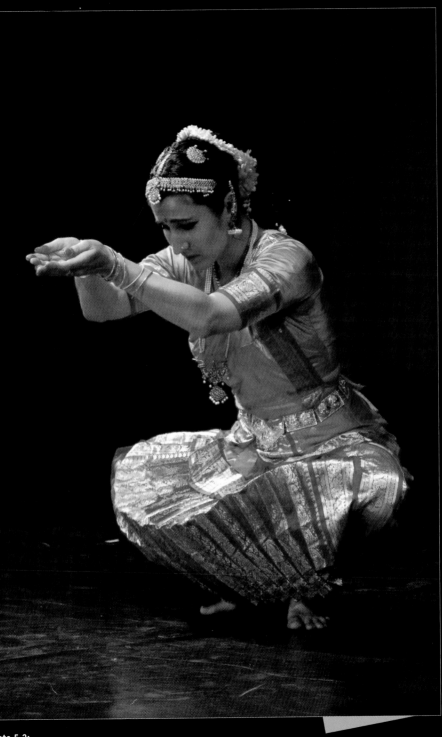

Bharata Natyam dancer in full costume. Photo courtesy of Bollynatyam™.

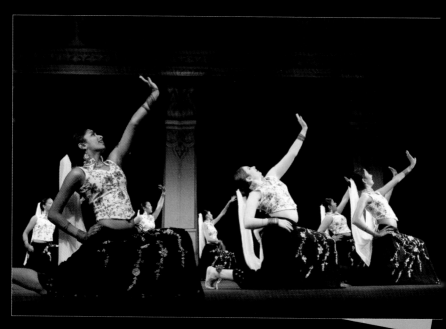

Photo 5.3:
Children perform Bollywood dances that they learned at NDM Bollywood Dance Studios.
Photo courtesy of NDM Bollywood Dance Productions Inc.

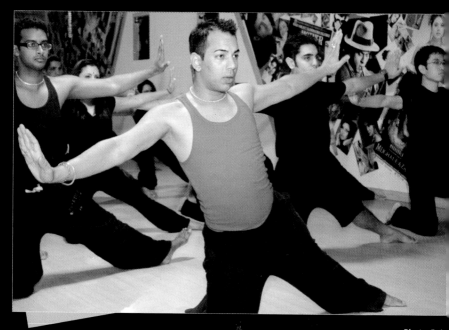

Photo 5.4:
Dance classes at the NDM Bollywood Dance Studios.
Photo courtesy of NDM Bollywood Dance Productions Inc.

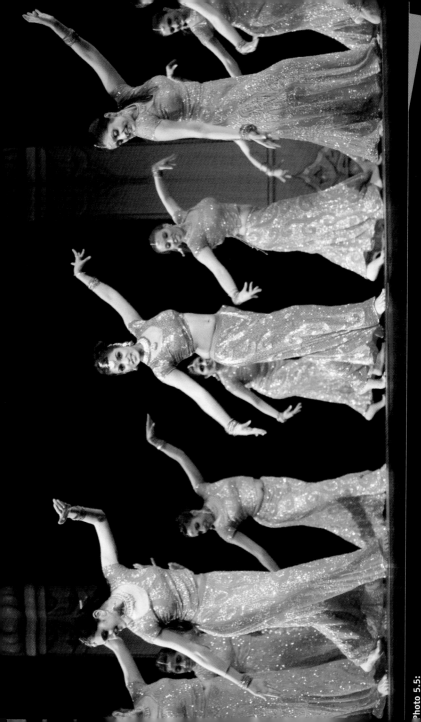

Photo 5.5:
NDMBDS dancers performing a Bollywood dance. Photo courtesy of NDM Bollywood Dance Productions Inc.

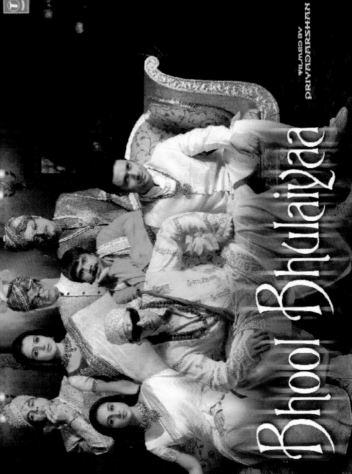

GULSHAN KUMAR
PRESENTS

A T-SERIES FILM

www.bhoolbhulaiya.com
www.t-series.com

Bhool Bhulaiyaa

IN CINEMAS OCT. 12

PRODUCED BY BHUSHAN KUMAR & KRISHAN KUMAR MUSIC PRITAM LYRICS SAMEER
SCREENPLAY NEERAJ VORA DIALOGUE MANISHA KORDE CINEMATOGRAPHY S. THIRU ART DIRECTOR SABU CYRIL

A FILM BY
PRIYADARSHAN

EROS
www.erosentertainment.com

here, but he knows where I work. What can he say? Nothing." She looks at me through the mirror's reflection. Binita uses her financial means to assert her independence.

Although bar dancers are often talked of disrespectfully by dancers at the NDC, the bar dancers argue that their work is more morally upstanding than what the girls at the NDC do. "I would not go and dance in films," asserts Manjita, a bar dancer. The idea of her image being publicly available in films is unacceptable to her. The stage in the bar is seen as a private space; live performance is seen as a fleeting moment, offering only a temporary opportunity to watch and be watched.

Contrary to the rhetoric about forced prostitution common in Nepal, "most of the girls are doing it of their own free will," the STEP field worker explains, "no one dragged them there. They just need the money."[89] Although some dancers say that they want to continue to perform as long as possible, most plan to stop some time in the near future.

Interestingly between 2004–2006, the entry of more women into the dance-bar business displaced cross-dressing male performers from the bar dance stages. At the Blue Diamond Society, a support organization for lesbian, gay, bisexual and transgender issues in Nepal, Kumari and Rakesh, two male-to-female transgender dancers reminisce about how they used to perform in bars. "We would listen to the lyrics, watch the films and embellish movements." I even took dance classes at the government-sponsored dance institution Naach Ghar to learn to move better. Like female dancers currently employed in bars, these dancers chose to dance mostly to Hindi film songs. "They are more energetic and fast," they explain. Kumari demonstrates her approach to Bollywood dance and chooses the song "Barso Re" (It's Raining) from the Hindi film *Guru* (2005). Her movements echo the choreography performed by Aishwarya Rai in the film but she embellishes it with hip movements and sideward glances toward the audience. Today, transgender dancers rarely perform in dance bars. "The women took our jobs," Rakesh explains. "But we used to dance better."

Back at the XXX bar, a small audience has now assembled around the stage area in the bar. As the lights dim and music

becomes louder, Sanju, dressed in a strapless top, miniskirt and high boots, enters the stage. She turns away from her mostly male audience and runs her hands over her hips, upwards toward her head—until her fingers intertwine in her hair. Slowly she turns to face the front as she lip-syncs the words to a Bollywood song remix. She moves her hips back and forth as she whirls her wrists above her head. She gazes beyond her audience as the neon lights blink to the pulsating rhythm. As Sanju's performance ends, she turns, waving goodbye to her audience.

In the dressing room later that evening, Pooja hurriedly reapplies powder under the harsh light. "Bollywood songs are what we dance to the most. Different dancers specialize in different moves." She adjusts her miniskirt and checks the tension in her bra straps. "We practice our dance moves at home in front of the TV, and then come here and perform." The bar manager pokes his head into the dressing room to tell us that they are about to start. Pooja nods and takes one last look toward the mirror. As she heads toward the door, she pauses, "... and *didi* [older sister], we know all about AIDS, how it's transmitted and all. We are not like that." She laughs as the door swings shut behind her. But her comment points to how bar dancers in Kathmandu bear the brunt of the sexual stigma associated with dance in Nepal, a stigma exacerbated by the looming AIDS epidemic in the country.[90] In Kathmandu, bar dancers embody the stigma that links dance, sexuality, and Bollywood.

Over the past 20 years, development agencies recorded continual increases in HIV/AIDS infection rates in Nepal. Limited testing facilities, underreporting of test results (especially by private clinics), financial constraints, and people's hesitation to be tested have systematically contributed to the inaccuracy of official statistics on HIV/AIDS in Nepal. Officially only 0.5 percent of Nepal's adult population is HIV positive but rates are rising as longitudinal studies indicate that infection rates may be increasing by as much as 200 percent annually. In Nepal's development discourse, "AIDS has played an important role in establishing sexuality as a matter of public debate and national concern in Nepal."[91] Unfortunately, the discourse tends toward discussions of "ignorant" or "backward" persons with HIV/AIDS and "social marginalization."[92]

Sexualized Dances of the Badi in Western Nepal

As dancers at NDC speak about a new era in dance, they often also allude to another legacy of dance in Nepal that predates the introduction of modern media technologies and the recent emergence of dance bars. Before the dance bars, one of the most prominent public discourse focused on the links between dance, sexuality and social marginality concerned the Badi communities of western Nepal.[93]

The Badi dancer communities trace their origins to the courtesans of the Nepali and Mughal royal courts. While historical evidence on this subject is scarce, historians suggest that the Badis later migrated to central and western Nepal. In their encyclopedic anthology, Gautam and Thapa-Magar further theorize a tentative historical link between Badi communities and the court dancers of the Mughals in the area currently located in present-day northern India.[94] While very little has been written about their dance practices, it is generally agreed that in the past, the Badi were supported primarily by local rulers and landlords, who provided for their needs in exchange for live entertainment.

In many ways, the narratives about the Badi of Western Nepal resonate with those of the *tawaif*s, who were courtesans, of northern India.[95] Historical accounts indicate that the *tawaif*s trained extensively in song-and-dance, occupied a prominent, even prestigious position in northern India's society for centuries leading up to India's Independence.[96] Like the *tawaif*s, the Badi, at their peak were respected for their artistic abilities and their performances were coveted for their auspiciousness.

Upon their encounter with dance traditions on the South Asian subcontinent, the British adopted *nautch* as a term that described all forms of dance, and *nautch girl*, perceived as indicating something similar to a prostitute, became the label given to dancers. Their artistic accomplishment was all but ignored.[97] In response to what they saw as the scandal of the *nautch*, the British initiated social reforms, which included the Anti-Nautch Movement launched in Madras in 1893 and culminated in the Devadasi Abolition Bill of 1947. Put simply, the reformist movement identified

dancers as prostitutes, and accused traditional dances of being training grounds for commercial sex work.[98] Along with other similar dancer communities, the *tawaif*s now found themselves living on the outer limits of social acceptability.

Like the *tawaif*s in India, the Badi in Nepal have borne the stigmas associated with dance entertainment and commercial sex work. Legally, the Badi have been historically categorized with the lower castes in Nepal's legal code (Muluki Ain) since 1854, which identified "singing, dancing and begging" as professions of the "low" standing.[99] Although the old Muluki Ain has been replaced, its influence persists in upholding the socially-conservative norms of Kathmandu's Hindu middle and elite classes.[100] According to these norms, Badi dance is a form of entertainment that, in effect, fronts for prostitution. In her anthropological work on women in the village of Bhalara, Mary Cameron confirms that local Badi are often perceived as both dancers and prostitutes by their neighbors.[101]

The similarities between the Badi and *tawaif*s coexist with several key differences. Particularly significant for Bollywood dance in Nepal are those differences that emerge through their distinct colonial and postcolonial histories. In northern India, the decline of the *tawaif* was largely driven by colonialism and its legacies in the early postcolonial period. Unlike India, Nepal (which has had no experience of direct colonial rule) did not develop a national independence movement that partly defined itself through recuperative efforts to reclaim cultural traditions from what was seen as moral decay. Rather, it was primarily Nepal's experiences in the second half of the 20th century of new development projects and modern media—including Hindi film related content—that ushered in a period of rapid cultural change for the Badi.

Development scholar Linnet Pike identifies the overthrow of the Rana hegemony in the 1950s and the related erosion of the "traditional economic power base of the rulers of small principalities and large landowners" as key factors that led to the undermining of the Badi's traditional support structures.[102] This period also brought new music through modern media technologies. Radio Nepal, the national shortwave radio station, brought prerecorded

music—ranging from Nepali folk tunes to Nepali and Hindi film songs—to rural Nepal for the first time in 1951. This access greatly influenced public taste and Pike concludes that the demand for Badi music and dance skills decreased as a direct consequence.[103]

During this research, members of the Badi community spoke about and showed their dance. "We had a very special way of moving that we would learn through our families," Shanta Nepali, a Badi performer, explains. The Badi feel their profession underwent significant change when radios, cassettes, and television arrived on the scene. "People listen to cassettes, Hindi songs, and they don't ask us to come and perform any more. So nowadays we don't get asked to dance much anymore," Nepali continues. Technological innovations in media brought with them alternative sources of entertainment and decreased the value of Badi performances. Badi dances involve slow, flowing movements with occasional turns and squats set to live musical accompaniment. Technological innovations in media brought with them alternative sources of entertainment and decreased the value of Badi performances.

According to Prema, a senior Badi, "Badi performers are asked today to dance 'Hindi style'," which they understand to mean a less flow-oriented, and more percussive dance style. "We have to move the chest more, and the hips side to side," Prema demonstrates. In contrast, the way the Badi used to dance before the arrival of Bollywood involves very gradual, fluid movements characterized by multiple turns, level changes, and wrist whirls—all accompanied by live percussion on the drum, or *madal*, and singing. As they show how they move to Hindi film songs, the Badi dancers' movements become more percussive, less internally oriented. The dancers pulsate through their chest and thrust their hips from side as they look coquettishly to accentuate their movements (*see* Photograph 4.6).

Prema goes on to explain that, despite being a significant expense, purchasing a cassette player is now essential to keeping up with customers' demands for dances set to the latest Bollywood songs. This thus reflects the Badi struggle to integrate their traditional role as entertainers with the same media technologies and content that the NDC dancers see as having brought about a new period for dancers in Nepal.[104]

Yet their performance may find some continuity through urban-based *filmi* dancers. Just like the Badi, *filmi* dancers are in the profession of entertaining their audiences. Just like the Badi, *filmi* dancers negotiate the persistent normative gendered expectations informed both by historical perceptions and pressures of modernity in Nepal.

Legacies of Dance

Back in Kathmandu, emerging professional dancers at the NDC are careful to disassociate themselves from the Badi and the bar dancers. The NDC dancers assert that their dance practices are absolutely respectable. Seema, a lead NDC dancer, explains:

> If you go back five or ten years, it was very hard. Now people are more educated.... Before if you were a dancer you were considered a very low class woman. Even the society used to discard the women especially who perform in the movie also, whether an actress or a dancer... [Then they assume that] she doesn't have a good character....[105]

Seema's account is based upon assumptions of education and progress, which may lead to more respect for dancers and actresses.

While Sanjana, an older dancer at the Centre confesses that she "never thought that dance could be a professional means of earning money," younger dancers disagree.[106] Deeya, who is working to establish herself as an actress in Nepal, explains how her parents forced her to stop dancing after her eighth grade.[107] While she grudgingly accepted their decision at the time, looking back she feels that her parents misjudged the potential of dance as a lucrative profession. At the NDC, Seema explains: "I make a living as a dancer. Before... it was very hard to survive only with this career, but now it's quite easy.... You can earn very good amount."[108] New and prestigious employment opportunities in films, ads, dance videos and stage shows have arisen for dancers over the past five

to ten years. Seema asserts: "if my husband did not want me to dance, I would back off from the marriage."[109] Her confidence grows, at least in part, out of her economic independence—she identifies with young female professionals in Kathmandu who have successfully broken obligatory marriage traditions through paid employment.

The claims of respectability made by these dancers, however, remain precarious as perceptions of dancers as morally compromised women persist and converge with the new stigmatization of economically independent and publicly visible women. Adamantly upholding the more conservative stance on dance as a profession for women, dancer teacher Rajendra Shrestha asserts, "Nepal is conservative" and "not that liberal...like Germany or France." While he acknowledges that Nepali society has become more tolerant he insists that the content available through Hindi films and other modern media channels is difficult for him to accept.

Filmi dancers exist in these controversial spaces that also include Kathmandu's emerging economies of labor. Mark Liechty delineates these economies as he explores the sex-based rumors that are aimed at economically-active women in Kathmandu:

> Travel agency or hotel receptionists ("They also work as 'escorts'"), secretaries ("It's for the boss too, you know"), nurses ("They know a lot about contraception"), and waitresses: In the popular imagination, all of them are more or less synonymous with prostitutes.[110]

As Liechty explains, these women are generally surrounded by assumptions about their sexual promiscuity, and this linking of sex and independent women workers fuels Nepali male fantasies. In other words, Liechty argues that in Nepal, women who gain economic independence through their own jobs are often associated subliminally with the commercial sex industry. Such popular misconceptions further complicate Seema's justification of her dancing career as a respectable and generously remunerated profession. Through their simultaneous engagement with these views and their negotiations with the traditional stigmas associated with dance as

performance, the situation of the *filmi* dancers in Kathmandu finds many parallels with the dual positioning of the Badi as independent women who have to live with the risk of being seen as morally compromised.

In 2002, a scandal shook Kathmandu as a Nepali film starlet and dancer, Shrisha Karki, killed herself a week after a leftist tabloid published a nude picture of her under the heading of "A Colourful Evening in Film City".[111] In her obituary for the actress, journalist Manjushree Thapa poignantly writes:

> The actress in the photograph, Shrisha Karki, hung herself at her home in Chabahil six days later in a case that shook the film industry over Dasain. It is not hard to imagine the intense degradation the young woman must have felt in her last days. What support would she have possibly received from a society obsessed with women's sexual purity? Anyone who looks at her photograph can measure her vulnerability: in it, she stares up from a hunched-over position in bed, her face contorted in fear, her body frozen in humiliation. It is obvious that the photograph was taken against her will. Karki's is the face of a victimised woman pleading, unmistakably, for some decency from her victimiser.[112]

In the photograph Shrisha Karki kneels on a bed, apparently naked and terrified as she stares directly into the lens of the camera. The article detailed "the alleged prostitution, sexual escapades and love affairs of those in the Nepali film industry."[113]

While mystery still surrounds the incident, its realities bring forth into a harsh light the contradictions in the Nepali society relating to female actresses, which also apply to other commercial female performers such as *filmi* dancers. Prior to this scandal, Shrisha Karki was perceived as a model of an emancipated, successful woman—a rising film star who belonged to the a growing elite group of professional female public performers in Kathmandu, who have been trained in prestigious institutions like the NDC.

In spite of this, a single tabloid photograph had the power to undermine her apparent emancipation, leading her to be so ashamed that she no longer wanted to live. Why? Was the shame she felt a

manifestation of a deeply rooted, internalized conservative moral code? According to prevailing arguments expressed in the Nepali public debate around the affair, Shrisha Karki was, at least in part, responsible for her own demise and so did not deserve public sympathy. Karki's story suggests some similar underlying assumptions about public performers in the Nepali society, namely, performers who enter the public economic space, without overt coercion, apparently cannot ever be accepted as victims in the Nepali public discourse. Unlike the women in the "innocent narrative" of forced prostitution, Shrisha Karki was not deemed to deserve social forgiveness. Her status as a public performer translated into evidence of sexual promiscuity, which in turn was felt to have justified her humiliation.

Shrisha Karki's suicide is a painful reminder of the implosive potency of the unstable border space occupied by Bollywood dances in Nepal. The silence maintained by most Nepali feminist organizations in the aftermath of Karki's tragic death is an even more frightening indication of the deep-rooted assumptions that persist about female dancers and performers in Nepal.

Karki's story comments on Bollywood dance in Nepal. The series of incidents that led to Karki's death reflect a potent collision of sexuality and bodily display in the public and private norms of female respectability upheld by Kathmandu's middle classes, which provide continuity to the stigmas faced by Badi of western Nepal.

Sexualized National Dimensions of Bollywood Dance

Nepali dancers connect to each other through the complex web of Bollywood dance imagery that binds together the otherwise distinct instances of dance that are dispersed across the country. Students at the NDC, dancers at the dance bars in Thamel, and the Badi in western Nepal coexist in a social space carved out for dancers who entertain. Male and female students struggle to execute a Hindi film dance duet in the early morning hours at the NDC. In the evening,

dancers prepare to perform sexually explicit dances in the dance bars of Nepal's nightlife. In western Nepal, Prema Nepali pauses to whirl her wrists while practicing her chest pulses to a Bollywood song. These dancers may never meet. As one falls asleep, the other begins to stir.

A particularly intriguing example of the sexualized and national dimensions of Bollywood dance in Nepal coalescing is the 2004 Hindi film *Love in Nepal*. The film centers around Abby, a young Indian advertising executive, and his team's decision to set a big fashion shoot in Nepal. The team's plans go awry when Abby meets Tanya, a young Nepali seductress. Played by Jharana Bhajracharya, a former Miss Nepal, Tanya boldly invites Abby to her room where she tries to seduce him through a song-and-dance routine. She undulates in front of him dressed only in a man's shirt and lingerie. Licking her lips, she leans forward to demonstrate her desire. Her quintessential "item" dance ends when a drunk Abby falls asleep before anything of consequence happens. When Abby wakes up, he discovers a murdered Tanya lying in bed next to him. Once he determines that he could not have killed her, Abby sets off to find her murderer in order to clear both their names. In the film's climax, Abby discovers that the group's Nepali, and apparently crazed, male tour guide murdered Tanya when she did not reciprocate his romantic feelings for her. Thus, the film promotes Indian filmic stereotypes of the Nepalis even as it raises Nepali concerns about nationality and gender roles through its characters and narrative.

The fact that the film's femme fatale character was played by a former Miss Nepal, understood by many to be a prominent national symbol, became a very sensitive point in the Nepali media. Bajracharya was questioned extensively about her decision to accept the Tanya role in *Love in Nepal*.[114] She was even accused of compromising her Nepali cultural values by dancing provocatively in a Bollywood film for an Indian character. Furthermore, Tanya's apparent sexual emancipation and economic affluence was deemed to be a further evidence of her compromised morality. The fact that she was murdered by a mentally-disturbed

Nepali tour guide further inflamed Nepali nationalist sensitivities. The casting in *Love in Nepal* of a Nepali star in a sexually explicit vamp-like role very controversially intertwined the provocations of nation, modernity, and sexuality mediated by Bollywood films in Nepal.

Bollywood dance in Nepal becomes a site of conflict where notions of nation, modernity, tradition and respectable sexuality collide. On the one hand, performing Hindi film dances allows dancers to participate in the imagination engendered by Hindi films. On the other hand, Hindi film dance latches on to and exacerbates the sexualization of dance in Nepal. Karki's tragedy testifies to the potency of the controversies that surround Nepal's new dance and film performers. Like Tanya in *Love in Nepal*, Karki was seen as at least a partial orchestrator of her own demise. Through her public performances, Shrisha Karki walked a fine and treacherous line between ignominy and social acceptability. Bollywood dancers also traverse this dangerous national terrain as they inscribe and perform the possibilities and limitations of Hindi films on their bodies.

In performing Bollywood-inspired dances, students at the NDC engage with this terrain. Dipika's nervous laughter and refusal to be lifted can be seen as much more than an isolated instance of shyness. Her collapse can be read as a visible manifestation of the conflict between her desire to participate in the modern aspirations of the dance and her cultural memories of the traditional stigmas attached to dance. Even as they reach for the promises of affluence and modernity packaged in culturally familiar imagery as mediated by contemporary Bollywood films, the dancers inherit the sexual stigma of dance as entertainment in Nepal. Even as they aspire to help build a modern Nepal, Hindi film dance in Nepal contradicts Nepal's desperate nationalist rhetoric against the country's dependence on India.

Two weeks later, it is, once again, time for the morning class at the NDC. Students prepare to run their rehearsed choreography. Sushant rewinds the tape and hits play. Mohan watches as the students perform the first movements of the choreography. Dipika

and her partner execute their bouncy side step and move into their preparation for the lift. Dipika pauses. She bites her lip. Then, on the count of four, she moves forward and jumps clumsily into her partner's arms. Staggering slightly under her weight, her partner lifts her. The sound of "Rock and Roll Soniye" echoes through the studio, calling up images of New York City mediated through the song-and-dance sequence in *Kabhie Alvida Naa Kehna*. In Kathmandu, Dipika and her partner, their arms around one another, begin to turn.

5

More Indian than India?
Bollywood Dance in Los Angeles

One day on American TV in 2008, the host on the Fox Network's dance competition and reality show *So You Think You Can Dance?* is introducing the next performance.[1] "When Katee and Joshua [the dance contestants] picked this one from the hat, they felt more than a little confused," she tells us. The show cuts back to that moment when Katee, a young Japanese–American woman reads uncertainly from a card. "It's something called Bollywood," her tone is perplexed. To clarify matters, we cut to choreographers Nakul and Marla who tell us that Bollywood is a dance style that originated in India. We witness Katee and Joshua rehearsing for their Bollywood dance debut. They leap to a precise beat and practice their hand gestures. Concerned about his performance, Joshua, an African American, tells us that he wants to make the choreographers proud because this is their culture. The tension seems high in the rehearsal studio.

We return to the show where Katee and Joshua take center stage, ready to present their dance. Dressed in a glittering midriff baring costume, Katee waves a transparent shawl as she circles her dance partner. With great care, Joshua moves through the staccato movements that introduce their vigorous Bollywood dance set to

"Dhoom Tana" from the film *Om Shanti Om* (2007). Over the next few minutes, they cavort with flirtatious gestures and expressions, leaping to the song's catchy beat, punctuating their athleticism with precise gestures borrowed from Indian classical dance.

As Joshua sweeps Katee off her feet and into a visually impressive final pose, the audience breaks into enthusiastic applause. "Who would have ever dreamt that we would be seeing Indian cultural dancing on this program?" Nigel Lithgoe, a judge on the show, exclaims before the program cuts to Nakul Dev Mahajan, the Los Angeles-based US Bollywood choreographer who is now seated in the audience. He beams into the camera. This example from *So You Think You Can Dance?* is just one indication of the growing mainstream popularity of Bollywood in the US.

To the extent that live Bollywood dance has been known about in the US, it has mostly been a phenomenon associated with informal social gatherings of young Indians in America. Over the past decade, however, live Bollywood dance has become a more formalized cultural movement that is now the dominant influence on the vast majority of staged performances showcasing Indian culture in the US. Dances set to Hindi film songs feature prominently at Indian–American community celebrations, parties and festivals. On college campuses across America, Bollywood routines are a favorite at student-run Indian cultural shows.

In many major US cities, the popularity of Bollywood has led to a new wave of Bollywood dance classes taught by instructors often with little or no experience of, or connection to, Mumbai's film industry. In New York, Pooja Narang's Bollywood Axion caters to hundreds of Indians eager to master Bollywood choreographies. In the Chicago area, Bollywood Rhythms imbues its students with the basic movements from recent films. Bollywood dance classes are also on offer in many other cities including Washington DC, Boston, and San Francisco.

Although it is the Indian diaspora that drives the popularity of Bollywood in the US, Hindi films and dances have recently gained prominence among non-Indian populations as well. This has been fueled in part by the high profile and mainstream distribution of major Indian-themed films such as *Monsoon Wedding* (2001) and

Bride and Prejudice (2004), made by film directors of Indian origin who selectively apply Bollywood aesthetics in their films. The rare application of Bollywood film conventions or use of Bollywood music in certain Hollywood films directed by non-Indians, like Baz Luhrmann's *Moulin Rouge* (2001) and Spike Lee's *Inside Man* (2006), may have also raised awareness of Bollywood among American cinemagoers. Although hardly a Bollywood film, the Academy Award for Best Picture winning British film *Slumdog Millionaire's* (2008) runaway success also helped build Indian commercial cinema's presence in the popular imagination of the US public.

In the live performance arena, the Broadway staging and the subsequent US tour of the Andrew Lloyd Webber musical *Bombay Dreams* brought Bollywood songs and dances to American theater audiences between 2004–2006. The profile of Bollywood in the US benefits from additional publicity surrounding the international career development of certain major Bollywood stars. Aishwarya Rai Bachchan, a leading female Bollywood star, became an L'Oréal cosmetics model in 2003, and appeared in the Hollywood film *Pink Panther 2* directed by Harald Zwart in 2009. Another Bollywood star, Hrithik Roshan was in discussion for a Hollywood-produced sequel to the Bollywood sci-fi blockbuster that he starred in, *Krrish* (2006).[2] The growing familiarity with Bollywood in the western world is not limited to the US. Hindi film choreographer Vaibhavi Merchant's music and dance stage extravaganza *Merchants of Bollywood* brought Hindi film dance to Australia in 2005. In Germany, instructional DVDs bring Bollywood dance to those who want to try out the steps in the privacy of their homes.

Responding to the increased US interest in Bollywood, Mahajan (NDM) promotes himself as "Hollywood's Favorite Bollywood Choreographer" as he splits his time between providing dance instruction to the local Indian diasporic community in Los Angeles, and bringing Bollywood dance to Hollywood productions. Over the past few years, NDM's dance troupe has appeared in several American television shows including NBC's soap opera *Passions*, the Diwali episode of NBC's sitcom *The Office*, USA Network's makeover reality show *Character Fantasy*, MTV's dating reality

show *Next*, as well as on the already mentioned *So You Think You Can Dance?* dance competition reality show on Fox.[3]

NDM Bollywood Dance Studios (NDMBDS) now occupies the dual position of an American Bollywood dance institution that grew out of the Indian diaspora's Hindi film spectatorship, and also increasingly strives to establish itself in Hollywood productions in Los Angeles. Here we meet the students that take classes with NDM and inquire about their understanding of what Bollywood dance means for the Indian diaspora in America.[4] We interpret Bollywood dance as a manifestation of the role that Hindi cinema plays in defining an imagined original cultural home for NRIs. We explore the historical continuities between Bollywood dance and Indian classical dance in America. We consider how the story of the developing popularity of Bollywood dance in the US differs from the Bollywood phenomena that we have observed in India and Nepal. NDMBDS, a dance institution in the Los Angeles area, becomes an entry point into our exploration of Bollywood dance in the US.

The Indian Diaspora and Bollywood Dance

Launched in 2003, NDMBDS specializes in Bollywood dance instruction and performance. The studio is located in Artesia, the Little India of Los Angeles. The 2000 US Census indicates that persons of Indian origin make up only approximately 5 percent of Artesia's total population. But for approximately five blocks, Indian fabric, garment, grocery, and video/CD/DVD stores line Pioneer Boulevard, the city's main street. Somewhat quiet during the week, the area is invariably lively on weekends as Indians and other South Asians crowd the sidewalks. Indian American families stroll the streets and their children smack their lips as the taste of masala dosa, idli, and *bhelpuri* (Indian snacks) linger on their tongues. Women peer into the gold jewelry store display windows. Bollywood songs seep into the air and mix with the smell of Indian spices and *ghee*. At the Cash and Carry on 186th and Pioneer Boulevard, shoppers scramble for their favorite mixed pickle as they

shout to friends elbowing their way toward prized "just-arrived" Alphonso mangoes from India. Walking down Pioneer Boulevard on a Saturday is for many an "almost-in-India" experience. It is here, in the heart of Little India, toward the back of a strip mall, that NDMBDS can be found (*see* Photograph 5.1).

Bollywood dance classes are taught at NDMBDS all week and range from classes for children to adults, and even include classes for senior citizens. The vast majority of the students who take classes at NDMBDS are of Indian origin. Most students range from five to eighteen years of age—older students tend to stop classes to focus more on their schoolwork, but then sometimes return to join the school's adult classes. The school typically has at least 200 students enrolled at any given time and claims to have taught over 3,000 students since its opening. Periodically, NDMBDS auditions dancers for the NDM dance troupe, which specializes in performing Bollywood dances in live venues as well as for television and film projects. NDMBDS, with its location in Artesia and comparatively high enrollment numbers, is one of the largest and most prominent Indian dance institutions in the Los Angeles area.[5]

One Sunday evening, Nakul Dev Mahajan enters his class visibly upset. After conducting the warm-up, he turns off the music to speak to the students. Apparently someone from a neighboring apartment building had been throwing raw eggs at his car for some time. That morning, it was a bottle. Mahajan lost his temper and started yelling at the building. He demanded that the vandals stop and threatened to call the police. He narrates that eventually a "big white guy" came out on to the balcony.

Mahajan suspected that it was the man's children who were throwing the objects and told the man to better control his kids. The man said that he would "come down there and beat him up." Mahajan told his cousin to call the police. Eventually the white man came back out and shouted at Mahajan: "Go back to your fucking country, you terrorist." Concluding his anecdote, Mahajan turns to his class and says "and I was like... what? Look where you are? You are in Little India. Maybe you should go back to your country on the *Santa Maria*." The class laughs. "I mean, this is our space," Nakul Mahajan continues. A palpable feeling of affinity sweeps

through the class. For Mahajan and his students, Little India in Artesia stands as a safe space within Los Angeles' urban sprawl.

The 2005 American Community Survey, produced by the US Census bureau, reported that there were approximately 450,000 Indian–Americans living in California—more than any other US state.[6] Although records of Indian presence in the US date back centuries,[7] Indians in the US continue to be widely recognized as members of a "model minority."[8] Tracing the history of Indians in America since their first documented arrival in the 18th century, Vijay Prashad argues that the key turning point for the Indian–American community came in 1965 when the US Congress actively supported employment-based migration to meet skilled labor demands.[9] The Act allowed for skilled professionals from India to work and settle in the US, and records show that 83 percent of those who arrived under this law from 1966–1977 as skilled professionals were from India.[10] The 2000 US Census records a near doubling of Indian-origin populations over the past decade reaching 1.7 million. In 2010, *India-West* (a prominent Indian weekly) declared Indians as the "third-largest immigrant group in the US after Mexicans and Filipinos."[11]

In practical terms, Prashad observes that multiculturalism in the US encourages immigrants to showcase their cultural heritage rather than suppress it from public view.[12] Distinct from assimilation, which asks immigrants to conform to standards of locally-acceptable behavior, multiculturalism stresses that the immigrant communities maintain, and even, sustain their cultural heritage. Multiculturalism allows for their visibility in particular arenas and spaces.

According to Prashad, with the ethos of multiculturalism, Indians in the US are encouraged to proudly demonstrate the difference in their identity. The performance of Indian culture thus becomes a way to celebrate multiculturalism in America even for those who are not of Indian origin. As he explores what Indians in America choose to use in their public displays of diversity, Prashad observes that they often draw on the arts officially supported by Indian national institutions that were instrumental in defining India's postcolonial, national culture. Staging of Indian dances is often a presentation of Indian culture in the United States.

Authentic India? Indian Classical Dance in the United States

When performed at the Indian–American cultural and social events, India's classical dances are typically being used to communicate and display Indian national identity.[13] Whether seen at a college cultural show or at a local community gathering, these dances in the US are the vehicle for an indulgent celebration of India for the performers and audiences alike. Perhaps most prominently, the practice and performance of Bharata Natyam, allows Indian–Americans to explore their Indian heritage as they simultaneously claim their multicultural identity as US residents and citizens. To varying degrees, other classical Indian dance forms like Odissi and Kathak are used in the same way as the Bharata Natyam practice. Bharata Natyam, however, is by far the most common of Indian classical dances studied and performed in the US and so is the most useful example to examine in detail here.

Historically linked to the dancer communities of *devadasi*s of South India, whose dance practices were suppressed under colonialism, Bharata Natyam underwent a revival at the turn of the 20th century. Active efforts by India's elites who sought to establish it as the model, respectable, classical Indian dance. Bharata Natyam was purged of sexual content so it could then be reclaimed by middle- and upper-class women as a national dance.[14] In remaking Bharata Natyam as *the* authentic dance performance of Indian nationhood, Indian cultural reconstructionists—notably, Rukmini Devi Arundale—reworked traditions so that they could become acceptable representations of the cultural foundations of a newly narrated shared national history.[15] Crucially, the colonial experience helped shape the assembling of this cultural heritage. Even as scholars and dancers opposed the impact of colonialism on their culture through Bharata Natyam, they reaffirmed the divisions between Western and Eastern cultures.[16] In particular, reconstructionists drew on Indian classical dance links to the East—a constructed concept steeped in romanticized views of India as an ancient culture in need of reclaiming its history.[17] Ironically, the concept of the Orient became central to this aspect of India's cultural renaissance.

Here Edward Said's seminal *Orientalism: Western Conceptions of the Orient* becomes helpful as it traces the construction of the Orientalist discourse in the colonial period.[18] According to Said, Orientalism was:

> A political vision of reality whose structure promoted the difference between the familiar (Europe, the West, 'us') and the strange (the Orient, East, 'them'). This vision in a sense created the two worlds....[19]

The work of Said and other scholars suggests that the influence of Orientalism tended toward presentations of the Eastern cultures as "mysterious, sexually decadent, and indolent; and steeped in traditions."[20] Given the prevalence of these notions in colonial India, it is not surprising that the dancers, and the intelligentsia who worked to recuperate Indian dance as a part of India's struggle for Independence, were also inadvertently influenced by Orientalism.[21]

Indian classical dance in general, and Bharata Natyam specifically, was an integral part of the creation of India's post-Independence traditions.[22] With its elaborate silk costumes, prominent jewelry, allusion to Hindu mythology, and distinct movement particularities, Bharata Natyam also assumes an exotic appeal in some ways linked of the Oriental fascinations surrounding classical Indian dance.[23] (*See* Photograph 5.2).

In its reincarnated, postcolonial form, Bharata Natyam was soon established as a live theatrical performance practice. Through government-sponsored tours, Bharata Natyam dancers like Mrinalini Sarabhai and Rukmini Devi Arundale became semi-official international ambassadors of Indian culture. Once only a regional dance tradition within one part of India, Bharata Natyam became a respected and exportable national dance of India.

As classical dancers migrated out of India, mostly as wives of NRIs working abroad, they took their dance skills with them. Priya Srinivasan's research on Indian dancers in the United States, indicates that these female Bharata Natyam dancers, along with other classical dancers to a lesser extent, became teachers and opened dance schools. They helped fulfill a desire for arts that represented

cultural roots to Indian immigrants who were particularly anxious that their children in America be connected with their heritage and traditions.[24] While the schools varied in size and reputation, their objectives were strikingly similar—to impart knowledge and experience of an Indian heritage to children of Indian descent growing up outside India. Presented in these classes and school as the most important authentically Indian dance form, Bharata Natyam not only provides refined cultural and physical training, but also imparts knowledge about Indian traditions and rituals to its students, so better enabling them assert their Indianness in American society.[25]

Founded in 1977, Viji Prakash's Shakti School of Bharata Natyam is one of the oldest Indian classical dance institutions in Los Angeles.[26] The school has taught over 2,000 students over the past 30 years. A majority of the students have been, and continue to be, of Indian origin. The school runs classes in several locations throughout the larger metropolitan Los Angeles area. In a pattern that approximates observed enrollment patterns at the NDMBDS, the students at the Shakti School of Dance are predominantly female and often enter the classes around the age of five. Some students continue their Bharata Natyam lessons here until they leave for college. A select few graduate to the Shakti Dance Company; even fewer students eventually pursue solo dance careers.

The shared events of classes, rehearsals and performances become opportunities for students and parents to meet, compare experiences of living in Los Angeles, exchange recipes, and admire each other's Indian fashions. In a self-reflexive ethnography of her Bharata Natyam training under Viji Prakash, Anita Kumar explains how sending children to Bharata Natyam enables the "South Asian immigrant to resist complete 'Westernization,' in this case Americanization, which represents sex, drugs, and rock and roll."[27] Parents and students perceive Bharata Natyam in the US as a dance that imparts lessons in tradition. Indian classical dance instruction tends to stress spirituality, precise gestures, and complex rhythms.[28] As teachers, sometimes called gurus, teach movements and narratives from the Bharata Natyam dance repertoire, they also impart

culturally-marked mannerisms, which in turn communicate the Indian cultural heritage.[29]

It is also safe to say that many, if not most, dancers trained in Bharata Natyam do not venture beyond the classical dance repertoire. Rather, they prefer to generally stay within the stylistic and thematic boundaries set up by the traditions of Bharata Natyam. This, in turn, allows them to use Bharata Natyam as a way to rehearse, and ultimately perform, their Indian heritage in the US. There are, however, some notable exceptions. In her exploration of the global dimensions of Bharata Natyam, dance scholar Janet O'Shea observes that for some students, Bharata Natyam becomes a point of departure for more critical explorations of immigrant realities.[30] In the Los Angeles area, the choreography of Mythili Prakash, Viji Prakash's daughter, as well as Anjali Tata, of the Post Natyam contemporary South Asian dance Collective who also trained under Viji Prakash, indicates the broad spectrum of movement and meaning possibilities created through interrogations of Bharata Natyam.[31] Despite the clear thematic differences that distinguish the work of Prakash and Tata—Prakash's pieces stay within the Bharata Natyam aesthetic and Tata reaches out of the classical dance repertoire for movement possibilities—both artists share an approach in which Bharata Natyam movements, gestures and stories become the base for more contemporary work.

Initially trained in Bharata Natyam by her mother, Mythili Prakash innovates rhythmic variations of the Bharata Natyam technique. In "Current," a dance initially set to Anushka Shankar's musical composition "Red Sun" and performed at the 2006 Indian–American arts festival Artwallah, Prakash deployed dramatic Bharata Natyam movement vocabulary, complex footwork, and asymmetrical formations in an abstract contemporary interpretation of the dance form's rhythmic complexities. Anjali Tata imbues Bharata Natyam movements with the expansiveness of contemporary dance and the flow of yoga in her choreography "Offering." For Prakash and Tata, their training in Bharata Natyam provides a foundation for their hybrid cultural expression. In these contemporary choreographic works, Bharata Natyam becomes both an embodiment of memory and an expression of negotiated diasporic

identities. The work of these artists suggests the practice of Bharata Natyam in the Indian diaspora in America allows for the expression of novel and inventive hybrid Indian–American identities as an alternative or critical complement to identity forms shaped by Indian nationalism, Orientalism, and postcolonialism.[32]

Bollywood Dance as Indian Dance

The growing popularity of Bollywood dance among second-generation Indian–American youth was initially a subject of derision for many classical dance teachers who felt that Bollywood did not deserve the attention it was receiving.[33] In an editorial for *Little India*, the most popular US magazine specifically for NRIs, Preeti Vinayak Shah, a Bharata Natyam teacher in the US, champions the benefits of Bharata Natyam training over those of Bollywood dance classes:

> I tell my students that a Bharatanatyam dancer can do the *filmi* dances with ease due to the rigorous training their bodies have been through, but a Bollywood dancer will never be able to capture the nuances and intricacies of Bharatanatyam.[34]

Interestingly, Shah's assertion that Bharata Natyam equips students with the skills necessary for Bollywood dance, contradicts the situation at SDIPA in Bombay where extensive Western dance, rather than Indian classical dance, emerges as desired training for aspiring Bollywood dancers.

As Bollywood dance gains popularity in the US, the dismissive scorn of many Bharata Natyam teachers in the US has begun to turn into anxious concern. In the October 2007 issue of *Little India*, Madhu Bhatia Jha, another classical dance teacher, similarly fears that "Bollywood is drowning out classical dance" in the US Indian community.[35] Jha deploringly recounts how a Bollywood song surfaced in an *Arangetram*, a debut public performance for a Bharata Natyam student:

> The lights are dimmed in the hall and the music begins. But instead of the sitar and mridangam, the hall reverberates with the popular

Hindi film song "Dola Re" from King Khan's film *Devdas*. The student performs her arangetram to the song and her career is launched as a Bharatanatyam dancer.[36]

According to Jha, Indian classical dance schools are beginning to lose ground to Hindi film dance instruction in the United States because Bollywood dances allow students and parents easier and more convenient access to markers of Indianness through dance.

Some Bharata Natyam teachers in the United States worry that Bollywood dance now assumes at least some of the markers of Indianness through dance, in the diaspora, previously reserved for classical dances. In a gesture that would have been unthinkable a few years ago, these teachers now occasionally include "acceptable" (or what they perceive as more traditional) Bollywood songs in their classes.[37] Often, teachers will also exalt a supposed past "golden age" of Hindi films of their youth whose songs they feel are more authentic than those of today's Bollywood. Classical teachers have also grudgingly become more tolerant of their students' participation in Bollywood dance events while also continuing their classical dance training (*see* Photograph 5.3).

Bollywood dance's ease of access derives from both the accessibility of Hindi films and the short time required to master the initial movements needed to perform. Compared to classical dance performances, which are not as easy to find online, thousands of Bollywood dances are accessible through DVDs, Internet, and other media that facilitate the circulation of Hindi films and songs among diasporic audiences. Although Bollywood dance steps do at times get complicated and physically demanding, there are always easier movement alternatives readily available. A double turn can become a two-step pivot. When in doubt, one can always shake their hips in a gesture that brings forth memories of the dance in the film.

In addition, Bollywood dance classes tend to focus on the mastery of dance sequences set to songs from Hindi films. This allows the students to immediately experience and potentially display their mastery of the dance through performance. They are free to try the steps out as they replay the song in the privacy of their homes. By comparison, typical Bharata Natyam training takes more time to

focus on basic body exercises that do not immediately translate into performable material. It may take a year or more of classes before a Bharata Natyam student is deemed to have gained the skill necessary to perform even the most rudimentary dance from the classical repertoire. In this key way, Bollywood is a substantively easier option for many Indian–American dance students.

Imagining India through Bollywood Dance

Walking into Nakul Dev Mahajan's dance studio in Artesia is like walking into a temple dedicated to India, Bollywood and dance. The studio walls are filled with Hindi film star posters—Madhuri Dixit, Aishwarya Rai and Hrithik Roshan in various dance poses.

Across the room, a large statue of Nataraj—the dance form of the Hindu God Shiva—is posed over the studio's sound system, which is almost exclusively dedicated to playing Hindi film songs. An Indian tricolor flag hanging by the door has an eye-catching difference in its design. The Dharma Chakra, the spoked wheel linked to Buddhism and Hinduism, at the centre of the Indian flag has been replaced with a Nataraj silhouette. It is here among these striking symbols of nation, religion, and celebrity that the dance students regularly assemble.

One Sunday, the dance class for adult women starts a little after 7 pm. Students begin the class with warm-up exercises. Wrist whirls and hip rotations complement basic stretches, all set to Bollywood songs. Soon the class transitions to learning a dance routine set to "Eli Re," a song from the film *Yaadein* (2001). The choreography the students are learning contrasts slow gestures with percussive stamps. Four rapid turns culminate in a run forward and a slide to the floor. Laughter and joking ceases as students work to master movement nuances. Glamorous film images from *Yaadein* seem present in the studios as the class progresses.

Set in an unspecified, yet opulent setting in the UK, *Yaadein* is the "quintessentially NRI" film—obsessed with memories.[38] The story focuses on a widowed father's efforts to secure happy marriages for his three daughters. After a "love marriage" of one of his

daughters fails, the father adamantly refuses to allow his youngest daughter Isha (played by actor Kareena Kapoor) to marry her love Ronit (played by actor Hrithik Roshan), the heir to an industrial empire. Set in the family's mansion, the song-and-dance sequence "Eli Re" is a spontaneously shared moment between the three sisters as they skip and weave through the rooms of their home in their silk pajamas. In the film, memories of their deceased mother, of the tradition of arranged marriage, and of other films focused on the Indian diasporic experience permeate the song-and-dance sequences. Commercially unsuccessful in India, the film did much better among diasporic audiences in the UK and the US who appreciated its positive and sentimental portrayal of NRIs.[39] (See Photograph 5.4)

In teaching the "Eli Re" sequence, Mahajan is demonstrating a particular movement to his Sunday class. He holds up one hand and points it toward the audience. With his other hand, he gestures toward his outstretched hand. "You are showing off your *mehndi*," he explains to his class.[40] He then proceeds to pull the hand toward himself in a gesture of mock shyness. All the students nod. They are eager to show that they understand the gesture as well as its culturally specific meanings related to courtship and marriage. Bollywood dance here is taught as a lesson in Indianness, and thus encroaches on dance representations of Indian cultural heritage previously reserved exclusively for Indian classical dances in the US. Unlike classical dance, which appeals to tradition and spirituality in its claim to authenticity, Bollywood dance's role in teaching Indianness grows out of the Indian diaspora's consumption of Hindi films, which are easily accessible source material for Indian culture.[41] For dance students of Indian origin, performing Bollywood dance creates the embodied experience of this visual source material. Students struggle with the movements in NDM's rendition of the song. As some fail, they look around to assess their classmates' success, before attempting the movement again. Bollywood dance "is harder than it looks," a young female student comments.

From crowded screenings in college auditoriums to DVDs rented from the Indian grocery store and played back in living rooms,

watching Hindi cinema has been an activity that has created memory-based communities for many diasporic Indians.[42] In addition, recent growth of satellite channels such as B4U and Zee Television in the US, as well as the proliferation of dedicated Hindi cinema halls, provide ready access to Hindi films and related materials.[43] In the diaspora, Bollywood films provide opportunities for viewers to reacquaint themselves with Indian culture, albeit in its cinematic form. Hindi films are a crucial means of keeping in touch with home for the first generation Indians.[44] For second, and even the third generation viewers, more recent Bollywood films encourage a sense of cultural belonging with India. Most students at NDMBDS come from the latter group.

Many students at NDMBDS use Bollywood films to learn about, and vicariously "remember," India. As one of them, Prema, explains her relationship to Hindi films:

> I learned a lot about India from Bollywood films. We didn't get to go to India regularly, so Bollywood was a way for me to keep in touch.[45]

For another, Tara, Bollywood allowed her to keep up with trends in India. She explains: "It's nice to watch these films to get a sense of the latest songs and dance steps. I also watch the movies to get an idea of the latest fashion like Indian outfits, jewelry, etc."[46] These examples suggest how Bollywood films assume a role in defining authentic Indianness for diasporic Indian–American youths, sometimes known as *desi*.[47] The films allow members of the Indian diaspora to forge a personal connection through audiences' memories of an imagined homeland, which they may have actually never visited.[48]

Bollywood dance is the negotiated, embodied experience of these created memories. Although the students at NDMBDS maintain the basic steps of the "Eli Re" sequence from the *Yaadein* film, large sections of the choreography they learn do not exist in the filmed version of the song. Mahajan assembles, rather than simply reproduces, the sequences. It is through this process that Bollywood dance becomes an interplay between an imagined India and appropriated film content.

Hybrid Identities of Bollywood Dance

As dancers both mimic and rechoreograph movement, Bollywood dance, as it is practiced at NDMBDS, moves between nostalgia and interpretive creative expression. This kind of interpretive process makes distinctive the work of several different choreographers in the Los Angeles area. One dancer explains, "Nakul's work is truly unique. It's totally different from what you find in the films." The dancer stresses Mahajan's ability to interpret, rather than merely mimic, dances in films.

Similarly, at the Massachusetts Institute of Technology (MIT), interpretation rather than reproduction was a key consideration in the staging of Bollywood dances.[49] When Chamak, an Indian fusion dance troupe at MIT, integrated "Dola Re Dola"—a song from the Hindi film *Devdas* (2001)—into their performance for a campus show, they created a collage of movement elements from the film that mixed with movements they personally encounter in their lives as Indians living in the US. This process is described in the following excerpt:

> While the red-and-white costumes worn by Chamak dancers referred to those worn by Paro and Chandramukhi [the film's female protagonists], Chamak's costumes accented the performers' shared Indian-American identities. The red sequined wrap-around trousers, white sleeveless scarf blouses, and red hairbands helped to stress the group's uniform, up-to-date identity.[50]

In his classes, Mahajan similarly combines movements from Hindi films, Indian classical dances, and the latest MTV videos to teach his students. In this way the creation of Bollywood dance can be understood as one way of expressing the hybridity of Indian–American identities in the US.

The notion of Bollywood dance as a form of hybrid expression in the US calls up Edward Said's assertion that "no one today is purely *one* thing."[51] In the age of globalization, the flux of hybridity, stands in opposition to stable and limited definitions of culture and ethnicity.[52]

Critical media studies scholar Stuart Hall has argued that people's identities change constantly and depend on the ties and circumstances of any given moment. Judith Butler's theorization of performance and identity asserts that our identities are constantly reimagined, rehearsed and performed.[53] Bollywood dances can thus be understood as an opportunity to reimagine, rehearse and otherwise physically perform hybrid Indian–American identities.

Padma Rangaswamy points out that many Indian youths are often very conscious of the dual "American at School" and "Indian At Home" identities they have to assume in order to function well in their lives in the US.[54] This duality is captured in the "ABCD" ("American Born Confused Desi") label given to people of Indian origin born in the US.[55]

For many Indian–Americans, their experience at college is a key site for identity negotiation as they meet other youth like themselves. As these young people make an effort to learn about their own historical heritage, they often begin to express their Indian–American identities through their fashion, music, and film choices.[56] To build up these choices for themselves, these young people need ongoing access to material that would provide with more information about their Indian heritage. Bollywood films, in particular, are easily accessible cultural source materials that play a major role in supporting the memory function for diasporic Indians.[57]

In her research on second-generation Indian adolescent girls in the US, Meenakshi Gigi Durham finds that while the girls generally disassociate themselves from mainstream "American" entertainment, they often tend to follow India's latest popular culture trends.[58] The girls in Durham's study tend to shy away from criticizing Indian films and music, choosing to accept them as their cultural heritage.[59]

Similarly, Sunaina Marr Maira's study of American college culture identifies Bollywood-themed dance performances as instances that display Indian culture for the second-generation Indians.[60] These cultural shows also become opportunities for the embodied performance of the participants' identities.[61] Often, membership in such cultural shows on US college campuses (where many of young people find expression for their cultural identities) is by audition

only, and first-year students even enroll in dance classes to prepare for the selection process. Participation in these performances and competitions creates a sense of community as well as rivalry among the dancers. These, on-campus groups offer opportunities for Indians to experience and perform their cultural heritage for the local community.[62] In fact, the process of preparing for the show is just as important as, if not more important than, the final public performance. In this way, Indian–American college students' practice of Bollywood dance allows for a particular sense of Indian–American affinity on college campuses. NDM's company participates actively in these college events: Mahajan and his dancers serve as judges who can provide professional evaluations of choreographic choices and executions of movements. In a way, they are perceived as an institution that sets the standards for Bollywood dance practice in the Los Angeles area.

At NDMBDS, dancers bridge the distance between India and the US through their dance. Sunita, a student at NDMBDS, explains, "Bollywood dance ... incorporates both Indian culture as well as a tinge of Western or American elements."[63] Sunita acknowledges the various styles that inform dances in Hindi films, but suggests Bollywood dance is predominantly Indian dance. Unlike in Bombay where non-Indian movements are the latest fashion, the authentic Indian influence in Bollywood dance is valued most at the NDMBDS. Sunita elaborates:

> Although the dance movements are Indian style, Bollywood dancing incorporates a sense of Western dance as well.... I feel that I have grown out of performing pure Bharata Natyam and Kuchipudi dance, so this was a nice way to continue in the art of Indian dance.[64]

For Anita, a NDM company dancer trained extensively in Kathak, Bollywood dance allows her to venture beyond her classical dance training without losing her roots.[65] Although she also enjoys performing Kathak, the constraints of this traditional form do not allow Anita the same freedom as Bollywood dance, which encourages improvisation as well as the user of other, non-Indian movement.

Many dance students at NDMBDS understand Bollywood in terms of a loosening of the constraints of classical dance forms. Bollywood dance is perceived as easier to learn. It provides quicker access to performances of Indianness as students acquire at least a passive knowledge of films, songs, beats, gestures, and lyrics. While Bharata Natyam's spiritual symbolism encourages a respectful spectatorship of dances in this style, Bollywood dance audiences, often familiar with the songs, tend to want to participate as they sing and clap during the performance.

Although classical companies like the Shakti Dance Company perform as an ensemble, Bharata Natyam is most often presented and taught as a solo dance form. Even though many solo performances of Bollywood dance exist, it is more often performed as group dance, further emphasizing its communal aspects. At first glance, the growing popularity of Bollywood dance in Los Angeles would indicate a distinction between Bollywood as interpretive movement and Indian classical dance as a codified form. Yet, a closer examination suggests a contrary view of Bollywood dances—one in which NDMBDS dancers imbue their Bollywood dance with a particular definition of India and Indianness.

Spectacularizing India

Every two years, NDM's Bollywood Dance Company produces a Bollywood dance show for students, parents, and the general public. While the themes of the show vary, they always focus on Indian–American topics. In 2006, NDMBDC's show was called Love Letters and was based around the story of an Indian–American couple who travel to India on business. Upon their arrival in Bangalore, the couple discovers a chest of love letters—each letter tells a love story. Each of these stories lead to a Bollywood song-and-dance sequence. The experience of the stories and dances allows the couple to adjust to India. The songs selected included old classics as well as new blockbuster hits. For the couple in the story, Bollywood dance is the language which reintroduces them to the culture of India. For the audience of Indian–Americans,

such performances facilitate a process of remembering (for the first generation immigrants) and memory creation (for the second and later generations). The NDM dancers perform their choreography with enthusiasm and conviction. They evoke memories of the films that their dances are taken from, which in turn evoke the audience's own memories of India. These memories of India, mediated through Bollywood, are being brought back throughout the show (*see* Photograph 5.5).

In Love Letters, many of the dancers performing are dressed up glittery and colorful Indian formalwear. Women tend to appear in *choli*s (short blouses), skirts, saris, and flare pants, with their hair, if it is long, tied back in ponytails and buns. The men's costumes vary between jeans and Indian formalwear. Classically inflected Bollywood movement dominates. Female dancers deploy Bharata Natyam gestures to communicate meanings implied by song lyrics. They use Indian aesthetic principles of facial expression or *abhinaya* to emotionally enhance their performance. Percussive steps interject into more fluid choreography. Male dancers often perform more expansive movement while female dancers tend toward more contained vocabularies. The choreography and costumes at the NDMBDS show reflect a preference for spectacularized portrayals of India that draw on Bollywood film content.

The selective content chosen for Love Letters echoes Indian film scholar Ashish Rajadhyaksha's definition of "Bollywoodized" films as being filled with "feel-good, all-happy-in-the-end, tender love stories with lots of songs and dances" that are aimed at capturing the imagination of its global diasporic audiences.[66] Bollywood films aimed at the diaspora tend to reinforce socially-conservative notions of Indian identity through spectacular portrayals of tradition (*Devdas*, 2002), and of affluence in India (*Dil Chahta Hai*, 2001), and abroad (*Kal Ho Na Ho*, 2002). Tradition, as represented through festivals, weddings and dances, is often portrayed as glamorous and participative. These "Bollywoodized" films display a tendency toward spectacular, glossy, celebratory portrayals of India coupled with exaggerated evidence of Indian economic affluence as they provide a cultural guide of sorts for a diasporic Indian imagining a homeland.[67] Geographical distance ceases to be

a barrier to partaking in a discourse of purportedly authentic yet glamorous Indian identity.

Bollywood films as remembered Indianness are also evident in the so-called "crossover films" created by diasporic filmmakers of Indian origin like Gurinder Chadha and Mira Nair. Gurinder Chadha's *Bhaji on the Beach* (1993) is set in the UK. In the film, Asha's recurring Bollywood-style daydreams are symptomatic of her unfulfilled love life. In *American Chai* (2001), a film directed by Anurag Mehta, Sureel and Maya, two second-generation Indian–Americans, engage in a Bollywood-style fantasy dance at a crucial moment in their romantic relationship. In these indie productions, Bollywood stands in for, or approximates, memories that may be exceeded in everyday life, but are not questioned.

In NDMBDS's Love Letters, Bollywood dances fulfill a similar function as they evoke an imagined memory of India. Dancers at NDMBDS appropriate Hindi film dance content as a way of claiming their Indian cultural authenticity in the US. Despite the diversity of movement conventions that defines Hindi film dance content, Bollywood dance in the US begins to approximate Bharata Natyam's mediation of Indianness through dance.

Internalized Censorship

As Bollywood at times stands for India in the US, it comes into potential conflict with the hybridity that defined dances in Hindi films over the past 100 years. As previously discussed, dances in Hindi films are by definition hybrid and tied to narratives, audience preferences, political priorities, current trends, and cultural norms. Although important, Ashish Rajadhyaksha's discussion of the "bollywoodization" of Hindi film content represents only one trend in contemporary commercial Hindi film production. Other parallel trends include the introduction of more sexually explicit scenes, more risqué narrative content that includes premarital sexual relationships, dysfunctional marriages (*Raaz*, 2005), extramarital affairs (*No Entry*, 2005), allusions to alternative sexual orientations (*Page 3*, 2005), and sexualized displays of toned bodies. All these

challenge the conservative norms supported by the Indian Censor Board. While such Hindi film content is not completely new— for example, Raj Kapoor's *Ram Teri Ganga Maili* (1985) and even Yash Chopra's *Silsila* (1981) do somewhat grapple with a few of these topics—it does present a marked trend away from the celebratory sagas that define Rajadhyaksha's "bollywoodized" content. These hybrid, even somewhat socially challenging, trends complicate the use of Bollywood film as a source of memory creation for the Indian diaspora.

These Bollywood film industry trends made Mahajan more selective in the songs he chose for his classes over the past five years. There are some songs that Mahajan does not even want to play in his studio because of the context within which they appeared in their original film. He explains that he cannot restage these dances for his students. At other times, he does teach a song, but realizes that he cannot ask his students go and watch the film because of its socially daring, often overtly sexual, content. Mahajan explains:

> Sometimes, I can't even ask the kids to watch the film version of the dance anymore.... Like in *Salaam Namaste*, I used a lot of the songs, but the students told me they couldn't watch the film.[68]

Salaam Namaste (2005) depicted an extramarital affair, along with a relatively explicit (for Bollywood) visualization of lovemaking, which results in an unwanted pregnancy. As Mahajan explains:

> Bollywood films to me are like a family dinner. They are supposed to be shared. There is not supposed to be any discomfort. In some films today there is discomfort.[69]

As Mahajan rechoreographed the songs, he worked to obliterate any connection to the film's narrative content. More and more often, Mahajan now struggles to write more traditional Indian values back into the movements he borrows from recent Bollywood films. Mahajan elaborates: "If there is a song that I really like, but the dance in the film sucks, then I will re-choreograph it."[70]

Mahajan relates that on another occasion, an Indian bride refused to learn "Dola Re Dola" (My Heart Swayed) from Sanjay Leela Bhansali's remake of the film *Devdas* as the dance she would perform at her wedding—a typical social occasion when Bollywood dances are often performed. Her reasons related to the narrative of the film wherein the song-and-dance sequences facilitate a meeting between Paro, an unhappily married woman, and Chandramukhi, a courtesan. The two women are united in their love for Devdas, who eventually succumbs to alcoholism at the end of the film. For the bride-to-be, her memories of the film made the song inappropriate for her wedding in Los Angeles. Mahajan smiles in relating the story and explains that such reactions are somewhat subjective and that he has successfully choreographed the song for other students for whom the dual star appeal of Madhuri Dixit and Aishwarya Rai as heroines in *Devdas* overpowered the potential stigma of the film's narrative. While the diasporic Indians are able to manipulate portrayals of their negotiated "Indianness" through Bollywood dance, there do seem to be limits to what is deemed acceptable.[71]

These limits are in some ways reminiscent processes that surrounded Bharata Natyam and its later deployment in performances of Indianness in the United States. The result is an ironic situation in which Bollywood dance in the United States moves toward being recognizably Indian. This seems to be particularly true for the dancers and instructors at NDMBDS. As several dancers explain:

Payal: I hate the recent Bollywood films. I guess I am a Madhuri Dixit girl. I see young kids now trying to do hip hop like Dhoom and it makes me sad. They don't realize that the beauty of Bollywood is in its Indianness.[72]

Tara: I don't like the new Bollywood lately. Once in a while you'll get a good movie. It's only because the movies have changed so much, trying to be Western, and not remembering to be proud of their ethnicity. Instead, everyone is trying to be like someone else. So that's why I see no depth into Bollywood lately. Hopefully it'll change. I love watching all old Bollywood films, back then in the 70s. They *totally* define Bollywood. I only watch old Bollywood movies now.[73]

Sheila: I don't really like the new stuff. What's Indian about that? I like it when it looks more Indian—when I see the folk and classical in it.[74]

Nilesh: Why would I want to go to a Bollywood movie to see the latest hip-hop move? I mean why would I want to watch someone trying to dance like Beyoncé, if I can watch Beyoncé herself?[75]

These Bollywood dancers express nostalgia for more "purely" authentic Indian films and lament current trends within the industry. Perceived Westernized trends in recent Bollywood films may be alienating many Bollywood dancers in the United States.

Conflicted Hierarchies

In line with these nostalgic preferences for Indianized Bollywood dances, instructors at NDMBDS regularly integrate movements that refer to the Bharata Natyam and Kathak dance vocabularies. Mahajan highlights his own Indian classical dance training and encourages his students to train in classical dance as a complement to their Bollywood classes. Two other especially prominent teachers also offer classes in classical Indian dance at NDMBDS. On Tuesdays, Viji Prakash brings a class in Bharata Natyam, and on Thursdays, Amarpali Ambegaokar teaches Kathak. Both teachers are aware that many of their students are enrolling in both classical and Bollywood dance classes. Although NDMBDS instructors continue to integrate a broad range of movement styles into their choreography, a hierarchy of movement has developed at the school in which Indian classical dance receives special treatment. As Mahajan explains, "Bollywood came from the classical. Ten years down the line, the latest hip hop movements will be gone, but classical will always be there." Tellingly, and unlike the previously mentioned Indian classical dance critics of Bollywood dance in the US, Mahajan defines Bollywood dance as a movement form that is rooted in the dances of India.

This preference for Indianized movement at NDMBDS resonates with Shilpa Dave's investigation of Miss India Georgia Pageant,

which is held every summer in Atlanta, Georgia and in which young women of Indian origin compete to secure recognition within the Indian community of that state.[76] At the pageant, a Bollywood dance performed to a song from the popular film *Umraojaan* (1981) affirmed a contestant's Indian heritage. Dave explains that the dance allowed the contestant to identify with the idealized courtesan figure in the film. Despite its sexual connotations, the judges and audiences deemed this performance acceptable based on its choreographic choices.[77] In Dave's account, memories of Hindi films and Indian classical dance allow some contestants to present themselves as authentically Indian. In contrast, non-Indian choreography complicates others' claims to diasporic Indian identity.

Similarly for both female and male students, norms of acceptability are of utmost importance as NDMBDS instructors actively censor material they deem to be inappropriate. According to NDMBDS instructors, the expectations of the students and the parents strongly influence how dances are taught. Mahajan explains that he is "very careful about" what songs he teaches. He states, "I have to make sure that the songs are appropriate for my students."[78] Mahajan selects music based on lyrics and melody but also based on the "memory" of the song as mediated by the film that contained it. He then teaches his version of the choreography. As certain Hindi films diverge from acceptable definitions of Indianness in the diaspora, expectations set by Indian classical dances—most prominently Bharata Natyam—help define what is or is not authentically Indian. Pressures related to these acceptability issues place the US Bollywood choreographers in an ironic situation where now they often feel compelled to choreograph traditional Indian values back into Bollywood dance.

The choreographic choices at NDMBDS generally reinforce rather than challenge conservative sociocultural norms contained in Hindi films and classical dance. NDM instructors do not teach boys classical movements, which are associated with females.[79] "They want to dance like Hrithik, not like Madhuri," Mahajan explains. Rather he concentrates on teaching them movements he deems to be more masculine, which include stamps, punches, slashes and kicks. Occasionally, Mahajan sneaks in a classical dance movement

without the students noticing. He explains how he taught the students a Kathak-like turn, but that he used punches instead of the more flowing hands. For the female students who are generally taught movements associated with femininity, the instructor concentrates on teaching precise hand gestures, tight footwork, shy glances, and suspended arm movements.

Similarly movement hierarchies differ for the female and male dancers. For female dancers, classical dance movement remains the ideal. For male dancers, displays of supple masculinity are most valued. In fact, the movements taught to the two groups are so distinct that most classes at NDMBDS are segregated by gender. Reflecting a strong gender bias, only two classes out of a total of eighteen are exclusively for boys, one class is coeducational and the rest of the classes at the school are exclusively for girls and women. Although NDM's dance troupe has adult male dancers, there are currently no adult male students and Mahajan observes that there is a general "shortage of boys" in the school.

Even as Mahajan works to choreograph respectable Indianness into his renditions of Bollywood dance, he feels obligated to keep up with the latest Bollywood hits for business reasons. Blockbusters like *Dhoom* (2004) and its sequel *Dhoom 2* (2006) drew new students to NDMBDS to learn to dance exactly the way they did it in the films. Instructors at NDMBDS have to work to meet this demand so they keep up with the latest industry releases. The scope of choreography that Mahajan can create for his students is thus to some extent delineated by the original film dance. Even as his instructors and dancers distance themselves from certain tendencies within the industry, they still feel pressured to keep up with the overall trends. Mahajan explains that the budget for his biennial show must be more ambitious each new time so that he can match audience expectations as "Bollywood films go more and more over the top." The sets, costumes, and choreography need to be more and more spectacular, "just to keep up" with trends in the industry. Mahajan explains:

People have that visual memory that we talked about. So then, you have us dancing to *Om Shanti Om*, a very over the top, hugely set,

hugely expensive movie. And they [the audience] remember Shah Rukh dancing with these drapes in the back and the wind blowing and the rain and the lake and then you have Nakul on stage with five girls wearing *kurta-pajama* and a black scrim in the back.... How is that going to work?[80]

Mahajan is even pushed to complain: "Bollywood has gone so over the top now that I can't keep up with it." NDMBDS have to strive ever harder to shape their bodies to keep up with the ever more impressive look of the actors and dancers in the Hindi film industry.

Hollywood's Bollywood: Between Kitsch and Orientalism

Bollywood dance, instruction and performance is today also increasingly popular among non-Indian populations in the US, as well as in other regions of the West. Driven in part by films like *Slumdog Millionaire*—which ironically only featured a dance in the final credits—Bollywood dance is now an increasingly popular dance that surfaces in venues and programs previously reserved for non-Indian dance forms. As journalists and film critics speak of a possible "Bollywood Mania" in the US, NDM actively seeks out Hollywood engagements to perform and choreograph Bollywood-inspired dances.[81] These engagements, in turn, consolidate Mahajan's leading Bollywood dance instructor position in the local Indian community.

Although NDM's appearances in nationally televised dance competitions, like *So You Think You Can Dance?* and the less popular *Superstars of Dance*, have brought his company the most exposure, the troupe has also appeared in several other programs. In an episode of US TV network soap opera *Passions*, Bollywood dancing—performed by NDM dancers—frames the hero and heroine's visit to India to renew their wedding vows. Dressed in Indian clothes, the actors exchange garlands and join the dancers

in a celebratory dance around the "tree of life." The villainess, out to steal the man, enters to the lyrics of "there is another woman in the room." A dance duel ensues. Finally, with the villainess defeated, the couple joins the background dancers in another celebratory dance. The use of Bollywood dance in *Passions* is illuminating. On one level, the insertion of a Bollywood dance sequence highlights the escapism of the episode's setting in India. On another level, the use of Bollywood dance fits in with the melodramatic conventions often associated with the soap opera genre.[82] On both levels, the expectations driving the new interest in Bollywood among non-Indian audiences in the US interweave historical portrayals of India as exotic with a more recent post-modern engagement with notions of kitsch.

Hollywood's recent fascination with Bollywood needs to be understood partly through preexisting stereotypes of Indians in American popular media. These portrayals hark all the way back to discourses of British colonialism in which travelogues, missionary agendas, government studies and other accounts tended to portray Indians as "uncivilized," even "savage."[83] Vijay Prashad traces India's entry into the popular psyche in the US via cultural content created by Emerson, Thoreau, Barnum & Bailey Circus, Christian missionaries, and Swami Vivekananda.[84] Through these influences on the 19th century US popular imagination, India emerged as both romantic and dangerous.[85] Despite ongoing critical work and many changes, these images of India may still inform some stereotyped portrayals of Indians in American popular media.[86]

Srividya Ramasubramanian argues that these stereotyped portrayals of India and Indians—as demonstrated in 20th century US films—point to associations of Indianness in the US.[87] Generally speaking, these portrayals fall somewhere between two extremes. At one extreme, they focus on what are seen as India's oppressive social structures, like the caste system and persistent gender inequalities—often through the lens of poverty and suffering. At the other extreme, we encounter views of India as a source of enlightened spiritual wisdoms, and yoga, ayurveda and Hindu mysticism.[88] These two extreme views have recently been tempered with

more mundane images and narratives about outsourcing and call centers that are identified with modern India.

Similarly, when Hollywood TV and film producers contact NDM for possible engagements, they tend to look for "colorful" and "Indian" dances complete with Indian clothes and rhythms—a demand that ironically in many ways aligns with Indian–American communities.[89] To successfully present his troupe to Hollywood producers, Mahajan stresses that his NDM troupe dancers are all of Indian origin. He also highlights the authentically Indian content of his Bollywood choreographies. "I know exactly which dances to show to the production teams," he says. Although the producers are not usually exact in their requirements, he understands that NDM has to provide a particular look that fits with their perception and understanding of Bollywood dance. To secure Hollywood engagements, NDM troupe members work to use these stereotyped portrayals to their advantage. In explaining this, Mahajan laughs, "So now when someone tells me that we are too traditional, I say: 'Thanks, that is a compliment'." To be traditional may imply staleness in the ever-changing world of Bollywood dance in Mumbai; in Los Angeles, it provides credibility for NDMBDS's image as an authentic Indian dance institution. In responding to Hollywood demands, NDM dancers position themselves as 'colorful,' 'brown,' and quintessentially Indian performers.

Although exotic stereotyping begins to help us understand Bollywood's current popularity in the US, it does not provide an all-encompassing explanation. There is another aesthetic trend at play here, namely the postmodern fascination with kitsch.[90]

While its exact roots remain unclear, kitsch is likely originally a German or Yiddish word.[91] Kitsch historically described aesthetic deprivation that resulted from an absence of real artistic value and originality.[92] As Milan Kundera observes in his novel *The Unbearable Lightness of Being* (1984), kitsch is a stereotyped aesthetic ideal that appeals to the masses and relies on familiar storytelling.[93] Positioned as the opposite of art and steeped in hierarchies of taste once used to describe art that was considered inferior, and lacking in originality, kitsch gained new credence through postmodernism in the 1980s.

Postmodernists eschewed boundaries between highbrow and lowbrow art, and revisited kitsch. Inherently imitative and excessive, kitsch also becomes implicated in pastiche—content creation through select imitation.[94] In this context, kitsch becomes an ironic reading of predictability and opulence.

In 2002 a *New York Times* article tellingly titled "Kitsch With a Niche: Bollywood Chic Finds a Home," Ruth La Ferla identifies Bollywood as a part of both New York's fascination with Indian culture and with the appeal of kitsch in contemporary society.[95] Descriptions of Bollywood as kitsch in the US and Europe typically use the term in an ironic, deconstructive way. Notably, the demand for Bollywood as kitsch in North America and Europe is driven almost entirely by persons of non-Indian heritage.[96] As media scholar Rajinder Dudrah observes, technically speaking kitsch and fun both exist in Bollywood films, yet they have not been interpreted as such.[97]

Bollywood as Western kitsch was on full display in Berlin-based dance and theater company Dorkypark's *Big in Bombay* production when it premiered at the Schaubühne in 2005.[98] In researching for their show, Bollywood, Dorkypark dancers were most enthralled by situations and visuals that they felt exposed the technical shortcomings, and melodramatics, as well as the "imperfect" appropriations of Western cultural elements in Hindi films. The five Bollywood dances, performed by Dorkypark, were set in disturbingly violent and graphically-sexual scenes. They were also glaring, opulent, playful, escapist, and incomplete interruptions that simultaneously elided and reaffirmed any meaning by resorting to kitsch. In *Big in Bombay*, Dorkypark reasserted a Western understanding of Bollywood dance as kitsch.

So what makes Bollywood kitsch? Following Susan Sontag's seminal essay, Notes on 'Camp,'[99] which explores what defines the camp sensibility, we can identify the following 10 characteristics that define Bollywood as kitsch in Western cultural discourses:

1. Bollywood's "imperfect" imitation of the West;
2. visual sexual metaphors for sexuality—flowers blooming, horses running out of a stable, bananas peeling;

3. opulent, aesthetically mismatched sets;
4. creation of a fantasy space through narrative discontinuities;
5. imperfection of special effects;
6. universality and predictiveness of narratives;
7. drawn out, sentimental scenes;
8. normative, happy endings;
9. melodrama; and
10. unintentional comedy.

With a few notable exceptions, Bollywood can be broadly read as unintentional kitsch.

The unintentional association of Bollywood with kitsch becomes apparent every year at the Prague Bollywood Festival,[100] when Czech audiences and audiences of Indian origin respond differently to the same film. Rob Cameron, a Deutsche Welle correspondent wonders if the Czechs are laughing "with the film or at it."[101] Suchi Rudra Vasquez, a second-generation Indian–American currently living in Prague, sees the differences as crucial in her description of her experience of watching *Taal* (1999) at the festival:

> The movie began, and within the first ten minutes, the audience was giggling.... In the row in front of us, two women in their late 20s were intermittently convulsing with loud, cringe-inducing laughter. I knew there were some moments of comedy in the film, intentional funny scenes and dialogues and expressions, but the audience seemed to all be laughing at something that I could not figure out.... Memories of the first time I had ever seen *Taal* rushed back to me. I had been in college, sitting on the floor in a *desi* friend's tiny dorm room.... I questioned myself: had I laughed, too? No, surely not. That was impossible.[102]

Rudra Vasquez's description points to the cultural assumptions potentially at play in the positioning of Bollywood as kitsch in Europe and the US. Following a similar line of thought, Indian journalist, Mira Kamdar attributes Bollywood's popularity in France to that country's experience with colonial Orientalism. Thus read, Bollywood kitsch becomes symptomatic of a new generation of kitsch.[103] Western fascination with Bollywood as

kitsch simultaneously perpetuates and complicates the exoticization of India.[104]

Kitsch, Orientalism, and Bollywood Dance in *Vanity Fair*

When Mira Nair—the critically acclaimed director of Indian crossover films like *Salaam Bombay* (1988), *Mississippi Masala* (1991), and *Monsoon Wedding* (2001) released her interpretation of the British classic novel *Vanity Fair* by William Makepeace Thackeray, she explicitly acknowledged Edward Said's influence in her work in the film's credits and in subsequent interviews.[105] In her attempted critique of what she sees as the Orientalism in Thackeray's novel, Nair made several major changes to the plot in translating the *Vanity Fair* novel into film.

Thackeray's novel was initially published in serial form during 1847–1848. A critique of British high society, the novel follows the travails of Becky (Rebecca) Sharpe—a determined social climber from an impoverished background. She works her way into high society and along the way lures and tricks the wealthy Joseph Sedley to do her bidding.

The book makes several overt references to India, which Edward Said discusses in depth in his book *Culture and Imperialism* (1994).[106] These references include Joseph Sedley's employment with the East India Company's Civil Service stationed in Bengal. Tellingly, Sedley's associations with India are often accompanied by displays of wealth. In fact, his first appearance in the book is through the giving of an Indian gift to his sister Amelia:

"Thank you for the beautiful shawls, brother," said Amelia.... "Are they not beautiful, Rebecca?"[107]

For Thackeray, India symbolizes the effect of wealth on British society.

Mira Nair attempts to rewrite this colonial history in her reworking of *Vanity Fair* by introducing more Indian elements to

increase the visibility of the colonial wealth that fueled British society at that time.[108] By making India more visible, Nair appears to be engaging in a postcolonial exercise of resistance—or what Said called a "contrapuntal" reading—to include the colonial influences previously excluded.[109] One of Nair's attempts is the inclusion of a Bollywood dance style sequence in the film.

A closer examination, however, suggests that Nair's strategy does not necessarily have the desired effect. Rather than revoking the colonial idea of India as exotic, Nair's remapping, ironically and perhaps perversely, encourages the persistence of these ideas. Her decision to include a Bollywood dance sequence in the film demonstrates the challenges posed by Bollywood's current popularity outside India. In her attempt to write India into the narrative, Nair introduces a kitsch Bollywood like song-and-dance sequence into her interpretation of *Vanity Fair*. The dance replaces what is in the novel a scene set around a game of charades inspired by Bedouin and harem motifs at a royal court soiree. In the book, the event is a climactic point in Becky's attempts to break into high society.[110] Mira Nair reinvents these "charades" as a Bollywood-like "item dance" choreographed by Hindi film dance choreographer Farah Khan. The dance is set to a song that intentionally summons up markedly culturally vague notions of India.

Introduced as the "ballet *Zenana*," Lord Stein—Becky's scheming benefactor—unveils a *tableau vivant* of women dressed in bright red, revealing costumes. There are gasps of surprise from the audience. Percussive music begins. The women bend over and wave their hands looking directly into the camera as they advance. We cut to the musicians, who are of an eastern appearance. The dancers disperse and we see that a woman is poised behind a sheer curtain. As the curtain falls away, Becky, dressed in a black dress with four waist high slits, makes her way toward the audience, her hips undulating as she looks ahead seductively. This is a Bollywood item dance! As the dance ends, Becky kneels before the King, flirting with him while her husband, Dobbin, exits the room. Later that night, Becky's marriage falls apart when her husband discovers that she has been hiding money from him.

Here, it is important to note that the break-up of Becky's marriage takes on a different meaning in Nair's film than it does in

Thackeray's novel. In the novel, Becky's marriage falls apart as a direct consequence of her scheming and this becomes a hurdle in her attempts to enter high society. In Nair's film version, Becky's marriage becomes an actual tragedy for Becky who realizes that she has lost everything that was important to her. Thus in Nair's version, the dance in which Becky masquerades as a dancing girl contributes to her downfall. In her use of a 'titillating' Bollywood dance to portray this pivotal moment, Nair wants to show India's influence in the story.[111] Unfortunately her deployment of a Bollywood dance in *Vanity Fair* reaffirms, rather than challenges, assumptions about the exotic East.

William Makepeace Thackeray's satire of the British Empire's high society was founded upon his awareness that the decadence and impropriety he sought to critique were driven, at least in part, by wealth from the colonies. The choices that Mira Nair made, to make visible the influence of the colonies, were directly undercut by her commitment to revalorize Rebecca Sharpe into the sympathetic heroine of the film—whereas in the novel, she is the morally-suspect antiheroine. The result? Nair's *Vanity Fair* presents India as an exotic site of escapism. This makes it different from Thackeray's novel, which only begins to imagine the possibilities of colonial wealth. Postcolonial discourses of Orientalism thus, at least partially, subverted Mira Nair's efforts to write postcolonial perspectives into a film translation of a colonial novel. The case of *Vanity Fair* reveals some of the challenges faced by those who try to subvert assumptions about India in Western popular media. As NDM works to establish his presence in American popular media through Bollywood dance, his company and school also faces these challenges in particular, and at times, unexpected ways.

Bollywood Dance in MTV's *Next* in Los Angeles

It is a sunny day in downtown Los Angeles as people saunter through the County Courthouse park on their lunch break. A crowd forms

around trucks, tents, lighting equipment, and tripods. "Is it a film shoot?" one passerby asks. "Yeah, I think they're making an Indian movie," someone in the crowd responds.[112]

The park lawn is adorned with an Indian-style, stupa-like tent and an ornamental statue of the Hindu God Ganesha as well as colorful silk fabric. Film technicians scurry to and fro. They adjust the lights, ruffle the crimson silk fabric, and scatter flower petals. The stage seems set for an Indian wedding. Then, the NDM dance troupe arrives. Young female dancers check their saris as the men flick their hair into desired position and adjust their Indian formalwear. After a momentary hesitation, the women move tentatively through practiced steps as the men stretch out their hamstrings. They glance deferentially at an approaching Nakul Mahajan, dressed in red shirt and jeans. After greeting them, he begins to supervise their movement and intermittently demonstrates a particular dance technique, like a wrist whirl or a hip flick. Their clothes bright, colorful, and clearly displaying their Indianness, the troupe stands out against the background of downtown Los Angeles. Standing by the tent with a lawn strewn with rose petals, they seem to belong to another world. Eventually, crew members ask the bystanders to move aside. The cameras are about to roll for the filming of a gay-themed episode of US MTV's *Next*—a predominantly heterosexual reality dating TV show—in which contestants will seek to win the attention of Shakeel, a young American man of Indian origin.

Camera. Action. Shakeel faces the camera and introduces himself as someone who "always gets turned on by wood... Bollywood." As he embarks on his search for the ideal mate, Shakeel "hopes these guys are craving Indian." Later, Peji and Evan compete for Shakeel's favors by learning "traditional Indian dance moves" from Nakul Dev Mahajan. The Indian troupe stands on the sidelines waiting their turn. The first contestant is eliminated after he claims that he will show Shakeel "some awesome moves that are better than Bollywood." This statement invites scorn from Shakeel. After he selects Evan, he wants to find out if he "has what it takes for Bollywood." In subsequent sequences, Evan and Shakeel join the NDMBDS dancers. In a scene of cross-gender playfulness,

select members of the NDM dance troupe perform a heterosexual romantic duet. Shakeel and Evan then imitate the movements, thus celebrating Shakeel's Bollywood "fantasies."

Filmed at the LA County Court Park in 2007, this episode of MTV's *Next* brought together nostalgia, kitsch, and Orientalism as key elements of Bollywood and reflected a broader tendency toward such presentations of this industry in US mainstream entertainment media production. In the episode, NDM becomes the mediator of Indianness as Shakeel searches for his ideal mate. Shakeel's fascination with Bollywood is initially understandable as a result of diasporic nostalgia. Here, Bollywood dance approximates Indian classical dance in mediating Indianness through dance in the diaspora. At the same time, the integration of Bollywood movement and aesthetics into the show gains new significance when contextualized within the gay theme of this specific episode. This theme underscores how Bollywood is readable as kitsch or camp.

On first viewing, the use of Bollywood dance in this episode of MTV's *Next* brings to mind the work of queer and feminist media scholars such as Gayatri Gopinath who suggest that film dance sequences provide alternative interpreted meanings for queer and gay audiences.[113] Gopinath argues that this space enables the possibility of critiquing the socially conformist (and heteronormative) values that prevail in many Hindi film narratives.[114] Following in this line of argument, Raj R. Rao suggests the possibility of alternate queer interpretations of the *yaar* (friend or lover) and *yaari* (friendship) themes in Hindi film song lyrics.[115] Ashok Row Kavi's analysis of the eroticization of the Hindi film hero suggests a similar counter-reading of Hindi film content.[116] Film scholar Rajinder Dudrah suggests that homosexual subtexts are now becoming more acceptable in some Bollywood films.[117] Citing instances of such innuendos in the film *Kal Ho Na Ho*, Dudrah speculates that this increased visibility of queer possibilities in at least a few Hindi films creates, and possibly even encourages, more space for alternative readings of Hindi films.[118] An application of this approach to the MTV *Next* episode would suggest that NDM and Shakeel engage in an alternative gay reading of Bollywood dance in this show.

Yet this reading conflicts with nostalgic understandings of Bollywood as authentically Indian as suggested by research at NDMBDS. A closer examination of the MTV *Next* episode suggests Nakul Mahajan and his "all Indian" troupe engage in a performance that affirms, rather than challenges, traditional sexual norms through Bollywood movement. While their dance allows for queer interpretations through the actions of Shakeel and his partner, Bollywood dance in the show remains largely exclusively heteronormative and conforms to notions of Indianness in the US. Slippage between India and Bollywood runs rampant. Bollywood stands in for India as India collapses into the colorful fantasy space of Bollywood films.

Revisiting *So You Think You Can Dance?*

In many ways, Bollywood dance owes its current global popularity and form to the nostalgic impulses of the Indian diasporic communities. Over the years, dances once performed only at private celebrations found new expression and purpose in dance schools and on cultural stages in many locations across the US. Approximating the cultural lessons provided by India's classical dances, Bollywood dance gained popularity as an easily accessible and culturally enticing lesson in Indianness. This function of Bollywood dance coincided with a new visibility for Hindi cinema (and more broadly, all things Indian) facilitated by economic reforms and other elements of globalization, including new media technologies. This visibility, in turn, also brought Hindi cinema and with it, Bollywood dance to audiences beyond the diaspora. No longer a practice reserved for the connoisseurs of Indian culture, Bollywood dance is now mainstream in the West. Yet, even as Bollywood practitioners like Nakul Dev Mahajan rightfully celebrate their latest achievements, inevitable questions arise. Is Bollywood dance a trend that breaks past old stereotypes? Or does it give new life to existing preconceptions among and about Indians? What will be next for Bollywood dance in the US?

Back in the *So You Think You Can Dance?* studio, Katee and Josh breathe a sigh of relief. Their Bollywood dance sequence has

helped them avoid elimination for the time being. Seated in the audience, Nakul Mahajan smiles contentedly. He too has worked hard for this moment. He spent years building his reputation as a Bollywood dance teacher in the local Indian community. It all began with the many hours he spent watching, and moving to Hindi film dances in the privacy of his room. When others advised that he look at an alternative, easier career, he still persisted. He opened his school. He brought Bollywood dance to many students of Indian origin. Then he became "Hollywood's Favorite Bollywood Choreographer."

6

Conclusion

In Bombay, the air conditioning drones as Amrita packs her bags after a rehearsal with dance director Shiamak Davar. She exits the studio and runs toward the Mahalaxmi train station. En-route, she sends an SMS to her teaching assistant: "on my way." She boards the Churchgate train and sighs. It's going to be another long day.[1]

Sarala, a young Nepali woman, walks down a street in Kathmandu. She enters the studios of the National Dance Centre. She places her handbag to one side and runs into the studio space to join three other female dancers. Flick, flick, side step and turn. They execute their movement in unison. The sound track to Hindi blockbuster Dhoom 2 fills the room.[2]

Twelve timezones away, music blares through the speakers of a boombox in the NDM studio in Los Angeles as Nagesh, a teenager of Indian origin, practices Bollywood dance choreography for an upcoming show.[3]

From Mumbai to Kathmandu to Los Angeles, dancers engage with Bollywood dance. Amrita, Sarala, and Nagesh all translate dances they encounter in Hindi films into live performances of Bollywood dance. In this way, they are all part of a loosely configured global

Bollywood dance community. Yet their performances also take on different local meanings. Amrita's dance career is enabled by the increasing professionalization of Hindi film dance in Bombay/Mumbai. Sarala's performance of Bollywood dance in Kathmandu is enacted as a transgressive site of performed sexual desire within Nepal's dependence on India. Nagesh's dance grows out of his diasporic nostalgia.

The chapters in this book have approached Bollywood dance as a participatory global dance form that emerged from Hindi films. Inspired by the global proliferation of Hindi films through DVDs, VCDs, film theaters, satellite and cable TV, the Internet, as well as the current distribution priorities within the industry, these Bollywood dances become local choreographic translations of the global circulation of film content.

Unlike other dance styles like hip-hop or salsa, which all began with live performance and later migrated to film, Bollywood dance is by definition a mediated dance phenomenon enabled by media technologies. Inherently hybrid, it has always drawn upon a wide variety of Indian and non-Indian dance movements for its content. The sources of the movement elements used in the choreography of these dances for films have evolved in response to changing narrative needs and audience preferences. Dancers who perform Bollywood dances mingle dance content in films with their own locally defined movement vocabularies and preferences. As it is practiced today, Bollywood dance is a unique film-based global dance phenomenon.

Through the process of local interpretation, various versions of the same film dance typically emerge as it is performed around the world. One such example is the "Hare Ram" song-and-dance sequence from the film *Bhool Bhulaiya* (2007), which became a hit all over the world. In the film, the protagonist Dr Aditya (Akshay Kumar) performs the song as the concluding credits roll. Seen dressed alternately in a saffron robe and a black two-piece suit, he mouths into a suspended microphone and gestures to the lyrics, flanked by female dancers dressed in matching costumes. The song is a popular hit at Bombay's SDIPA presentation in March 2008 as students perform synchronized movements to its music for an

ecstatic audience. NDMBDS students in Los Angeles also perform the same song (*see* Photograph 6.1).

When the students at SDIPA dance to this song, one particular movement sequence stands out. During the first iteration of one line from the chorus lyrics of "Hare Ram, Hare Ram, Hare Krishna, Hare Ram," the students deploy Indian dance gestures to signify Krishna's flute to the left and right side of the face.[4] On the second iteration of the lyrics, the same gesture transforms as the students stretch their hands out in front of them in an Indianized version of a hip-hop hand gesture. In the final iteration of the chorus, the students use the same gesture holding holding their their arms above their head in a display of euphoric celebration. Thus in three repeating lines of the chorus, the students transform the gesture associated with a Hindu deity, through combining it with a hip- hop gesture, into a celebration of both.

When NDMBDS students in Los Angeles perform "Hare Ram" at the *Nache Baliye* show organized by Ektaa, an Indian cultural association based in Irvine County in Southern California, the overt transformation between traditional and contemporary movement present when SDIPA students danced to this song, gives way to more direct references to the lyrics as the students wave their hands in the air in a joyous body expression not found in the film version of the dance. Significantly, the students at SDIPA in Mumbai are dressed in jeans and a t-shirt. NDM students in Irvine appear on stage in matching traditional Indian attire. In both Irvine and Mumbai, the "Hare Ram" Bollywood song-and-dance sequence is a direct manifestation of the imagination inspired by Hindi film consumption, enabled by Hindi film circulation, and located in specific geographical contexts.

Let us revisit the three Bollywood dance locations explored in this book: Bombay/Mumbai, Kathmandu, and Los Angeles.

In Mumbai, classes at SDIPA are set to remixes of Hindi film songs and taught by members of the Institute's dance company. These classes allow students to begin to access the promises of success that they see in India's current globalizing tendencies. In SDIPA classes, students work to craft their bodies, so that they can be equipped with the body look and abilities they perceive as

necessary to satisfy the expectations set by Bollywood. SDIPA provides an opportunity for students to possess the ideal male and female bodies advertised through filmic and other images in contemporary India. As SDIPA's classes mediate expectations of globalization, they negotiate, and at times challenge, national and gender expectations of propriety and acceptability.[5]

Shiamak Davar's entry into Hindi films with his choreography of several dances in *Dil To Pagal Hai* (The Heart is Crazy 1997) marked a profound shift in Hindi film production and aesthetics. The success of Shiamak Davar dancers in contemporary Hindi films reflects a broader process of gentrification currently underway in the industry. The expectations set by SDIPA dancers and increasingly prominent foreign dancers in Hindi films have put additional pressure on other film dancers in the industry, particularly those not affiliated with a specific choreographer, as they must compete for work in a climate that privileges non-Indian dance training. Unable to afford such training, some of these dancers now find themselves relegated to the near-invisibility of the back rows of the chorus while other dancers trained in Western dance techniques are placed in the far more prominent front lines. Versatility becomes of crucial importance as lean and agile bodies now take center stage in Bollywood dance in Mumbai.

In Nepal, Bollywood-inspired dances exist on the unstable border between tradition and modernity, stigma and national pride, and pollution and purity. Underlying norms of sexuality take on profound dimensions as female dancers who perform film dances deal with the sexual stigmas associated with such a performance. In Kathmandu, dancers at the National Dance Centre inherit the historical stigmas of the Badi dancer communities of western Nepal even as the livelihoods of these traditional performers are eclipsed by the advent of dances inspired by modern entertainment media. Hindi films in Nepal assume new meanings through Bollywood dance.[6]

Nepali film actress Shrisha Karki's suicide was a potent threat of implosion of the unstable border space occupied by Bollywood dances in Nepal. Here, a single sexually-explicit photo published in a Nepali tabloid shattered a young actress's emancipation and

respectability. Yet, the silence maintained by most feminist organizations in the aftermath of the tragic incident has been an even more frightening display of the deep-rooted assumptions that persist about female performers in Nepal. As a woman who performed and entertained the public, Shrisha Karki was accused by prevailing opinions in the Nepali public discourse of being responsible for her own downfall as the fragile respectability of her profession was undermined.

Despite these powerful stigmas attached to Bollywood dance in Nepal, Hindi films also occupy an aspirational and liminal space characterized by fantasies of modernity and progress. Being taught Bollywood dance at the National Dance Centre is an embodied experience of these promises even as students must negotiate the stigmas.

In Los Angeles, the rising popularity of live Bollywood dance, which is fueled by Hindi film consumption among Indian–Americans, now assumes new meanings as Bollywood enters Hollywood's imaginary space. At the NDM studios, dancers and teachers cater to a clientele who are predominantly of Indian origin, whilst also striving to be hired by Hollywood productions. Nostalgic definitions of Indianness are held by the diaspora clash with present-day Orientalized preconceptions of India and Bollywood. On the one hand, spectacularized portrayals of Indianness assume an important role in multicultural constructions of diasporic identity in the US. On the other hand, romanticized, exaggerated, and kitsch portrayals of Bollywood are the most common ones in Hollywood, providing some continuity to a longer history of stereotyped portrayals of Indians as the Other in Western culture.

As the choreography of dances in Hindi films continues to be reshaped in response to market pressures, dancers at NDMBDS actively negotiate local expectations of what defines Bollywood dance through their choreographic choices—in ways intended to ensure their adherence to those definitions of Indianness that are currently dominant in their diasporic communities. At times, the dancers themselves will edit out elements they deem morally inappropriate from contemporary Hindi film dance sequences that they otherwise restage. In other instances, they may mix into their Hindi

film dance choreographies borrowed movements from the classical Indian dance vocabulary in an effort to affirm Bollywood dance as Indian dance. Ironically, their choreographic choices often show tendencies toward standardization that may erode the porousness that has historically distinguished Hindi film dance from the strict and comprehensive formal codification of Indian classical dance supported by Indian nationalism.[7]

Thus read, Bollywood dances in Mumbai and Los Angeles may actually on occasion contradict each other. SDIPA students in Mumbai value most of all dances and dance elements that they identify as Western. In Los Angeles, NDMBDS students tend toward favoring more emphatically Indianized portrayals of dance.

Yet, a further consideration of these accounts of Bollywood dance in different locales suggests an alternative, more connected possibility. Due to its hybrid content, Hindi film dance creates an aspirational space that instills itself in a particular place, thereby creating the experience of Bollywood dance. These spaces, however, are created through Hindi film dance, and are inflected with particular ideological considerations.

What emerges is a contrast between the mobility of the filmed dances that seem to circulate widely through various media and the geographical rootedness of the dancers who perform Bollywood-inspired live dances in specific locations. Although user-generated Internet video portals like YouTube may allow some dancers who interpret Hindi film dances to upload their videos and share them across geographical divides, the meanings these dances create continue to be predominantly local.

In each place, local dancers watch, interpret and re-create both select whole dances and specific dance elements contained in Hindi films. Some dance moves, or even entire dances, may be ignored. Some song-and-dance sequences may be completely restaged, largely stripped of their original choreography. A solo dance in the film may be turned into a group composition. A character's story in the film may be elided. Certain movements or themes that are especially recognizable or meaningful to local audiences may be added. The meanings of Bollywood dances are altered and adapted by every place where they are celebrated.

Yet, even as Bollywood dancers construct local meanings, they always draw, at least to substantial extent, on the material seen in the films themselves. This means, that, just like the choreography in the Hindi films, the reinterpretation of Bollywood dance here is dominated by local meanings. This process is always informed by the filmed version of the dance. Simply put, Bollywood dance does not just take on entirely different meanings in different places. These localized approaches to Bollywood dance point to more complicated relationships between the filmed and live, reinterpreted versions of dances. These relationships provide insights into how Hindi film dances engage with questions of Indian national identity and sexuality as well as global power structures and inequalities.

Read in this way, Mumbai, Kathmandu, and Los Angeles become more than distinctive locations for live Bollywood dance. These instances of live Bollywood dance can be understood as connected through networks of exchanges and migrations. In London for a choreographic project, dancer and choreographer Feroz Khan is shocked when he encounters pictures of his home and family from his early impoverished life in a slideshow designed to acquaint the performers of Andrew Lloyd Webber's musical *Bombay Dreams* with the realities of Mumbai slum life. Through her journey from her home in the San Francisco Bay area to the chorus lines of Hindi film dance in Bombay, Seema, a young second-generation Indian–American woman, encounters the Bombay film dance environment that bears little resemblance to preexisting expectations formed through her diasporic experience in the US. At SDIPA, which has a branch in Vancouver, instructors mediate between expectations of Bollywood dance in India and Canada as they adjust class content to local preferences. In Vancouver, students express a strong preference for dances full of Indian classical dance gestures, expressions, and movements. In Mumbai, students love punches, jumps, and shimmies set to Western techno remixes. In Kathmandu, Sanju, a bar dancer, prepares to travel to Bombay for work while warnings of Nepali women being forced into prostitution in India persist in the Nepali media. These anecdotes begin to reveal the complex interdependencies of the networks that link these far-flung locales.

The interdependencies raise further directions for research inquiry regarding the dynamics of power and mobility that shape live Bollywood dance. Who is able to travel in pursuit of their Bollywood artistic and commercial endeavors, and under what conditions? What understandings of Bollywood dance do these dancers encounter as they traverse geographical divides? What images are valorized? Whose realities are elided? Ultimately, it is these interdependencies and dynamics that define the content of both filmed and live Bollywood dance.

Hindi film dances mediate between India's colonial and post-colonial histories and its future global ambitions even as they cater to an increasingly transnational audience. Here the work of dance scholar Marta Savigliano becomes helpful. Savigliano's analysis of the musical film *Evita* shows how spectacular performances can wield political influence through artistic decisions which aim to present imagery loaded with symbolic significance.[8] Following Savigliano's reasoning, we need to examine the global politics that resonates through our journey into the worlds of Bollywood dance found in Mumbai, Kathmandu, and Los Angeles. In Los Angeles, the live Bollywood dance scene feeds its own sense of self-exoticization within the context of American multiculturalism and lingering Orientalism. In Mumbai, Bollywood dance is fast becoming a means toward upward mobility in the newly globally ambitious India. In Kathmandu, dancers whose performances are inspired by Hindi film dances are caught between modern notions of progress, moral controversies over the sexuality of dance and the country's troubled national identity. Shaped by local interpretations, Bollywood dances at all three sites negotiate notions of Orientalism, nationalism, tradition, modernity, sexuality, commercialization, and globalization.

At each site, it was crucially the power of the authenticity—defined as original or real—attributed to Hindi films, which determined much of what was acceptable for the local version of Bollywood dance. But authenticity is also a highly contested concept in Bollywood dance with its local and global definitions being in flux and greatly varying. The borrowing of content, inherent to the design of dances in Hindi films since their inception, is the most

important mechanism for mediations between the constructions of authenticity in Hindi film dance and the fantasy space encouraged by Hindi films. This borrowing also supports the emergence of Bollywood dance as taught and performed movement.

Bollywood dance affirms the supremacy of the mediated image, even as geographically specific appropriations of sound and choreographic content depart from the visual context to create their own meanings. On occasion these challenge the dances in Hindi films when dancers and choreographers choose to omit or include certain movements in their interpretations. Thus read, the choreographic processes engaged by instructors at SDIPA and NDMBDS can be seen as more similar than dissimilar since they respond to preferences they perceive as common in their specific geographical locations connected through the imagery of Bollywood cinema.

As dancers in Kathmandu, Los Angeles, and Mumbai perform dances choreographed to Bollywood songs, their performances become more than dislocated examples of Bollywood dance. Even as Hindi films facilitate expressions of Indian diasporic identities in Los Angeles, they may become helpful in an articulation of transgressive, unequal, nationally marked, difference in Nepal.[9] What emerges overall from each case is a complicated situation where, in the words of theorist Arjun Appadurai, "One man's imagined community [may become] another man's political prison."[10] As this research asked "whose prison?" and "whose imagined community" define Bollywood dance, Sarala, Amrita, and Nagesh's performances become more than instances of Bollywood consumption. They connect through complex global webs of images, experiences, and contexts that lie at the heart of understanding Bollywood dance. It is this connection—between film and live performance as well as between dancers around the world—that defines Bollywood dance. This connection brings us back to the symbiotic relationship between film and live performance.

In Chapter 1, we encountered the "Choli Ke Peeche Kya Hai?" (What is behind the Blouse?) song-and-dance sequence from *Khalnayak* both as film and as live performance as it was presented at the *Frame by Frame* Hindi film dance symposium in the UK. To complete our journey through Bollywood dance, we now

return to this sequence once again—albeit in a different context as we explore the changing role of the Hindi film dance director (or choreographer) in Bollywood.

So What Was behind the Blouse?

It is evening in India in early 2008. A catchy jingle introduces the start of a new show on New Delhi Television (NDTV).[11] A group of female dancers dressed in solid colors moves through a percussive dance phrase. Saroj Khan, a prominent Hindi film dance choreographer, enters the television frame. Her movements are simultaneously authoritative and flirtatious. Dressed in white, she covers her face with her right arm, then swings it downward to allow her to coquettishly peek into the camera. With a series of quick edits, the music climaxes. On the last beat, the visual cuts to a large Nataraj statue—the dancing Shiva—towering over a stage-like space. Saroj Khan, now dressed in red, faces the statue and bows down in reverence. Her movements are a salutation. She touches her eyes and then the floor respectfully. As the light shifts to a hue of pink and purple, she steps out toward the audience. Her left hand is on her waist. Her right arm, in a *dola*—or relaxed—position, sways gently. She breaks into gestural and expressive phrases, the vocabulary echoing Indian classical dance. As the song ends, she bows down to the floor as the camera pans over her head to fix on the Nataraj statue. The camera cuts to a close-up of Saroj Khan looking straight into the camera and speaking for the first time, "Dance is my life. If there is no dance, there is no Saroj Khan."

Saroj Khan tells the viewers,

> You all know me as a Bollywood *Filmi* choreographer. I have done many filmi dances ranging from *mujra*, Western, folk to classical. Any dance you think of I have taught it. I have taught dances to actresses from Vyjanthimala to Aishwarya. And today I am coming to teach you to dance.

The first episode of *Nachle Ve,* Saroj Khan's instructional dance series, has begun.[12] Over the next few months, audiences all over

India will have a chance to learn dance moves from the master of Hindi film dance herself. A senior member of the Hindi film dance community, Saroj Khan, has choreographed more than 100 dances in her long and illustrious career. Her outstanding achievements have been recognized by eight Filmfare Best Choreography awards, including the one she received for her choreography for Aishwarya Rai and the song "Barso Re" (Do Rain) in the film *Guru* (2007).

One by one, four young female dancers introduce themselves on the program—they will be Saroj's students on the show. Neha wants to be a choreographer. Preeti dreams of becoming an actress. All the women admire Saroj Khan. "If you know your basics, then you can dance any dance," Saroj Khan explains as she instructs her four students. She asks them to turn away from the audience, or in this case, the camera, and to place their feet apart and lean to their right. "Stretch your back leg," she corrects one student. "Don't do it in Western style, this is an Indian movement," she admonishes. Saroj Khan demonstrates a wave-like arm movement as she counts out four counts. She stresses that the flick of the wrist needs to be precise. When the arm is down, it should be flexed. When it's up, the hand should be cupped facing downward. "Yes, *masterji*," the students say as they try to follow suit.

Nachle Ve with Saroj Khan is one of several dance-based shows currently aired on India's expanding networks. Most dance shows follow a general competition model in which preselected contestants compete, sometimes on grounds of dance ability. *Jhalak Dikhla Jaa*, which first aired in 2006, is the Indian Bollywood version of the popular dance contest show *Strictly Come Dancing* in its original UK version, and *Dancing with the Stars* in the US. While the UK and US version focus on ballroom and Latin dances, the contest format common to all of them pairs non-dancer celebrities (who sometimes have no preexisting dance skills) with professional dancers. StarPlus's *Nach Baliye* teams up celebrity couples with choreographers. All the Indian dance programs draw heavily, if not exclusively, on Hindi film dance content. But *Nachle Ve* is different. The show focuses exclusively on the body of work created by a single choreographer, recognizing her choreographic prowess as it simultaneously works to translate film dance into a

participatory experience for the viewers. That is to say, *Nachle Ve with Saroj Khan* encourages not only the popularity of Hindi film dance as spectatorial pleasure, but by asking the audience members to actually get up and dance, the show also recognizes how popular film dances have become as live physical performance practice among Bollywood fans.

Saroj Khan then introduces the song she is going to teach in this episode of the show. "This song was a super-duper hit," Saroj Khan boasts. "The song was controversial...but I received the Filmfare award for it," she quips. The camera cuts to an edited clip. Women stand in a row as they jerk their heads to the side. A sole dancer breaks into a fast-paced rhythmic composition. A woman watching from the sidelines smirks and looks away in mock disgust. Back in the studio, students clap and Saroj Khan smiles. The assumption that TV audiences will immediately recognize images and music from the "Choli Ke Peeche Kya Hai?" song-and-dance sequence is clear. Khan turns to face the camera to address the TV audience at home. "So get up off your chair, move your furniture, and get ready to learn a dance by Madhuri Dixit." The rest of this first episode of *Nachle Ve with Saroj Khan* is dedicated to teaching movements from "Choli Ke Peeche Kya Hai?" to the show audience with the help of her students.

Although it has clearly acquired a life of its own beyond the original film, "Choli Ke Peeche Kya Hai?" was initially part of *Khalnayak* 1993, a film about a seemingly incorrigible terrorist whose waywardness is finally tamed by Ganga, a brave and morally righteous policewoman played by Madhuri Dixit. The "Choli Ke Peeche Kya Hai?" dance is performed by Ganga when she is undercover as a dancing girl. By performing the dance, she captures the attention of the terrorist group leader. The film was a runaway hit. Rumor has it that the Indian Central Bureau for Film Certification, appalled by the song's explicit sexual content, threatened to block the release of *Khalnayak*.[13] Extensive press coverage of the controversy created a huge draw for audiences when the film was released unedited.

Khan explains that her choreography was decisive in gaining the censor board's approval. To counter the explicit lyrics of the

songs, Khan explains that she consciously chose movements that were seen as morally "pure," made sure that no angle was "vulgar" by consciously avoiding frontal address, and chose movements that suppressed the impressions of explicitness created by the songs lyrics. Finally, Khan kisses the air as she recounts Madhuri Dixit's brilliant performance of the song. "I still remember it," she sighs. It is appropriate then that Saroj Khan would choose to teach this famous song-and-dance sequence in the opening episode of her show.

Proudly, Saroj Khan insists that it were her choreographic choices that were a big contribution to the film's success and the song's enduring popularity as a dance classic. An analysis of the film sequence confirms her assertion. For example, after the moment in the sequence when Ganga lifts up her veil to fully reveal her face, the camera ceases to focuses on her hips and chest. Once we have her expressive face, we no longer see a fragmented sexualized body. The choice to focus on Ganga's often shy facial expression works to offset the potentially sexually explicit connotations of her movement. This privileging of her face by the camerawork contrasts with recurring midriff shots of the chorus dancers.

The explicit bantering lyrics of the song are presented as a dialogue between Ganga and Devi, a Rajasthani woman who is assisting Ganga in her undercover mission. Staring into the camera brazenly, standing behind other dancers, Devi asks, "What is behind your blouse?" Facing away from the audience, head still veiled, Ganga answers, "In my blouse, is my heart." The camera cuts to her dance partner who smirks at her answer. This establishes a crucial sense of camaraderie between the two women that communicates Ganga's respectability. She continues to rebuff Devi's sexually specific questions and directions with playful innocence. Ganga's exit from the staged performance effectively ends her teasing conversation with the morally questionable dancing girls.

When it was initially released, "Choli Ke Peeche Kya Hai?" enjoyed enormous success as a film dance, with many audience members returning for repeat viewings of the film primarily because of this particular song-and-dance sequence. The popularity of the sequence lives on long after *Khalnayak* finally disappeared from film theaters. In circulation through videotapes, DVDs, online

video sites, and other media, the filmed version of the dance continues to inspire many live versions of this dance by dancers and audiences around the world.

For instance, performance scholar Sunita Mukhi's recounts a staging of "Choli Ke Peeche Kya Hai?" by seven-year-old Preeti at the Indian Independence Day parade in New York City in 1997. Consistent with our observations in Los Angeles, Mukhi observes that, although, Preeti mimicked many of the steps from the film, she also added Indian classical elements to the dance to make it more "purely" Indian and hence more acceptable.[14]

Ten years later and many time zones away in St Petersburg, Russia, "Choli Ke Peeche Kya Hai?" surfaces at a local Indian dance competition. Here, the social boundaries between Ganga, Devi, and the other chorus line dancers in the film give way to a dialog duet between two female dancers on stage. Dressed in costumes that approximate those in the film, the two dancers perform many of the steps from the original choreography without making the original distinction between the heroine and the dancing girl. Flanked by female chorus line dancers, of mostly non-Indian origin, the two performers effectively erase the narrative significance achieved through Khan's nuanced choreography. Rather than stressing the unison movement and the Indian appearance of the costumes, they emphasize Bollywood as an Orientalized dance in their interpretation.

In the climax of the film, *Gulabi Aina* (2003), there is also a performance of "Choli Ke Peeche Kya Hai?" which was even more controversial than the original. It was performed by two *hijra*s (eunuchs), Shabbo and Bibbo, one of them HIV-positive and both of them in drag. Throughout this alternative risqué interpretation of "Choli Ke Peeche Kya Hai?" the dancers reference Saroj Khan's choreography even as they exaggerate the expressive and physical intensity of individual movements. Their hips swing more forcefully. They bat their eyelashes more vehemently. This has the connotation of anger. They also exaggerate the sexuality of the lyrics. Their sexual identities increase the intensity of the performance. Simultaneously, a celebration of life, acceptance, and an acknowledgment of the challenges of HIV, the dance becomes a locus of

queer desire and pleasure through an exaggeration of the version performed in *Khalnayak*.

Inspired by Saroj Khan's choreography, these interpretive performances of "Choli Ke Peeche Kya Hai?" give new life to the song-and-dance sequence in the film itself. Even as these performances draw from the film, they do not simply mimic the dance in the film. For Preeti in New York City, her choreographic and costuming decisions are guided by her desire to communicate her respectable Indian identity in the US. For the dancers in St Petersburg, the performance of "Choli Ke Peeche Kya Hai?" is an opportunity for creating a spectacle for their Russian audience which shows off the exoticness of India. In the case of *Gulabi Aina*, the original song-and-dance sequence is the inspiration for the expression of alternative sexual identities through dance. Each instance affirms the symbiotic nature of Bollywood dance.

Yet, Saroj Khan's appearance in *Nachle Ve with Saroj Khan* also adds further nuances to the circulation of Bollywood dance from film to live performance, and back to film. When Saroj Khan appears before television viewers and invites them to learn steps from "Choli Ke Peeche Kya Hai?" she asserts herself as the originator of the sequence. She becomes the author of the dance as she reclaims the originality of her choreography. The emerging celebrity status of certain Bollywood choreographers in recent years shows that the personal brand of major choreographers has a new level of importance. Once relegated to the ranks of technicians, choreographers—more often referred to as dance directors—now often feature prominently in film publicity and credits. A junior choreographer in the industry, Shabina Khan elaborates, "If I choreograph the whole film, then everyone will know that is my work."[15]

This trend introduces a tension into the production of Hindi film dance, which has remained intentionally porous throughout its history. Film choreographer Farah Khan explains determining what is and what isn't a film dance move was not important in the film production process.[16] Rather, choreographers usually proposed content based on past films, narrative demands, star ability, and current popular culture trends. Innovation through appropriation was valued over codification. While a certain degree of

specialization has emerged in film choreography, the standard of excellence among choreographers continues to be the ability to "choreograph all styles." "I have to be able to choreograph them all," explains Rekha Prakash, a film choreographer.

The requirement for a broad spectrum of choreographic possibilities in Bollywood dance today also places demands on choreographers to keep up with current dance trends from around the world. "I have to keep up with everything that is new," Rekha Prakash explains. "I watch everything," a junior assistant explains. "Every time someone goes abroad, they come back with a suitcase full of DVDs. We have to keep up. The ideas have to come from somewhere," she laughs. Most choreographers are very open about how they appropriate dance content from other sources in order to create their song-and-dance sequences. Still, as Saroj Khan's public claim of authorship of the choreography in "Choli Ke Peeche Kya Hai?" demonstrates, changes may be underway in the way in which creative ownership of choreography is accorded a greater importance in the culture of the Bollywood industry.

Young choreographers look forward to being publicly credited in the titles of films that they have worked on as a crucial professional moment for their career. "I need to have my work recognized as mine to move forward," a junior choreographer in the industry explains. Most recently choreographers, or dance directors, strive to be recognized for their skills in particular movement genres. An assistant choreographer explains, "It's like, Saroj-ji is the master at filming Indian songs. Bosco and Caesar or Remu are best at hip-hop. Farah Khan's got that typical Bollywood style."[17] Currently, the Bosco and Caesar duo is coveted for their hip-hop inspired choreographies. Farah Khan is considered to be a master of the quintessential Bollywood repertoire. Shiamak Davar's jazz influenced movements and dance troupe work well in glamorous settings. Vaibhavi Merchant brings continuity to her family's film dance traditions. Specialization is a crucial factor in bringing fame to a choreographer. And directors may approach different dance directors for songs in the same film. Select choreographers now enjoy Hindi film celebrity status as their choreography in a film has increasingly

been recognized as a key contributor to a film's success. Specialization brings recognition.

On the live performance end of the Bollywood dance spectrum, dancers believe that it is their right to alter dance content from films to suit their abilities and local preferences. "I think of the dance in the film as just one version of the dance," a Bollywood dancer in Los Angeles explains. Following this reasoning, the dances in Hindi films inspire, rather than dictate, the ways in which Bollywood dance becomes live performance. If the dances in the film do fit the dancers' local preferences and fantasies, they simply adjust the dance content accordingly.

Bollywood dance, then, is a negotiation between dances in Hindi films and their reinterpretation in live performance. Film choreographers still need to create movement content for the film narrative. At the same time, they are increasingly conscious of the far-reaching effects of their movement choices. Recognizable dance movements travel far beyond the cinema as students in Bollywood classes arrive with set expectations of what they want to learn based on Bollywood films they have watched. Over the past few years, fan interest in learning, and ultimately mastering Bollywood dance, has created an implicit pressure to codify Bollywood dance movement for teaching purposes.

Dancers in the film industry depend on audience preferences for their professional success. Bollywood dancers and choreographers around the world depend on the Hindi film dance industry as a supplier of constant new streams of source material. As Bollywood dance has developed as a globally recognized form, conventions of appropriation collide with pressures for codification.

The Final Dance

Created through the symbiotic relationship between film dance and live performance and supported by appropriation and participatory culture, Bollywood dance has today become a recognized and contested dance style. Whether taught in formal schools or rehearsed in front of TVs and computers, whether performed at

parties or stage, live Bollywood dance expresses interpreted meanings associated with Hindi films. These meanings vary across communities in specific geographic sites.

Once such site is Prague, the capital of the Czech Republic.

It is a hot summer day, and a crowd has gathered for the 60th anniversary celebration of Indian Independence that has been organized by the Prague Bollywood Festival and the Indian Embassy to the Czech Republic. The event opens with a showcase of Indian dances as they are practiced in the Czech Republic. India's classical dances of Bharat Natyam and Kathak are on full display. The audience claps appreciatively. Then Garam Masala (Hot and Spicy), a troupe specializing in Bollywood dance, enters the stage. Their hips sway. Their arms extend above their head. Their wrists whirl as they smile coquettishly and mouth the lyrics to "Bole Chudiyan" from the diasporic epic *Kabhi Khushi Kabhi Gham* (Sometimes Happiness, Sometimes Sadness, 2001). The dancers alter the spatial configurations of the dance from the film in order to emphasize group formations even as they strive to imbue their performance with the characteristic innocent flirtatiousness from the film's original scene. The audience explodes with cheers, whistles, and applause. The performers respond by moving their hips even more vigorously as they step to the beat. Bollywood dance is a rich source of meaning for this to this celebration of India in the Czech Republic.

Garam Masala's performance is, of course, yet another location on Bollywood's global journey. As elsewhere, the dancers' interpretation of the Hindi film dance intermingles with local specificities. In their performance, the dancers give continuity to patterns of Hindi film consumption traceable back to the days of Communist Czechoslovakia. Garam Masala's performance is also a response to a renewed post-1990 interest in foreign cultures among the young Czechs. This zeal drives a growing interest in Bollywood dance in the Czech Republic.

Here in the Czech Republic, dances take on a life of their own in a country with a negligible South Asian population—their consumption is almost entirely cut off from the nostalgic audiences of the Indian diaspora.

As I watch this performance, I wonder what the Bollywood dancers in Mumbai, Kathmandu, and Los Angeles would say if they saw this performance at Prague's Strelecký Ostrov open-air film theater. How would the choreographers who created the dance in the original film react? Would the dancers at NDMBDS comment on the "Indianness" of the colorful costumes? Would SDIPA dancers critique the body shapes draped in these costumes? Would the dancers at the NDC be surprised by the fact that none of the dancers—and very few audience members at the event—are of Indian descent? What would all these dancers from different groups say to each other if they sat together as an audience of this performance? Would they compare their interpretations of the "Bole Chudiyan" song? Would they find each other's interpretation "too Indian," "too vulgar," "not Indian enough," "too tame," or simply "inauthentic?" Would they share their know-how about how to best appropriate and reinterpret elements of Bollywood song-and-dance sequences? Or would their local cultural differences in how they relate to Bollywood dance ultimately undermine any sense of shared connection? I wonder whether we will one day see a global network emerge around the shared practice of Bollywood dance.

Around the world, Bollywood dancers in Bombay, Kathmandu, and Los Angeles—and in many places elsewhere—prepare for their next class or performance. They eagerly await the next Hindi film release and look forward to scrutinizing the choreography it contains. They may or may not know about each other. They may watch each other's uploaded videos on YouTube. They may pass each other on the street. They may never meet. Bollywood dance, in film and performance, continues to travel the world, to Lima, Cairo, Sydney.

In the meantime at the Prague performance, the song reaches its finale, and the dancers of Garam Masala spin into their final pose. The audience breaks into a standing ovation—and the dancers take their bow....

APPENDIX 1

Personal Narrative: Bombay Story[1]

If you would come to Bombay and ask me to choreograph a song, you will have some draft in your head. You will give me a reference… like "I want to do a video like Shah Rukh Khan did two years back." You may say, "I want to do Justin Timberlake type of stuff." If you give me too much referencing, I will get stuck. I don't copy. I cannot. See, I have left projects where they have given me too many DVDs for homework. I'll ask you for the music and I will listen to it. You will tell me the storyline. Then you will ask me whether I want to add something to it. I may say I want to add some colors. Maybe I will say, "let the girl go and dance on the other side," something like that. Sometimes I design the set. I figure out the camerawork. Then, I become the dance director.

When shooting, we always make several plans and go. If it doesn't work the way we planned then we go with plan B. Sometimes plan C happens on the location. Every shoot, first day, there is always a delay. The actor comes late. The generator is not working. The set was not put up properly. So now we do a lot of pre-production planning to cut down on time. If the video is not very high budget, we may shoot only for one day. The rehearsal may be on the set. Nowadays if I need ten dancers, four will come, six won't come for a rehearsal. They will choose to accept another shoot to earn money. I understand they are choosing to earn money. A sense commitment does not exist anymore. That is what's happening in Bollywood.

I was born in the Mahim slum. I come from a very conservative Muslim family where dancing is not in the culture. My dad was in Saudi Arabia because of work. He earned money, sent it to

us and came to visit every three years. My mother used to calculate the allowance and sent us to a good school. Then I lost interest in studies, got into dancing. I wasted so much of my parents' money. I never studied. I used to hide my dance from my mom. Then one day, she came to know, and she warned me that when my dad comes to know there will be shouting. I begged my ama to let me keep dancing and she never told my dad. After I grew up, he came to know that I was working in films. He told me to stop and I refused. And he left me on my own. But when I gained a good reputation six years ago, he gave his permission that I do what I want. Honestly, my journey from the slum to a flat and now to a bigger flat has been superb. Today, I am 33 and my mom passed recently.

I went to London with Farah Khan to work on the choreography for the musical Bombay Dreams. I was shocked when they narrated the story of the musical. It was about a boy from the Mahim slum who becomes a Bollywood star. It was my story. I could see my own house in the pictures of the slum that they projected for the cast to show them how the slum people lived. I was in tears. Then Farah found out that I come for the slum. I had never told her though she is like my family. That was when I told her everything. She was amazed. She told me to teach the cast how to behave like the people who used to live in the slums. I remembered everything. I remembered how my mom used to fetch water from the well. How she used to carry the pot on her head. I was supposed to be in London for a month but ended up staying for three months.

I also worked with Farah Khan on Main Hoo Naa (2004). I will tell you the complication with the song "Chale Jaise Hawaein" (The Way the Wind Blows) song in that film. We took 100 dancers, junior artists, extras, and crew to Darjeeling for one month. We stayed in the dormitory. It was winter vacation at the school. We would get up at three in the morning and start shooting at five with the sunrise. The sun set a four o'clock in the evening. After that, we rehearsed. We had to practice up there because of the high altitude. We practiced with a cameraman because the camera had to be mounted on his body. If one person made a mistake, we

were dead. We had to start again. Finally, we filmed the song in one day because once you start shooting you cannot stop.

I took my mom to the premiere of Main Hoo Na and she met Farah Khan. For all those years, she had only spoken to Farah on the phone. My mom bought new clothes to go to the premiere. She bought new jewelry and she went with me. I introduced her to everyone including famous actors. They all talked about me to my mom and she listened. She was very happy. She came back home and told everyone—my aunt and brothers, family friends. After that she fell ill. It was meant to be. Before she died, she saw what I was doing. I had never taken her for any shooting. She never asked me. I used get money and give it to her. My dad is still in Saudi where he works as a laborer. He is going to come back soon. My sister got married this year. So my dad has accepted everything now. He is happy to see me on television. I think he is proud of me.

From the time we were brought up, we have always seen people dancing in films. They look so happy. You don't do it in real life. You cannot go out on the street and dance. Even today, I may be driving in the car with my girlfriend and may just sing a song to her. It is just happiness. It goes away. In the commercial cinemas, families who are going through a lot of financial pain and other problems come to watch us. At least we give them three hours of relaxation where there is no fighting with your brother, wife or sister. You are watching—you see a lot of colors, you see a lot of places that you may not have seen.

I never went to a proper school to train myself in dance. I didn't know what a warm up is. When I went to London, I came to know that dancers do a 45-minute warm-up before they start the day. Today whenever I rehearse, I always do a warm-up for the dancers, actors and myself. Today, more dance techniques are coming to India and others are adopting our Bollywood dancing all over the world. It's not about copying. It's about liking something and appreciating it. I don't want to say that the British are copying our Bollywood style. They are not copying. We are happy that we are giving them something. We took a lot of things from them. Now, it's payback time.

My journey has been really good in the last eleven years. I have a lot of memories. I always thank my boss Farah Khan. She showed me the places. She showed me the people. She showed me the world. She inspired and supported me. I get a lot of offers to move to London now because I belong to the Farah Khan school. But my roots are in Bombay.

Personal Narrative: Kathmandu Story[1]

I am from southern Nepal, from the district of Chitwan. My mother is still there in the village. Father passed away a long time ago. I came to Kathmandu more than nine years ago with friends. I thought life would be better here. You know, there are Maoists back in the village, and it's not safe. Even though there are Maoists here too, it's still safer than over there. Kathmandu is a big city and it's well protected.

Photograph 4.5 was taken at the dance club in Thamel[2] where I work. I have been working at this club for some time. Before I became a dancer, I worked in thangka lekhde.[3] The shifts were really long—more than twelve hours each. I was so tired, working all the time and earning barely Rs 3,000–4,000 a month.[4] Then I ran into a friend who was working in a dance bar. She told me that the work in the bars was good and that I could earn a lot of money. I was so tired and frustrated that I decided to try it. I started out as waitress in a dance bar and then moved to dancing.

I like to dance. It's fun. If there is a lot tension in my life, I meet my friends at the dance bar, we dance and I feel better. But sometimes, I don't like it. Maybe I don't feel like dancing or something like that. Maybe I am tired. Then I just have to force myself. I dance everyday. There is no holiday. I arrive at the bar around 6:30 in the evening or earlier if I want to hang out with my friends there. Then I dance until around 10:30 in the evening. Sometimes, it goes a little later. Honestly, I am always at the bar.

Sometimes, I get to choose the song that I want to dance to; at other times person operating the sound system just tells me to go and dance without telling me what the song is in advance. Then I just have to go. There are four other dancers at the bar and we take turns performing. So we do get to take small breaks.

When I perform, I listen to the music and catch the beat. Then I dance to the beat and lyrics. I don't have time to watch many films. Very rarely, I will go with my friends to watch a film in the theater. It becomes a special event. Sometime ago, I really like to go and see Nepali films. I also really enjoyed the Hindi film *Devdas* with Madhuri Dixit and Aishwarya Rai. I loved the dancing in that film. It was so beautiful and looked very classical. If the songs and dances in a film are good, then I don't care about whether the film is good.

I am too shy to work in films. It is funny but I get very shy with the camera. I have gotten offers to be in pop videos. But I am too shy [laughter]. You see the picture remains in the camera. On stage the show ends and it is gone. I guess I am also okay with dancing on stage because I have been dancing there for more than five years. I was very shy in the beginning. I didn't think I could get out there and dance. Now I have no problem with it.

I do pooja[5] at home everyday. I have a statue of Shiva and Nateshwara.[6] As a dancer I have to worship Nateshwara. He helps me make the dance good. If the dance isn't coming to me when I am on stage, I turn to him and he makes it happen.

I don't have a boyfriend now. I did before. We lived together. After a few months he asked me to marry him. We agreed, so he called his mother and told her that he wants to get married. She said fine, if you like her marry her. So I went home to tell my mother in the village. I don't know what he heard when I was away. But when I came back he was gone. He didn't come back to the room. He had told me that I didn't have to work any more so I had quit a few months earlier. But then he didn't come back and rent was late. I waited and waited and then came back to work.

I am not sure about my future. It will depend on the situation in this country. Maybe I will return to the village one day. I won't marry though. Never. I don't even want to think about the idea. My mother does not know that I dance. If she found out she would probably be angry with me. So if I go back to the village, I won't be able to dance there. Actually I wouldn't even want to. Over there, the "'sahar'" is not like here over there. It is a small village. There

is no one to watch the dancing [laughter]. I don't think there ever will be like Kathmandu over there. It is a small place, even though it is a big village.

I cannot tell you what I will do in the future. I don't think about that. I am here today.

Personal Narrative: Los Angeles Story[1]

I was born and raised in the Bay Area. I started doing jazz and Garba growing up and then I joined a dance nonprofit out of the bay area.[2] I never really did Bollywood dancing. But I would watch Bollywood movies, and I remember mentioning to friends that one day I want to go and be in films. Then came a time when I was going through a lot of changes, and I decided I wanted to take time off and go to India and do this. I just decided one day and told at work I was going to take time off. People I knew in the Bay Area said, "Oh, I know so and so in the film world." So I had a couple of contact names in the industry before I left. I had mentioned that I may want to go to Bombay a long time ago to my family they were like, "Oh my gosh, you have never lived in India, you never worked there, you don't know what its like." But then I decided to go anyway. I just bought my ticket. I needed to take time off.

I went to Bombay. I landed there and I stayed with relatives. But I quickly realized that if I stayed with them, I was not going to have the experience that I wanted and be able to do the things that I wanted to do. They were very conservative. They wanted me to be home at 8 o'clock in the evening and in the film industry this was not really possible. I spent about a week or so in Bombay and then I went to Ahmedabad. Monsoon season was coming and everyone said, don't stay in Bombay. I stayed in Ahmedabad for the summer. I danced over there, studied Kathak, and taught Western dance classes—film-like stuff, salsa, hip-hop and jazz—at another school. The guy who had started the school was a student of Shiamak Davar. He had left and started his own thing. I taught and choreographed for him.

When I returned to Bombay, I had to find a place. So I looked in the newspaper and talked to people to see if anyone I knew could

help me out. But I didn't know a lot of people in Bombay at the time and nothing really panned out. All the names and all the contacts that I had before I went to India did not turn out to be very helpful for what I wanted to do.

Eventually, I found a room on offer through the newspaper. It was in the Lokhanwala area. It was a room in an apartment shared by people living on their own. I just really clicked with one of the girls living there. She was an actress and was pursuing a career in Bombay. We became really good friends. She would take me if she would have to go to the studios.... she would say, "You never know whom you are going to meet!" Then one day, she was like, "Come to the gym." So I started going to this really big gym with my roommate.

There I met a guy who was a dancer and was starting out with his choreography. He said, "Why don't you come? You can teach." I started helping him out and teaching. It literally felt like something out of the movies. Some of the guys would show up for class in a red shirt, yellow undershirt, and red sunglasses. I was like, "God, where am I?"

So I was teaching with him and then he said, "Oh, there are some auditions for a film, why don't you go and check it out?" So I went to the auditions for Dhoom 2. *I got selected. That was the first dancing in films that I did in India. I realized that when you meet the right people, the networking happens. Once you are in the circle, people know you and call you for work. I met a lot of dancers. They would call me when there was stuff going on. Then the choreographer I was helping mentioned that somebody else was looking for an assistant. I met with her and I started working with her. I worked on serials, commercials, videos and other stuff. I was really busy the entire time.*

In Bombay, I got to meet a lot of the dancers. Some of them were really nice and some of them weren't so nice. Some dancers sent me the feeling of, "Who are you?" and "What are you doing here?" Language was also sometimes an issue. Some of them speak English but a lot of them speak a Bombay style of Hindi. I tried my best. I had studied Hindi before but not the street Hindi that they spoke. I can't say it was all necessarily easy.

I stayed in India for a year. Looking back one of the biggest things I learned is that you really need a lot of support. That goes for here as well but over there you really need someone who is going to look for you and look out for your career. I really had to be very careful about the decisions that I was making and the people that I was working with. I noticed that a lot of people who moved up ahead were people who had a lot of family support. Maybe, their brother was in the industry. Maybe, he helped them make connections. That was one of the biggest lessons I learned. I really had to watch out for myself.

I also had to be very careful about who I hung out with. I had a couple of really interesting incidents. For example on the first shoot I worked, the assistant asked me how I was getting home. Rickshaw was my mode of transport. He said he was going in my direction and told me to wait for him. The choreographer and some other people found out and said, "don't ever do that." I just felt very stupid at that moment, because I should have known. But it didn't even occur to me...

I also learned to be careful about the "ya, ya, ya, ya, ya." People would always be like "ya, ya, ya, ya, ya, don't worry." I learned that until it's done, whatever somebody says is not a given. I went and saw what was behind the movies. I realized that I was actually more conservative than some of the people over there. Now I know what the reality is, and it is not like in the movies.

Personal Narrative: Author's Story[1]

I don't remember when I watched my first Hindi film. It must've been many, many years ago in Kathmandu. I would go over to my relatives' house. My cousin ran a video rental store and was always making copies of Hindi films. I would just sit there and watch anything that was playing. Most of the time, it was some Hindi movie. I would just watch a part of one movie and another part of another one. I don't think I ever really even knew what their names were.

I would look forward to the songs and dances. I loved the dances most of all. I watched the heroes and heroines and the dancers and tried to memorize every movement that they made. They looked so beautiful, confident and moved with such ease.

Looking back, I think I was particularly drawn to the way that these dancers seemed to blend movements from different parts of the world together to create the medley of Bollywood dance. There was a bit of classical Indian dance, a bit of ballet and a bit of Madonna's latest music video. They got all mixed to become a dance in a Hindi film. I loved that. It was almost as if the cultural conflicts I felt as a product of an intercultural marriage could be resolved if the definitions of what is acceptable could be expanded wide enough.

I always wanted to dance, but never seemed to be able to get the courage up to tell my parents. It's not that they would've gotten angry or something like that. I just felt that it was not what was expected of me. No one in our family had ever danced or even pursued art as a full-time job. The idea just seemed completely preposterous. So I didn't tell them until much later.

So I would watch these Hindi dances and try to remember how the dancers moved—the steps, the hand gestures, and facial

expressions. When no one was at home, I would move the furniture in our living room and try the moves out. I would imagine that there were other dancers there too and would try to choreograph group choreographies. It seems so funny now [laughter]. But back then I could sometimes barely wait to get home on some days. I would dance and dance. Throughout the day I moved through such different worlds—my Czech family, my Nepali family, the international school. I had learned to act appropriately in each situation. But when I danced, I could just be myself and mix up everything. Sometimes I would go up to our rooftop terrace at night and try the movements against the wall where I could see my shadow. That way, I could see what it looked like. But then I noticed some neighbors watching me one day and I stopped doing that. I was so ashamed. I avoided the terrace for weeks.

Years later, I got the courage up to go to my first dance class, and today dance is an inseparable part of my life. Looking back, I don't think I would have ever got the courage to do that had I not seen those dances in Hindi films. I guess I dance because of them.

Notes

Chapter 1

A brief summary of this chapter appeared in, Sangita Shresthova. "Global Bollywood Dance Beats," *Confluence: South Asian Perspectives* (January 3, 2010): 11–12. Reprinted by permission of the publisher (Confluence, http://www.confluence.org.uk).

1. In 1995, Bombay was renamed Mumbai. During my research, as most respondents used Bombay rather than Mumbai while speaking, I use Bombay in this book. When referring to research I conducted at SDIPA. I use Mumbai to refer to the city in general contexts.

2. Julia Casper, *Bollyrobics—Tanzen Wie Die Stars*, DVD, (Germany: AV Visionen GmbH, 2006); Ulaya Gadalla, *Bollywood-Dance – Fitness mit allen Sinnen*, DVD, (Germany: Droemer/Knaur, 2007). In Germany, Julia Casper's exercise DVD markets Bollywood dance as *Bollyrobics – Tanzen Wie Die Stars* (Bollyrobics – Dance Like the Stars). Another DVD workout video exalts Bollywood dance as *Fitness mit allen Sinnen* (Fitness with all Senses).

3. A musical, *Bombay Dreams*, included choreography by Bollywood film dance director Farah Khan.

4. Sunita Mukhi, *Doing the Desi Thing: Performing Indianness in New York City* (New York: Garland Publishing, 2000), 115–119; Sunaina Marr Maira, *Desis in the House: Indian American Youth Culture in New York City* (Philadelphia: Temple University Press, 2002), 360.

5. Rustom Bharucha, *The Politics of Cultural Practice: Thinking through Theater in an Age of Globalization* (New Delhi: Oxford University Press, 2001), 2.

6. Honey's Dance Academy, "About Us," 2011, http://www.honeys danceacademy.com/ (accessed April 3, 2011).

7. NDMBDS, "Nakul Dev Mahajan—Bio," 2011, http://www.ndmdance. com/bollywood-choreographer-nakul-dev-mahajan (accessed April 3, 2011).

8. Drawing on Henry Jenkins and Project New Media Literacies, I define participatory culture as "1. With relatively low barriers to artistic expression and civic engagement, 2. With strong support for creating and sharing one's creations with others, 3. With some type of informal mentorship whereby what is known by the most experienced is passed along to novices, 4. Where members believe that their contributions matter, 5. Where members feel some degree of social connection with one another (at the least they care what other people think about what they have created)." Henry Jenkins, Ravi Purushotma, Katherine Clinton, Margaret Weigel, and Alice J. Robison, *Confronting the Challenges of Participatory Culture: Media Education for the 21st Century* (Cambridge: MacArthur Foundation, 2006), 9.

9. B. Bahadur. *Indian Cinema Superbazaar*, ed. Phillipe Lenglet and Aruna Vasudev (Delhi: UBS Publishers' Distributors Ltd, 1995), 110.

10. Manjeet Kripalani, "The Business of Bollywood," in *India Briefing: Takeoff at Last?* ed. Alyssa Ayres and Philip Oldenburg (Armonk: M.E. Sharpe, 2005), 171.

11. Arjun Appadurai, *Modernity at Large, Cultural Dimensions of Globalization* (Minneapolis: University of Minnesota Press, 1996), 27–47. Appadurai proposes the suffix "scapes" to describe the deterritorialized nature of the flow of media, ideas, ethnicities, and finance.

12. Ravi Vasudevan, *Making Meaning in Indian Cinema* (Delhi: Oxford University Press, 2000), 9; Dimitris Eleftheriotis and Dina Iordanova, "Indian Cinema Abroad: Historiography of Transnational Cinematic Exchanges," *South Asian Popular Culture* (Special Issue) 4 no. 2 (October 2006), 79–82.

13. Sudha Rajagopalan, *Leave Disco Dancer Alone! Indian Cinema and Soviet Movie: Going after Stalin* (New Delhi: Yoda Press, 2008), 116.

14. Brian Larkin, "Itineraries of Indian Cinema: African Videos, Bollywood and Global Media," in *Multiculturalism, Postcoloniality, and Transnational Media*, eds Ella Shohat and Robert Stam (New Jersey: Rutgers University Press, 2003), 170.

15. Ibid.: 178. Larkin's account of the "work of the Kenyan photographer Omar Said Bakor" who "developed a style of photography involving the superimposition of Indian actresses over portraits of local Lambu men" suggests a powerful connection between "the use of photographic space" and Bollywood as a site of "imagination and transgression." This imagination is strongly gendered. Hindi films in Nigeria evoke imagined alternatives to modernity for Nigerians as they negotiate their postcolonial identities, facilitating an imagination not necessarily defined by the paradigms of modernization.

16. Vamsee Juluri, *Becoming a Global Audience: Longing and Belonging in Indian Music Television* (New York: Peter Long, 2003), 65–93.

17. Rini Bhattacharya Mehta, "Bollywood, Nation, Globalization: An Incomplete Introduction," in *Bollywood and Globalization: Indian Popular Cinema Nation and Diaspora*, ed. Rini Bhattacharya Mehta and Rajeshwari Pandharipande (New York: Anthem Press, 2010), 4–5.

18. Today, Bollywood has become common colloquial term to describe the commercial film industry based in Mumbai, India. The definition of Bollywood, however, remains controversial. Viewed by many as an external descriptive label, the descriptor of "Bollywood" faces a lot of resistance from professionals in the Bombay-based film industry. This critical stance toward the Bollywood label within the industry is significant as it identifies an interesting contradiction currently at play in Bombay/Mumbai. On the one hand, professionals involved with the industry are eager to assert themselves as separate from Hollywood. On the other hand, Hindi cinema does increasingly aspire to challenge Hollywood, rendering Bollywood an apt descriptor for this particular sub-segment of commercial Hindi cinema.

19. Juluri, *Becoming a Global Audience*, 24–48.

20. Nyay Bhushan, "Reliance-CBS to Launch with Three Channels," *The Hollywood Reporter*, August 18, 2010, http://www.hollywoodreporter.com/hr/content_display/news/e3i8f8572de75e9b833dd865093012c8 24a (accessed August 27, 2010).

21. Sheila J. Nayar, "Dis-Orientalizing Bollywood: Incorporating Indian Popular Cinema into a Survey Film Course," *New Review of Film and Television Studies* 3, no. 1 (2005): 61.

22. This number reflects a "Bollywood Dance" keyword search in YouTube conducted on August 8, 2010.

23. For a detailed analysis of my choice to use Bombay rather than Mumbai when referring to research please see Chapter 2 of this book.

24. Saskia Sassen, "Introduction. Locating Cities on Global Circuits," in *Global Networks, Linked Cities*, ed. Saskia Sassen (New York: Routledge, 2002), xix. Sassen proposes cities as a way to locate globalization discourse within notions of place: "Introducing cities into an analysis of economic globalization allows us to reconceptualize processes of economic complexes situated in specific places."

25. NRI is a colloquial term referring to people of Indian origin living outside India.

Chapter 2

1. Iyes Thoraval, *The Cinemas of India* (New Delhi: Macmillan India Limited, 2000), 5; V.A.K. Ranga Rao, "Dance in Indian Cinema," in *Rasa: The Indian Performing Arts in the Last Twenty-Five Years*, eds Sunil Kothari and Bimal Mukherjee (Calcutta: Anamika Sangam Research and Publications, 1995), 301. V.A.K. Ranga Rao estimates that "in the 13 or so films that exist... (only two or three are complete; others are truncated to various degrees), there must be a few [dances].... *Lankadahan* (Wealth of Lanka) (1917) of Dadasaheb Phalke, which clearly shows that a trick sequence must have employed the technique of music dictated movement."

2. Peter Manuel, *Cassette Culture: Popular Culture and Music Technology in North India* (Chicago: University of Chicago Press, 1993), 40.

3. Vivek Dhareshwar and Tejaswini Niranjana, "Kaadalan and the Politics of Re-Signification: Fashion, Violence and the Body," *Journal of Arts and Ideas*, no. 29 (1996): 5, http://dsal.uchicago.edu/books/artsandideas/toc.html?issue=29 (accessed June 6, 2009).

4. Ibid. As Tejaswini Niranjana and Vivek Dhareshwar point out in their discussion of Tamil song-and-dance sequence "Mukkala Muqabla" starring South Indian dancer/choreographer Prabhudeva, the "competition of television and MTV as well as the market opened up by them" have intensified the narrative "autonomy" of song-and-dance sequences in relation to the rest of the film.

5. Wimal Dissanayake and Anthony Guneratne, *Rethinking Third Cinema* (London: Routledge, 2003), 207–209. The stunning impact of the low budget Hindu mythological film *Jai Santoshi Ma* (1975), and its successful deployment of storytelling through the film, is a clear example of the potential popular appeal of Hindi films. Similarly, *Lagaan* (2001), a film in which the metaphor of cricket was deployed to comment on India's struggle against British colonial rule, becomes a compelling example of how a story told within the conventions of Bollywood cinema, having a distinctly social message that manages to appeal to international audiences.

6. Ravi Vasudevan, "Bombay and Its Public," *Journal of Arts and Ideas* 29 (1996): 44–56.

7. Lalitha Gopalan, *Cinema of Interruptions: Action Genres in Contemporary Indian Cinema* (London: BFI Publishing, 2002), 17.

8. Madhava Prasad, *Ideology of the Hindi Film: A Historical Construction* (New Delhi: Oxford University Press, 1998), 88–115.

9. Ibid., 73.
10. Anna Morcom, *Hindi Film Songs and the Cinema* (Hampshire: Ashgate, 2007), 59.
11. Asha Kasbekar, "Hidden Pleasures: Negotiating the Myth of the Female Ideal in Popular Hindi Cinema," in *Pleasure and the Nation*, ed. Rachel Dwyer and Christopher Pinney (Oxford: Oxford University Press, 2001), 298.
12. Sumita Chakravarty, *National Identity in Indian Popular Cinema 1947–1987.* (Austin: University of Texas Press, 1993), 269.
13. Ashis Nandy focused on cinema as an entry into studying popular culture. Lalitha Gopalan and Madhava Prasad addressed the cultural politics of Indian cinema. Scholars like Ashish Rajadhyaksha and Gita Kapur provided us with in-depth explorations of Hindi cinema and modernity. Allessio and Langer suggest that Hindi film narratives subvert Hollywood conventions. Recent ethnographic and other research postulate that the way audiences see Hindi films are in fact crucial to their definition. Ashis Nandy, "Introduction: Indian Popular Cinema as a Slum's Eye View of Politics," in *Secret Politics of Our Desires: Innocence, Culpability, and Indian Popular Cinema*, ed. Ashis Nandy (New Delhi: Oxford University Press, 1998), 2; Lalitha Gopalan, *Cinema of Interruptions*, 17; Madhava Prasad, *Ideology of the Hindi Film: A Historical Construction* (New Delhi: Oxford University Press, 1998), 88–115; Dissanayake and Anthony Guneratne, *Rethinking Third Cinema*, 212; Dominic Alessio and Jessica Langer, "Nationalism and Postcolonialism in Indian Science Fiction: Bollywood's Koi Mil Gaya (2003)," *New Cinemas: Journal of Contemporary Film* 5, no. 3 (2007): 217–229, Aswin Punathambekar, "Bollywood in the Indian–American Diaspora: Mediating a Transitive Logic of Cultural Citizenship," *International Journal of Cultural Studies* 8, no. 151 (2005): 151–173; Sara Dickey, "Consuming Utopia: Film Watching in Tamil Nadu," in *Consuming Modernity: Public Culture in a South Asian World*, ed. Carol A. Breckenridge (Minneapolis: University of Minnesota Press, 1995): 131–56; Brian Larkin, "Itineraries of Indian Cinema: African Videos, Bollywood, and Global Media," in *Multiculturalism, Postcoloniality and Transnational Media*, eds Ella Shohat and Robert Stam (New Brunswick: Rutgers University Press, 2003), 173; Laksmi Srinivas, "The Active Audience: Spectatorship, Social Relations and the Experience of Cinema in India," *Media, Culture & Society* no. 24 (2002): 155–73.

14. V.A.K. Ranga Rao, "Dance in Indian Cinema," 302; Arundhati Subramaniam, "Dance in Films," in *New Directions in Indian Dance*, ed. Sunil Kothari (New Delhi: Marg Publications, 2003), 132–145; Ajay Gehlawat, "The Bollywood Song-and-dance, or Making a Culinary Theatre from Dung-Cakes and Dust," *Quarterly Review of Film and Video* 23, no. 4 (2006): 331–340; Ann R. David, "Beyond the Silver Screen: Bollywood and *Filmi* Dance in the UK," *South Asia Research* 27, no. 1 (2007): 5–24; Kai-Ti Kao and Rebecca-Anne Do Rozario, "Imagined Spaces: The Implications of Song-and-dance for Bollywood's Diasporic Communities," *Continuum: Journal of Media & Cultural Studies* 22, no. 3 (2008): 313–326; Anna Morcom, "Bollywood, Tibet, and the Spatial and Temporal Dimensions of Global Modernity," *Studies in South Asian Film and Media* 1, no. 1 (2009): 145–172.

15. Ashis Nandy, "Introduction Indian Popular Cinema as a Slum's Eye View of Politics," in *The Secret Politics of Our Desires Innocence Culpability and Indian Popular Cinema*, ed. Ashis Nandy (New Delhi: Oxford University Press, 1998), 2–6.

16. The literature on these forms is voluminous. See: Norvin Hein, "The Ram Lila," *The Journal of American Folklore* 71, no. 281 (1958): 279–304; K.R. Sawant, *Tamasha: A Unique Folk-Theatre of Maharashtra* (Delhi: Natya Shikshan Kendra, 1983), 25; Somnath Gupt, *The Parsi Theatre: Its Origins and Development*, trans. Kathryn Hansen (New Delhi: Seagull Books, 2005), 191. Here I reference Norvin Hein's ethnographic study of the Ram Lila from 1958 and K.R. Sawant's study of the Tamasha. Somnath Gupt's *The Parsi Theater: Its Origins and Development* traces the end of the Parsi theater era to the arrival of "talkies" and argues that "films like Alam Ara and Khun-e-Nahaq were taken directly from the Parsi stage."

17. Eric Barnouw and S. Krishnaswami, *Indian Film* (New York: Columbia University Press, 1963), 71.

18. Rao, "Dance in Indian Cinema," 303–305.

19. Ibid.

20. Arjun Appadurai and Carol A. Breckenridge, "Public Modernity in India," in *Consuming Public Modernity: Public Culture in a South Asian World*, ed. Carol A. Breckenridge (Minneapolis: University of Minnesota Press, 1995), 1–22.

21. Nasreen Munni Kabir, "Why Make Song & Dance: What Defines Indian Cinema and How Is It Different to World Cinema?," Lecture at *Frame by Frame: A Symposium on the Dance of Indian Cinema & Its*

Transition into Bollywood Dancing, Linsbury Studio Theatre, Royal Opera House (London, July 12, 2009).

22. Farah Khan. Interview by author. Notes. London, May 2003.

23. Firoze Rangoonwalla, Ashish Rajadhyaksha, Paul Willemen, Anna Morcom, Gregory Booth, Biswarup Sen, and Alison Arnold among others.

24. Alison Arnold, "Hindi Film Git: On the History of Commercial Indian Popular Music" (PhD diss., University of Illinois at Urbana-Champaign, 1991), 232.

25. Ganesh Anantharaman, *Bollywood Melodies: A History of the Hindi Film Song* (New Delhi: Penguin Books, 2008), 1–25; Ashok Da Ranade, *Hindi Film Song: Music Beyond Boundaries* (New Delhi: Promilla & Co. Publishers, 2006), 11–26.

26. Biswarup Sen, "The Sounds of Modernity: The Evolution of Bollywood Film Song" in *Global Bollywood: Travels of Hindi Song and Dance,* ed. Sangita Gopal and Sujata Moorti (Minneapolis: University of Minnesota Press, 2008), 93.

27. Anantharaman, *Bollywood Melodies*, 1.

28. Arnold, "Hindi Film Git", 59–61.

29. Gregory D. Booth, "Musicking the Other: Orientalism in the Hindi Cinema," in *Music and Orientalism in the British Empire, 1780s–1940s,* ed. Martin Clayton and Bennett Zon (Burlington: Ashgate Publishing Company, 2007), 330.

30. Booth, "Musicking the Other," 321.

31. Morcom, *Hindi Film Songs*, 55.

32. Sen, "The Sounds of Modernity," 92.

33. Morcom, *Hindi Film Songs*, 138.

34. Sen, "The Sounds of Modernity," 95.

35. Ibid., 97–98.

36. Morcom, *Hindi Film Songs*, 56.

37. Sen, "The Sounds of Modernity," 99.

38. Morcom, *Hindi Film Songs*, 181.

39. Ibid., 186.

40. Ibid., 39.

41. Ibid., 37.

42. Ibid., 40–41.

43. Rekha Prakash (choreographer), in discussion with the author, May 2008.

44. Jenkins' theorization of textual poachers builds on Michel de Certeau's assertion of consumption as an active rather than a passive process.

Henry Jenkins, *Textual Poachers*, 46. Michel de Certeau, *The Practice of Everyday Life* (Berkeley: University of California Press, 1984), 29–41.

45. Anne-Marie Gaston, "Devadasis and Geishas," in *Attendance: The Dance Annual of India 2003–04*, ed. Shanta Serbjeet (New Delhi: Ekah-Printways, 2004), 31–32; Pallabi Chakravorty, "Choreographing Modernity: Kathak Dance, Public Culture and Women's Identity in India" (PhD dissertation, Temple University, 1999), 125.

46. Purnima Shah, "National Dance Festivals in India: Public Culture, Social Memory and Identity" (PhD dissertation, University of Wisconsin-Madison, 2000), 178.

47. Avanthi Meduri, "Bharat Natyam—What Are You?" in *Moving History/Dancing Cultures*, ed. Ann Cooper Albright and Ann Dils (Middletown: Wesleyan University Press, 2001), 109.

48. Joan Erdman's work has focused on making visible "the impact of western ideas of oriental dance on the history of Indian dance" by tracing "the choronological development from dances thematically "Indian" or "Hindu" (Mata Hari, Ruth St. Denis, Pavlova) to dances argued to be "authentically Indian." Priya Srinivasan's recent work demonstrates how these early modern dancers in the West benefited from their interactions with the other through Indian dance. Joan L. Erdman, "Dance Discourses: Rethinking History of the 'Oriental Dance'," in *Moving Words: Re-Writing Dance*, ed. Gay Morris (New York: Routledge, 1996), 290–293; Priya Srinivasan, "Renegotiating South Asian and American National Culture through Bharat Natyam Performance Practice," (paper presented at Dance in South Asia New Approaches, Politics and Aesthetics Symposium, March 2–3 (Pennsylvania: Swarthmore College, 2002), 32.

49. Erdman, "Dance Discourses," 299.

50. Meduri, "Bharat Natyam," 109.

51. Uttara Asha Coorlawala, "Classical and Contemporary Indian Dance: Overview Criteria and Choreographic Analysis" (PhD dissertation, New York University, 1994), 74.

52. Sandra Chatterjee, "Undomesticated Bodies: South Asian Women Perform the Impossible" (PhD dissertation, University of California, Los Angeles, 2006), 38.

53. Ibid.

54. Coorlawala, "Classical and Contemporary Indian Dance," 35. As Coorlawala elaborated: "M.N. Srinivas described Sanskritization as a deliberate self-conscious return to ancient Vedic and Brahmanical

values and customs (often but not necessarily in response to 'western-ization') which usually confers status."

55. Davesh Soneji, "Living History, Performing Memory: Devadasi Women in Telugu-speaking South India," *Dance Research Journal* 36, no. 2 (2004): 32.

56. Vijay Mishra, *Bollywood Cinema: Temples of Desire* (New York: Routledge), 55.

57. Sangita Shresthova, "Swaying to an Indian Beat, Dola Goes My Diasporic Heart: Exploring Hindi Film Dance," *Dance Research Journal* 36, no. 2 (2004): 91–101.

58. Sangita Shresthova, "Dancing to an Indian Beat: "Dola" Goes My Diasporic Heart," in *Global Bollywood: Travels of Hindi Song and Dance*, eds Sangita Gopal and Sujata Moorti (Minneapolis: University of Minnesota Press, 2010), 250.

59. While women admittedly dominated in Hindi film dance, it is impor-tant to note that norms of acceptability for men's dances, though sub-ject to a different logic, underwent a similar shift from Raj Kapoors "Awara Hoon" (I am a Tramp) playfulness to the virtuosic (arguably objectifying) emergence of Hrithik Roshan as a dance icon of the new millennium in *Kaho Na Pyar Hai?* (2000).

60. Shiamak Davar. Interview by author. Notes. Mumbai, India. Septem-ber 5, 2007.

61. Vinay Lal, "The Near Impossibility of the Outsider, or the Signifi-cant Other in the Modern Hindi Film," in *Of Cricket, Guinness and Gandhi* (Calcutta: Seagull Books: 2003), 14–27.

62. Rao, "Dance in Indian Cinema," 302.

63. Nasreen Munni Kabir, *Bollywood: The Indian Cinema Story* (London: Channel Four Books, 2001), 56.

64. Kasbekar, "Hidden Pleasures," 298.

65. The dances in *Pakeezah* were created by Gauri Shankar, with one dance from Lacchu Maharaj.

66. Female SDIPA Dancer. Interview by author. Audio Recording. Mum-bai, India. September 4, 2007.

67. Susan Leigh Foster, "Dancing Bodies," in *Meaning in Motion, New Cultural Studies of Dance*, ed. Jane C. Desmond (Durham: Duke University Press, 1997), 235–253. The organization of my approach to the bodies of Bollywood dancers in Bombay borrows from Susan Foster's approach to studying bodies. In particular, her categoriza-tions of "perceived," "ideal," "hired," and "video" bodies are par-ticularly useful to my investigation. Foster's "perceived" body relates to dancers' sensory experiences. The "ideal body" reflects what the

dancer wants to become. The "hired body" describes the versatile body, trained in various dance styles, currently in demand in the contemporary dance scene in the United States. Finally the "video dancing body" describes a staged dance captured by film for future reference.

68. Jane C. Desmond, "Embodying Difference: Issues in Dance and Cultural Studies," in *Meaning in Motion: New Cultural Studies of Dance*, ed. Jane C. Desmond (Durham: Duke University Press, 1997), 29–31.

69. James H. Mills and Satadru Sen, "Introduction," in *Confronting the Body: The Politics of Physicality in Colonial and Post-Colonial India*, ed. James H. Mills and Satadru Sen (London: Anthem Press, 2004), 1.

70. Mills and Sen, "Introduction," 2.

71. Mills and Sen, "Introduction," 10.

72. Uttara Asha Coorlawala, "Classical and Contemporary Indian Dance: Overview Criteria and Choreographic Analysis" (PhD dissertation, New York University, 1994), 74–78.

Chapter 3

1. I use Bombay in this chapter as most respondents use this term during my research at SDIPA and on the film sets.

2. Throughout the chapter, I maintain the anonymity of the dancers and students through the use of first-name pseudonyms. I use surnames only when speaking about an interview respondent who explicitly requested that their identity be revealed. These descriptions are based in my research notes from 2006–2008.

3. Sanjana. Interview by author. Audio recording. Mumbai, India. September 12, 2007.

4. Rajesh. Interview by author. Notes. Mumbai, India. March 12, 2008.

5. Prema. Interview by author. Audio recording. Mumbai, India, September 6, 2007.

6. Sunita. Interview by author. Audio recording. Mumbai, India. September 2, 2007.

7. Chandrika. Interview by author. Audio recording. Mumbai, India. September 7, 2007.

8. Ibid.

9. Deepak. Interview by Author. Notes. Mumbai, India. September 7, 2007.

10. Mahesh. Interview by author. Audio recording. Mumbai, India. September 10, 2007.

11. Arvind. Interview by author. Audio recording. Mumbai, India. September 8, 2007.

12. Vinay. Interview by author. Audio recording. Mumbai, India. September 8, 2007.

13. Walter Benjamin, *Illuminations*, trans. Harry Zohn (New York: Schocken Books, 1969), 217–252.

14. Alice Thorner, "Bombay, Diversity and Change," in *Bombay, Mosaic of a Modern Culture*, ed. Sujata Patel and Alice Thorner (New Delhi: Oxford University Press, 1995), xiv.

15. Ranjit Hoskote, "Versions of a Postcolonial Metropolis: Competing Discourses on Bombay's Image," in *The Making of Global City Regions, Johannesburg, Mumbai/Bombay, São Paulo, and Shanghai*, ed. Klaus Segbers (Baltimore: Johns Hopkins University Press, 2007), 258.

16. Jyotsna Kapur and Manjunath Pendakur, "The Strange Disappearance of Bombay from Its Own Cinema: A Case of Imperializm or Globalization?" *Democratic Communiqué* 21, no. 1 (2007): 45.

17. Rashmi Varma, "Provincializing the Global City: From Bombay to Mumbai," *Social Text* 22, no. 4 (2004): 67.

18. Saskia Sassen, *Globalization and Its Discontents* (New York: New York Press, 1998), 1–13; Varma, "Provincializing the Global City," 74–75. Rashmi Varma points out, "...transnational capital also had another side—it unleashed the forces of the underworld in virtually all spheres of the city's life—encompassing business (film production, real estate, gold smuggling), administration, and politics, establishing a shadowy counterpoint to the supposedly above-ground entry of global capital."

19. Aparna Vedula, "Blueprint and Reality: Navi Mumbai, and the City of the 21st Century," *Habitat International* 31 (2007): 16; Ranjani Mazumdar, "Figure of the 'Tapori': Language, Gesture and Cinematic City," *The Economic and Political Weekly*, December 29 (2001): 4875.

20. Mark-Anthony Falzon, "'Bombay, Our Cultural Heart': Rethinking the Relation between Homeland and Diaspora," *Ethnic and Racial Studies* 26, no. 4 (2003): 671.

21. Varma, "Provincializing the Global City," 66.

22. Parmesh Shahani, *Gay Bombay: Globalization, Love and (Be)Longing in Contemporary India* (New Delhi: SAGE Publications, 2008), 30. Hoskote accounts for the shift in Mumbai name as follows: "*Mumbai* became formally reinforced as the symbol of a parochialist ideology,

while *Bombay* came to signalize the cosmopolitan resistance to such an ideology." Hoskote, "Versions of a Postcolonial Metropolis," 259.

23. Varma, "Provincializing the Global City," 78–79.

24. Kapur and Pendakur, "The Strange Disappearance of Bombay," 47.

25. Shernaaz Engineer, "Shiamak, Non-Stop!" in *Upper Crust*, 2008, http//:www.sdipa.com/forms_htm/images/shiamaknonstop.pdf (accessed May 2, 2008).

26. Shiamak Davar. Interview by author. Audio recording. Mumbai, India. September 15, 2007.

27. In my discussion of studio jazz dance here, I distinguish it from "jazz" itself, which does not have Orientalist roots, nor does Orientalism encompass appropriations from African–American culture. For a more detailed discussion of Orientalism please see Chapter Five.

28. Andrienne L. McLean, "The Thousand Ways There Are to Move: Camp and Oriental Dance in the Hollywood Musicals of Jack Cole," in *Visions of the East: Orientalism in Film*, ed. Matthew Bernstein and Gaylin Studlar (New Brunswick: Rutgers University Press, 1997), 130; Constance Valis Hill, "Jazz Modernism," in *Moving Words: Re-Writing Dance*, ed. Gay Morris (New York: Routledge, 1996), 239.

29. Hill, "Jazz Modernism," 239.

30. McLean, "The Thousand Ways There Are to Move," 130.

31. Drid Williams. "In the Shadow of Hollywood Orientalism: Authentic East-Indian Dancing," *Journal for the Anthropological Study of Human Movement*, 2003, http://findarticles.com/p/articles/mi_qa4093/is_200304/ai_n9183928 (accessed April 15, 2008); Glenn Loney, *Unsung Genius: The Passion of Dancer-Choreographer Jack Cole* (New York: Franklin Watts, 1984).

32. Shiamak Davar. Interview by author. Audio recording. Mumbai, India. September 15, 2007.

33. Arvind. Interview by author. Audio recording. Mumbai, India. September 8, 2007.

34. Sangeeta Datta, "Globalisation and Representations of Women in Indian Cinema," *Social Scientist* 28, no. 3/4 (2000): 76.

35. Ibid.

36. Manoj. Interview by author. Audio recording. Mumbai, India. September 12, 2007.

37. Rohit. Interview by author. Audio recording. Mumbai, India. September 7, 2007.

38. Ibid.

39. Meenakshi Gigi Durham, "Sex in the Transnational City: Discourses of Gender, Body, and Nation in the 'New Bollywood,'" in *Cinema,*

Law and the State in Asia, ed. Corey K. Creekmur and Mark Sidel (New York: Palgrave Macmillan, 2007), 47.

40. Shakuntala Rao, "The Globalization of Bollywood: An Ethnography of Non-Elite Audiences in India," *The Communication Review* 10, no. 1 (2007): 60.

41. Ibid.: 60.

42. Ibid.

43. Ibid. In his travelogue-style account of the commercial Hindi film industry in Bombay, Pankaj Mishra reaches a similar conclusion regarding contemporary Hindi film production and distribution. Mishra observes, "But as I quickly learned in Bombay, the small-town audiences with their cut-price tickets ... don't matter as much as they used to." Pankaj Mishra. *Temptations of the West: How to Be Modern in India, Pakistan and Beyond* (London: Picador, 2006), 175.

44. Staff Reporter, "The Trailblazer," *Time Magazine*, October 20, 2003, www.time.com/time/asia/covers/501031027/int_varma.html (accessed April 10, 2008).

45. Mishra, *Temptations of the West*, 152–160.

46. The history of Hindi film dance is described in more detail in Chapter 2.

47. Pallabi Chakravorty, "The Limits of Orientalism: Classical Indian Dance and the Discourse of Heritage," in *Reorienting Orientalism*, ed. Chandreyee Niyogi (New Delhi: SAGE Publications, 2006), 91.

48. Ibid.

49. Avanthi Meduri, "Bharatha Natyam—What Are You?" in *Moving History/Dancing Cultures: A Dance History Reader*, ed. Ann Dils and Ann Cooper Albright (Middletown: Wesleyan University Press, 2001), 109.

50. Coorlawala, "Classical and Contemporary Indian Dance," 35.

51. Meduri, "Bharatha Natyam—What Are You," 107.

52. Feroz Khan, choreographer. Interview by author. Notes. Mumbai, India. March 24, 2008.

53. Meredith Monk, Interviewed in Brenda Dixon Gottschild, *The Black Dancing Body, A Geography from Coon to Cool* (New York: Palgrave Macmillan, 2003), 131–148. Beyond India's borders, the values associated with *Dil To Pagal Hai* may also resonate with ballet as high art. Postmodern dancer and choreographer Meredith Monk notes that ballet's focus is on the visual geometry reflects a deep-rooted concern with shape and image. Strikingly, the descriptions associated with ballet are quite similar to the adjectives used to describe Shiamak

Davar's movement aesthetics. Following this line of reasoning further, Dixon Gottschild's account of the Eurocentric, and admittedly Orientalist, views of the non-white dancing body as "vulgar" and "lewd" echo some SDIPA dancers expressed about the pre-*Dil To Pagal Hai* era of Hindi film dance as "unrefined."

54. Radhika. Interview by author. Notes. Mumbai, India. September 2007.

55. The concerns voiced by female film dancers in Bombay are similar to those expressed by the special drama actresses of Tamil Nadu studied by Susan Seizer. Susan Seizer, "Offstage with Special Drama Actresses in Tamil Nadu, South India: Roadwork," in *Everyday Life in South Asia*, ed. Diane P. Mines and Sarah Lamb (Bloomington: Indiana University Press, 2002), 120.

56. Radhika. Interview by author. Notes. Mumbai, India. March 6, 2008.

57. Shabina. Interview by author. Notes. Mumbai, India. March 12, 2008.

58. Shamira. Interview by author. Audio recording. Mumbai, India. September 19, 2007.

59. Anonymous Choreography Manager. Interview by author. Notes. Mumbai, India. September 5, 2007.

60. The audition description is based in my research notes.

61. Shoma Munshi, "A Perfect 10 'Modern *and* Indian': Representations of The Body in Beauty Pageants and the Visual Media in Contemporary India," in *Confronting the Body: The Politics of Physicality in Colonial and Post-Colonial India*, ed. James H. Mills and Satadru Sen (London: Anthem Press, 2004), 167.

62. Ibid.

63. Kim Barker, "India Battles the Bulge," *Chicago Tribune*, Chicago, February 6, 2006.

64. P.V. Vaidyanathan, "Children Need More Exercise," *Times of India* (March 14, 2008): 6.

65. Rachel Dwyer, *All You Want Is Money, All You Need Is Love* (London: Cassell, 2000), 88.

66. Ibid.

67. These quotes are excerpted from my interviews with SDIPA students.

68. Suparna Bhaskaran, *Made in India: Decolonizations, Queer Sexualities, Trans/National Projects* (New York: Palgrave Macmillan, 2004), 39.

69. Ibid., 9.

70. Madhu Kishwar, "When India 'Missed' the Universe," *Manushi* 88 (1995): 9.

71. Ibid., 9.
72. Ibid.
73. Ibid., 11.
74. Vanita Reddy, "The Nationalization of the Global Indian Woman," *South Asian Popular Culture* 4, no. 1 (2006): 63.
75. Ibid., 61.
76. Akram. Interview by author. Audio recording. September 2007. Mumbai, India.
77. Sanjay Srivastava, "The Masculinity of Dis-Location: Commodities, the Metropolis, and the Sex Clinics of Delhi and Mumbai," in *South Asian Masculinities: Context of Change, Sites of Continuity*, ed. Radhika Chopra, Caroline Osella and Filippo Osella (New Delhi: Kali for Women, 2004), 199.
78. Sudhanva Deshpande, "The Consumable Hero of Globalised India," in *Bollyworld, Popular Indian Cinema through a Transnational Lens*, ed. Raminder Kaur and Ajay J. Sinha (New Delhi: SAGE Publications, 2005), 187.
79. Ibid.
80. Jigna Desai, "Bombay Girls and Boys: The Gender and Sexual Politics of Transnationality in the New Indian Cinema in English," *South Asian Popular Culture* 1, no. 1 (2003): 47.
81. Dwyer, *All You Want Is Money*, 79.
82. Vinay. Interview by author. Notes. Mumbai, India. March 6, 2008.
83. Sanjana. Interview by author. Audio recording. Mumbai, India. September 12, 2007.
84. Manager of Bosco and Caesar. Discussion with author. Notes. Mumbai, India. September 18, 2007.
85. Nadya. Interview by author. Audio recording. Mumbai, India. September 20, 2007.
86. Ibid.
87. Feroz Khan. Interview by author. Audio recording. Mumbai, India, March 12, 2008.
88. Geetanjali Gangoli, "Sexuality, Sensuality, and Belonging: Representations of the 'Anglo-Indian' and the 'Western' Woman in Hindi Cinema," in *Bollyworld, Popular Indian Cinema through a Transnational Lens*, ed. Raminder Kaur and Ajay J. Sinha (New Delhi: SAGE Publications, 2005), 146.
89. Sanjay Srivastava, "The Masculinity of Dis-Location: Commodities, the Metropolis, and the Sex Clinics of Delhi and Mumbai," in *South Asian Masculinities: Context of Change, Sites of Continuity*, ed.

Radhika Chopra, Caroline Osella, and Filippo Osella (New Delhi: Kali for Women, 2004), 188.

90. Jerry Pinto, *Helen: The Life and Times of the H-Bomb* (New Delhi: Penguin, 2006), 46–47. Who introduced Cuckoo is a matter of debate.

91. Dorothee Wenner. *Fearless Nadia: The True Story of Bollywood's Original Stunt Queen* (London: Penguin, 2005), 153.

92. Ibid., 154.

93. Ibid.

94. Pinto, *Helen,* 208.

95. Gangoli, "Sexuality, Sensuality, and Belonging," 145.

96. Ibid., 144.

97. Nadya. Interview by author. Audio recording. Mumbai, India. September 20, 2007.

98. Sarah. Interview by author. Audio recording. Mumbai, India. September 2007.

99. Kaushi. Interview by author. Audio recording. Mumbai, India. March 2008.

100. Anonymous Insider. Interview by author. Audio recording. Mumbai, India. September 2007.

101. Ibid.

102. D. Srisha, "Fairness Wars," (Hyderabad: ICFAI Center for Management Research, 2001), 7; S. Ninan, "Seeing Red with This Pitch," *The Hindu* (March 16, 2006), 8.

103. Coorlawala, "Classical and Contemporary Indian Dance," 81.

104. Kavitha Cardoza and Radhika Parameswaran, "Fairness/Lightness/Whiteness in Advertising: The Mobility of Beauty in Globalizing India" (Presentation, International Communication Association, San Francisco, California, May 23, 2007) http://www.allacademic.com/meta/p169882_index.html (accessed August 15, 2010).

105. Kishwar, "When India 'Missed' the Universe," 16.

106. In one TV advertisement, a young actress despairs that she has just performed for an audience of ten. To fill her theater, she decides to become a film heroine. Fair and Lovely allows her to achieve her goals as fairness of skin is suggested to be a key requirement of her transformation into a film star.

107. Ashwini Deshpande, "Assets Versus Autonomy? The Changing Face of the Gender–Caste Overlap in India," *Feminist Economics* 8, no. 2 (2002): 23.

108. Ibid.

109. Fanon, Frantz. *Black Skin, White Masks* (New York: Grove Press, 1967), 46.
110. Ibid., 63.
111. Gangoli, "Sexuality, Sensuality, and Belonging," 150.
112. Nadya. Interview by author. Audio recording. Mumbai, India. September 20, 2007.

Chapter 4

An earlier version of this chapter appeared in, Sangita Shresthova, "Under India's Big Umbrella? Bollywood Dance in Nepal," *South Asian Popular Culture* 8, no. 3 (October 2010): 309–323. Reprinted by permission of the publisher (Taylor & Francis Ltd, http://www.tandf.co.uk/journals).

1. Throughout the chapter, I maintain the anonymity of the dancers and students through the use of first-name pseudonyms. I use surnames only when speaking about an interview respondent who explicitly requested that their identity be revealed.
2. This description is based on my research notes from 2005–2007.
3. Bhangra, a dance form, traces its roots to the region of Punjab located in today's India and Pakistan.
4. In this chapter, I apply the terminology used by my respondents and deploy the term *filmi* as a colloquial term used to describe dancers who are directly involved in or otherwise inspired by Hindi and other cinema.
5. Michael Hutt, "Introduction: Monarchy, Democracy and Maoism in Nepal," in *Himalayan People's War: Nepal's Maoist Rebellion*, ed. Michael Hutt (Indianapolis: Indiana University Press, 2004), 3–4.
6. Implemented by King Mahendra, the Panchayat System was a controlled "partyless" system, which limited political freedoms and subjected all major decisions to royal approval.
7. Michael Hutt, "Drafting the 1990 Constitution," in *Nepal in the Nineties: Versions of the Past, Visions of the Future*, ed. Michael Hutt (New Delhi: Oxford University Press 1994), 28–47.
8. John J. Metz, "Development in Nepal," *GeoJournal* 35, no. 2 (1995): 175–184.
9. Mark Liechty, *Suitably Modern: Making Middle-class Culture in a New Consumer Society* (Princeton: Princeton University Press, 2003), 47–48.

10. Basanta Shrestha. Interview by author. Video recording. Kathmandu, Nepal. July 15, 2005.
11. Liechty, *Suitably Modern*, 47–48.
12. Ibid., 67.
13. Ibid., 106.
14. Basanta Shrestha. Interview by author. Video recording. Kathmandu, Nepal. July 15, 2005.
15. Ibid.
16. Robert T. Anderson, and Edna M. Mitchell, "The Politics of Music in Nepal," *Anthropological Quarterly* 51, no. 4 (1978): 247–59.
17. Nabin Subba. Interview by author. Video recording. Kathmandu, Nepal. July 20, 2005.
18. Navin Singh Khadka, "Cable Wars: The Ratings Game," *Nepali Times*, November 28, 2003, 4–5.
19. Gustavo Esteva, "Development," in *The Development Dictionary*, ed. Wolfgang Sachs (Johannesburg: Witwatersrand University Press 1992), 7–8. Gustavo Esteva traces the origins of postcolonial development initiatives to the post-World War II era when "development" became synonymous with "escape from the undignified condition called underdevelopment" as it claimed the "centre of an incredibly powerful semantic constellation."
20. José Mariá Sbert, "Progress," in *The Development Dictionary: A Guide to Knowledge as Power*, ed. Wolfgang Sachs (Witerwatersrand University Press: Johannesburg 1992), 192. José María Sbert links developmental notions of progress to "the rise of the modern world."
21. Pushkar Bajracharya, "Development in Nepal: Issues, Challenges, and Strategies," in *Nepal: Myths and Realities*, ed. Ram Pratap Thapa and Joachim Baaden (New Delhi: Book Faith India, 2000), 158–163.
22. Badri Prasad Bhattarai, "Foreign Aid and Growth in Nepal: An Empirical Analysis," *Journal of Developing Areas* 42, no. 2, (2007): 283–302.
23. Wolfgang Sachs, ed., *Development Dictionary: A Guide to Knowledge as Power* (Johannesburg: Witwatersrand University Press, 1993), especially Arturo Escobar on "Planning" (132–43), Gustavo Esteva on "Development" (6–25), Wolfgang Sachs on "Environment" (26–37), and Vandana Shiva on "Resources" (206–18).
24. Peter Bunyard, "Tehri: A Catastrophic Dam in the Himalayas," in *The Post-Development Reader*, ed. Victoria Bowtree and Majid Rahnema (London: Zed Books, 1997), 256–62; James Ferguson, "Development

and Bureaucratic Power in Lesotho," in *The Post-Development Reader*, ed. Victoria Bowtree and Majid Rahnema (London: Zed Books, 1997), 223–233.

25. Dor Bahadur Bista, *Fatalism and Development Nepal's Struggle for Modernization* (Calcutta: Orient Longman, 1994), 3–54.

26. Nabin Subba. Interview by author. Video recording. Kathmandu, Nepal. July 20, 2005.

27. Masamine Jimba, Anand B. Joshi, Junko Okumura, Krishna C. Poudel, and Susumu Wakai, "Migrants' Risky Sexual Behaviours in India and at Home in Far Western Nepal," *Tropical Medicine and International Health* 9, no. 8 (2004): 900.

28. Shakuntala Rao, "The Globalization of Bollywood: An Ethnography of Non-Elite Audiences in India," *The Communication Review* 10, no. 1 (2007): 60. She notes:

> Other trendsetting Bollywood blockbusters include *Black* (2004), *Dhoom* (2004), *Dus* (2005), *Hum Tum* (2004), *Kabhi Kushi Kabhi Gum* (2001), *Kaho Na Pyar Hai* (2000), *Kal Ho Naa Ho* (2003), *Mohabbatein* (2000), *Murder* (2003), *Salaam Namaste* (2005), and *Yaadein* (2001).

29. Soo Yee Ho, "Is Bollywood an Imitation of Hollywood: An Essay on Western Media Influence on the Indian Movie Industry," *Film International* 11, no. 5 (2004): 40.

30. Seema. Interview by author. Video Recording. Kathmandu, Nepal. July 21, 2005.

31. Mahajan. Interview by author Research Notes. Kathmandu, Nepal. July 25, 2005.

32. Dev. Interview by author. Notes. Kathmandu, Nepal. June 24, 2007.

33. Wimal Dissanayake and K. Moti Gokulsing, *Indian Popular Cinema* (Stoke on Trent: Trentham Books, 2004), 55–76.

34. Sunil Thapa. Interview by author. Audio recording. Kathmandu, Nepal. July 10, 2005.

35. Nabin Subba. Interview by author. Video recording. Kathmandu, Nepal. July 20, 2005.

36. Viplob Pratik, "The Filmdom of Nepal," *Nepali Times*, November 28, 2003, 8–9.

37. Ibid.

38. Nabin Subba. Interview by author. Video recording. Kathmandu, Nepal. July 20, 2005.

39. Piers Blaikie, John Cameron, and David Seddon. *Nepal in Crisis: Growth and Stagnation at the Periphery* (Oxford: Clarendon Press, 1980), 63; L.F. Stiller, *The Silent Cry* (Kathmandu: Sahayogi

Prakashan, 1976), 5–89; Asad Husain, *British India's Relations with the Kingdom of Nepal 1857–1947* (London: George Allen and Unwin Ltd, 1970), 7.

40. Surya P. Subedi, *Dynamics of Foreign Policy and Law: A Study of Indo-Nepali Relations* (New Delhi: Oxford University Press, 2005), 105.

41. Hari Roka, "The Emergency and Nepal's Political Future," in *Himalayan People's War Nepal's Maoist Rebellion*, ed. Michael Hutt (Indiana University Press: Indianapolis, 2004), 243.

42. Alan Macfarlane, "Fatalism and Development in Nepal," in *Nepal in the Nineties: Versions of the Past, Visions of the Future*, ed. Michael Hutt (Delhi: Oxford University Press, 1994), 114.

43. Bista, *Fatalism and Development*, 8.

44. Linnet Pike, "Innocence, Danger and Desire: Representations of Sex Workers in Nepal," *Re/productions* 2, Spring (1999).

45. Michele R. Decker, Jay G. Silverman, Jhumka Gupta, Ayonija Maheshwari, Brian M. Willis, and Anita Raj. "HIV Prevalence and Predictors of Infection in Sex-trafficked Nepalese Girls and Women," *Journal of the American Medical Association* 298, no. 5 (2007): 536. The statistics resulted from a research project in which returning sex workers were interviewed and tested as they crossed the Indo-Nepali border.

46. Pike, "Innocence, Danger and Desire."

47. Sushma Joshi, "'Cheli Beti' Discourses of Trafficking and Constructions of Gender, Citizenship and Nation in Modern Nepal," *South Asia: Journal of South Asian Studies* 24, no. 1 (2001): 157.

48. Ibid.: 161.

49. Ibid.: 162.

50. Ibid.: 161.

51. Ibid.: 167.

52. Ibid.: 167–168.

53. Ibid.

54. Population Council, "Trafficking and Human Rights in Nepal: Community Perceptions and Policy and Program Responses, Research Summary" (Kathmandu: Population Council, 2001): 1–2.

55. Anju Chettri and Manju Thapa, "Writing against Trafficking" (Kathmandu: ASHMITA, 2006), 18–19.

56. Reproductive Health NGO Employee. Interview by author. Notes. Kathmandu, Nepal. June 19, 2007.

57. STEP Field-Staff. Interview by author. Notes. Kathmandu, Nepal. June 30, 2007.

58. Joshi, "'Cheli Beti' Discourses of Trafficking," 167–168.

59. Gazmir Satyajit. Interview by author. Mumbai, India. August 10, 2005.

60. Hutt, *Himalayan People's War*, 285.

61. Liechty, *Suitably Modern*, 158.

62. Nabin Subba. Interview by author. Video recording. Kathmandu, Nepal. July 20, 2005.

63. Staff Reporter, "Riots Break out over Actor's Remarks," *Kathmandu Post*, December 27, 2000, 1. The newspaper article states, "...the Nepal Motion Picture Association and Film Artist Association of Nepal (FAAN) has condemned the derogatory comments made by the Indian actor Hrithik Roshan against the sentiments of Nepal.... Agitated demonstrators, mostly comprising of students aligned with both the ruling Nepali Congress and the leftist parties, held rallies and burned photos of effigies of the Indian star throughout the country."

64. Staff Reporter, "Hrithik's Comments on Nepalis Invite Mass Fury," *Kathmandu Post*, December 25, 2000, 1.

65. Ibid., 1. The article states, "At least four people, one of them minor were killed and 30 policemen including 180 others were injured today during police efforts to disperse sporadic riots in the capital over the comments allegedly made by Indian actor, Hrithik Roshan in an interview to an Indian TV channel, aired on December 14."

66. Basanta Shrestha. Interview by author. Notes. Kathmandu, Nepal. June 28, 2007.

67. Avanthi Meduri, "Bharata Natyam—What Are You?" in *Moving History/Dancing a Dance History Reader*, ed. Ann Dils and Ann Cooper Albright (Middletown, Connecticut: Wesleyan University Press, 2001), 103–113.

68. Basanta Shrestha. Interview by author. Notes. Kathmandu, Nepal. June 28, 2007.

69. Seema. Interview by author. Video recording. Kathmandu, Nepal. July 20, 2005.

70. The Shrestha surname is common in the Kathmandu valley. Attributed to a subgroup on Kathmandu's Newari inhabitants, it is not necessarily an indication of family relations.

71. Rajendra Shrestha. Interview by author. Video Recording. Kathmandu, Nepal. July 5, 2005.

72. Mary Douglas, *Purity and Danger: An Analysis of Concepts of Pollution and Taboo* (New York: Routledge, 2002), 141.

73. Liechty, *Suitably Modern*, 71.

74. Gender approaches focus on the inequalities that emerge out of the sociocultural roles associated with the male and female sex. As Parpart says, "individuals who are born into biological categories of male and female become the social categories of men and women through the acquisition of locally defined attributes of masculinity and femininity." Judith Butler proposes that the body produces meaning through "performativity"—culturally compelled series of learned, repeated and reinforced constraints on movement and expression. From this perspective, Bollywood dance is a discipline that produces, perpetuates and sometimes disrupts the rehearsal of acceptable gendered behavior in Nepal. Jane Parpart, "Who is the Other? A Postmodernist Feminist Critique of Women and Development Theory and Practice," *Development and Change* 24, no. 3, (1993): 450. Judith Butler, *Bodies That Matter: On the Discursive Limits of "Sex"* (New York: Routledge, 1993), 2.

75. Yubaraj Sangroula, "Whose Property Is She Anyway?" *Face to Face: Magazine for Development* (1996): 10.

76. Mary E. John and Janaki Nair, "A Question of Silence? An Introduction," in *A Question of Silence? The Sexual Economies of Modern India*, ed. Mary E. John and Janaki Nair (New York: Zed Books, 2000), 12.

77. David G. Mandelbaum, *Women's Seclusion and Men's Honor: Sex Roles in North India, Bangladesh, and Pakistan* (Tucson: The University of Arizona Press, 1998), 120. Supporting this assessment through her study of a Hindu community in Nepal, Mary Cameron observes that caste differences play out differently for men and women as women's lack of control makes them more susceptible to the dangers of ritual pollution. Echoing these perspectives, anthropologist Sarah Lamb suggests that a perception of "openness" and its related heightened exposure to potentially dangerous substances is a crucial determinant of the social situation of women in northern India. See, Mary M. Cameron, *On the Edge of the Auspicious: Sarah Lamb, White Saris and Sweet Mangoes: Aging, Gender, and Body in North India* (Chicago: University of Illinois Press, 2000), 42.

78. Laura Mulvey, "Visual Pleasure and Narrative Cinema," in *Media and Cultural Studies: Key Works*, eds Meenakshi Gigi Durham and Douglas M. Kellner (Malden: Blackwell Publishing, 2001), 393–404;

Laura Mulvey, "Afterthoughts on Visual Pleasure and Narrative Cinema: Inspired by King Vidor's Duel in the Sun (1946)," in *Feminist Film Theory: A Reader*, ed. S. Thornham (Edinburgh: Edinburgh University Press, 1999), 58–69. In this later discussion she grapples with the possibility of a female gaze and asserts its existence through a "metaphor of masculinity." Mulvey's notion of the gaze has been critiqued for it has assumed heteronormativity (Gaylin Studlar), assumption of active male and passive female roles (Ann E. Kaplan) and insufficient engagement with the active audience member proposed by media reception scholars including Henry Jenkins. Gaylin Studlar, *In the Realm of Pleasure* (New York: Columbia University Press 1993), 45–69; Ann E. Kaplan, "Is the Gaze Male?" in *Feminism and Film*, ed. E. Ann Kaplan (Oxford: Oxford University Press, 1983), 119–38; Henry Jenkins, *Textual Poachers: Television Fans and Participatory Culture* (New York: Routledge, 1992), 20–63.

79. Diana L. Eck, *Darśán: Seeing the Divine Image in India* (New York: Columbia University Press, 1998), 3.

80. Vijay Mishra, *Bollywood Cinema: Temples of Desire* (New York: Routledge): 18–19. In his exploration of Hindi cinema, Vijay Mishra touches upon the notion of *darśán* in the film *Acchut Kanya* (Untouchable Maiden, 1936), directed by Franz Osten as he discusses the act of listening within the narrative as an instance of "privileged look endorsed by a higher authority but also an act of philosophical critique."

81. Beena Joshi. Interview by author. Video recording. Kathmandu, Nepal. July 24, 2005.

82. Liechty, *Suitably Modern*, 71.

83. Anju. Interview by author. Video Recording. Kathmandu, Nepal. July 14, 2005.

84. Though no official statistics exist on how many dance bars and cabin restaurants exist in Kathmandu, NGO workers estimated that there were more than 200 dance bars in Kathmandu in 2007.

85. Sudeshna Sarkar, "Bar Girls of Kathmandu," http://www.boloji.com/index.cfm?md=Content&sd=Articles&ArticleID=5725 (accessed April 4, 2011).

86. Ibid.

87. Anirban Roy, "Kathmandu New Dance Bar Capital," *Hindustan Times*, January 20, 2008, 4.

88. STEP Field-staff. Interview by author. Notes. Kathmandu, Nepal. June 30, 2007.

89. Ibid.

90. Dean Creer, "Peer Ethnographical Research Study of Female Sex Workers and Male Clients in the Kathmandu Valley." Kathmandu: PSI (2003): 1–48.

91. Stacey Leigh Pigg and Linnet Pike, "Knowledge, Attitudes, Beliefs and Practices the Social Shadow on AIDS and STD Prevention in Nepal," *Sexual Sites, Seminal Attitudes Sexualities, Masculinities and Culture in South Asia*, ed. Sanjay Srivastava (New Delhi: SAGE Publications, 2004), 274.

92. Ibid., 276.

93. Though I focus more on the Badi in this research, it is also important to recognize that Deuki dance communities are also sometimes cited as communities that foreground sexuality and dance in Nepal. Often compared to the *devadasi* traditions in South India, the *deuki*s are women offered, donated or sold to the temple as an offering of worship. Among the *deuki*s, dance became primarily an act of worship.

94. Rajesh Gautam and Asoke Thapa-Magar, *Tribal Ethnography of Nepal*, vol. 1 (Delhi: Book Faith India, 1994), 87.

95. Regula Burckhardt Qureshi, "Female Agency and Patrilineal Constraints: Situating Courtesans in Twentieth-Century India," in *The Courtesan's Arts, Cross-Cultural Perspectives*, ed. Martha Feldman and Bonnie Gordon (New York: Oxford University Press, 2006), 317.

96. In her research, dance scholar Margaret Walker argues that the *tawaif*s were respected for their artistic achievement. On a similar note, Veena Oldenburg's ethnographic research writing positions the courtesan as an artistically accomplished tradition that even at times challenged the accepted subservient roles for women. Whether seen as subversive or not, the *tawaif*s were members of the cultural life in North India. Margaret Edith Walker, "Kathak Dance, A Critical History" (Phd diss., University of Toronto, 2004), 168–169; Veena Talwar Oldenburg, "Lifestyle as Resistance: The Case of the Courtesans of Lucknow, India," *Feminist Studies* 16, no. 2 (1990): 258–87.

97. Walker, "Kathak Dance," 168–170.

98. Ibid., 171–72.

99. Linnet Pike, "Sex Work and Socialization in a Moral World: Conflict and Change in Badi Communities in Western Nepal," in *Coming of Age in South and Southeast Asia*, ed. Lenore Manderson and Pranee Liamputtong (Richmond: Curzon Press, 2002), 232.

100. Shanta Dixit, "Two Books," *Nepali Times*, September 17, 2004, www.nepalitimes.com.np/issue214/review/2276 (accessed October 20, 2007).
101. Cameron, *On the Edge of the Auspicious*, 31.
102. Pike, "Sex Work and Socialization in a Moral World," 234.
103. Ibid.
104. Prema. Interview by author. Notes. Kala Khola, Nepal. June 24, 2007.
105. Seema. Interview by author. Video Recording. Kathmandu, Nepal. July 20, 2005.
106. Sanjana. Interview by author. Video Recording. Kathmandu, Nepal. June 20, 2007.
107. Deeya. Interview by author. Video Recording. Kathmandu, Nepal, July 4, 2005.
108. Seema. Interview by author. Video Recording. Kathmandu, Nepal. July 20, 2005.
109. Ibid.
110. Liechty, "Carnal Economies in Kathmandu," 15.
111. The article was published on October 9, 2002 in the weekly *Jana Aastha* and was written by Bishwamani Subedi and Yadavprasad Pandey.
112. Manjushree Thapa, "Putting the Media on Trial," *Nepali Times*, October 25, 2002, www.nepalitimes.com.np/issue/116/Guest-Column/5352 (accessed October 4, 2006).
113. Ibid.
114. Jharana Bajracharya appeared in several interviews on this topic, including the "Disharnidesh" program in Nepal Television.

Chapter 5

1. The episode aired on July 9, 2008.
2. Indicine Team, "Hrithik's Krrish in Hollywood," in *Indicine*, http://www.indicine.com/movies/bollywood/hrithiks-krrish-in-hollywood (accessed June 27, 2008).
3. NDM, "Program Notes," in *Access Bollywood Performance*, Redondo Beach Performing Arts Center, Redondo Beach, California, April 12, 2008, 3.
4. As in other chapters, I maintain the anonymity of the dancers and students through the use of first-name pseudonyms. I use surnames

only when speaking about an interview respondent who explicitly requested that their identity be revealed.

5. Blue13 and Bollywood Step also run Bollywood dance classes in the Los Angeles area. Viji Prakash runs a Bharata Natyam school in several locations in the area as well.

6. US Census Bureau, "2005 American Community Survey," www.census.gov (accessed May 12, 2008).

7. Sanjukta Ghosh, "'Con-Fusing' Exotica: Producing India in U.S. Advertising," in Gender, Race, and Class in Media: A Text Reader, edited by Gail Dines and Jean M. Humez (Thousand Oaks: SAGE Publications, 2003), 275.

8. Vijay Prashad, Karma of Brown Folk (Minneapolis: University of Minnesota Press, 2000), 2. Vijay Prashad defines the South Asian minority in the US as, "…the body of Indians and others from the South Asian subcontinent, who now number 1.4 million in the United States. But these people are not all 'Indians.' Many are from Pakistan, Bangladesh, India, Sri Lanka, Bhutan, the Maldives, Africa, England, Canada, Fiji, or the Caribbean, and many are born and bred in the United States."

9. Ibid., 74–75.

10. Ibid.

11. U.S. Census Board. The Asian Population: 2000. (U.S. Department of Commerce, Washington DC: 2002); Lisa Tsering, "Indians Now Third-largest Immigrant Group in U.S.," India West, June 16, 2010, www.indiawest.com (accessed December 5, 2010).

12. Prashad, Karma of Brown Folk, 112–115.

13. Janet O'Shea, At Home in the World: Bharata Natyam on the Global Stage (Wesleyan University Press: Middletown, 2007), 3–25.

14. Sandra Chatterjee, "Undomesticated Bodies: South Asian Women Perform the Impossible" (PhD dissertation, University of California, Los Angeles, 2006), 38.

15. Avanthi Meduri, "Bharata Natyam—What Are You?" in Moving History/Dancing Cultures, ed. Ann Cooper Albright and Ann Dils (Middletown: Wesleyan University Press, 2001), 104; Pallabi Chakravorty, "The Limits of Orientalism: Classical Indian Dance and the Discourse of Heritage," in Reorienting Orientalism, ed. Chandreyee Niyogi (New Delhi: SAGE Publications, 2006), 89. As mentioned in Chapter 2, Rukmini Devi Arundale was "an upper-class Brahmin" who took up the dance today known as Bharata Natyam at the behest of her ballet instructor Anna Pavlova. Her engagement with the dance

contributed to its codification and transformation. Arundale also established a "dance school called Kalakshetra (Academy for Fine Arts) for the transmission of traditional dance knowledge," which continues to operate in Chennai, India.

16. Chakravorty, "The Limits of Orientalism," 91.
17. Ibid.
18. Edward W. Said. *Orientalism* (New York: Vintage Books, 1978), 49–72.
19. Ibid., 43–45.
20. Ghosh, "'Con-Fusing' Exotica," 275.
21. Chakravorty, "The Limits of Orientalism," 91.
22. Ibid., 89.
23. O'Shea, *At Home in the World*, 3.
24. Priya Srinivasan, "Performing Indian Dance in America: Interrogating Modernity, Tradition, and the Myth of Cultural Purity" (PhD dissertation, Northwestern University, 2003), 169.
25. Ibid., 172.
26. Narthaki, an Indian classical dance Internet portal www.narthaki. com (accessed November 23, 2010), indicates that today Bharata Natyam schools exist in almost every city with a sizeable diasporic population.
27. Anita Kumar, "What's the Matter? Shakti's (Re)collections of Race, Nationhood, and Gender," *TDR* 50, no. 4 (2006): 82.
28. Ketu H. Katrak, "'Cultural Translation' of Bharata Natyam into 'Contemporary Indian Dance' Second-generation South Asian Americans and Cultural Politics in Diasporic Locations," *South Asian Popular Culture* 2, no. 2 (2004): 80. Katrak's essay explores how Bharata Natyam "'translates' in contemporary times for second–generation students and performers who have grown up in the US and are located in the Southern California region."
29. Srinivasan, "Performing Indian Dance," 184.
30. O'Shea, *At Home in the World*, 4.
31. I refer to work created before I joined the Collective in January 2006.
32. O'Shea, *At Home in the World*, 13.
33. Preeti Vinayak Shah, "Editorial," *Little India*, November 6, 2007, 6–7.
34. Ibid.
35. Madhu Bhatia Jha, "Fading Ghungroos," *Little India*, October 3, 2007, www.littleindia.com/news/123/ARTICLE/1900/2007-10-03.htm (accessed February 5, 2008).

36. Ibid. King Khan is a colloquial term often applied to the Bollywood star Shah Rukh Khan.
37. Viji Prakash included the song "Ghanana Ghanana" from the film *Lagaan* (2001) in her company performance in Las Vegas 2006. Kathak dancer and teacher, Anjani Ambegaodkar included Kathak, like Hindi film dances in her production of "Made in Mumbai" in September 2007. The performance featured Nakul Dev Mahajan and other NDM company dancers.
38. N.K. Deoshi, "Review," Apukachoice, http://www.apunkachoice.com/movies/mov165/yaadein-review.html, (accessed June 15, 2008).
39. Aseem Chabra, "Yaadein: Ghai's Biggest Overseas Money Spinner," Rediff, http://www.rediff.com/movies/2001/aug/01yaad.htm (accessed May 11, 2008).
40. *Mehndi* in this context describes a henna pattern on the hands and feet often worn by Indian brides.
41. Prashad, *Karma of Brown Folk*, 115.
42. Aswin Punathambekar, "Bollywood in the Indian–American Diaspora: Mediating a Transitive Logic of Cultural Citizenship," in *International Journal of Cultural Studies* 8, no. 151 (2005): 154.
43. Ibid.
44. Dorinne Kondo, "The Narrative Production of 'Home'," Community, and Political Identity in Asian American Theater," in *Displacements, Diaspora and Geographies of Identity*, ed. Smadar Lavie and Ted Swedenburg (Durham: Duke University Press, 1996), 97; Jigna Desai, "Planet Bollywood Indian Cinema Abroad," in *East Main Street: Asian American Popular Culture*, ed. Shilpa Dave, LeiLani Nishime and Tasha G. Oren (New York: New York University Press, 2005), 56.
45. Prema. Interview by author. Notes. Los Angeles. California. November 15, 2006.
46. Tara. Interview by author. Notes. Los Angeles, California. April 10, 2007.
47. Desai, "Planet Bollywood," 63.
48. Vijay Mishra, *Bollywood Cinema: Temples of Desire* (New York: Routledge, 2002), 237.
49. Sangita Shresthova, "Swaying to an Indian Beat. *Dola* Goes My Diasporic Heart: Exploring Hindi Film Dance," *Dance Research Journal* 36, no. 2 (2004): 91–101.
50. Ibid.: 98.
51. Edward W. Said, *Culture and Imperialism* (New York: Vintage Books, 1994), 336.

52. Jan Nederveen Pieterse, *Globalization and Culture: Global Melange* (Lanham: Rowman & Littlefield Publishers, 2003), 142; Ayse S. Çaglar, "German Turks in Berlin: Migration and Their Quest for Social Mobility" (Montreal: McGill University, 1997), 172; Homi Bhabha, "Culture's in-Between," in *Questions of Cultural Identity*, ed. Paul Du Gay and Stuart Hall (Thousand Oaks: SAGE Publications, 2002), 54; Ayse S. Çaglar, "Constraining Metaphors and the Transnationalisation of Spaces in Berlin," *Journal of Ethnic and Migration Studies* 27, no. 4 (2001): 601–613; Stuart Hall, "Introduction: Who Needs 'Identity?'" in *Questions of Cultural Identity*, ed. Paul Du Gay and Stuart Hall (Thousand Oaks: SAGE Publications, 2002), 4–6; Anne J. Kershen, *A Question of Identity* (London: Ashgate Publishing, 1998), 1–22; and Tariq Modood, *Multicultural Politics: Racism, Ethnicity, and Muslims in Britain* (Minneapolis: University of Minnesota Press, 2005), 5–54.

53. Stuart Hall, "Introduction: Who Needs 'Identity?'" in *Questions of Cultural Identity*, ed. Paul Du Gay and Stuart Hall (Thousand Oaks: SAGE Publications, 2002), 4–6; Judith Butler, *Bodies That Matter: On the Discursive Limits of "Sex"* (New York: Routledge, 1993), 105; and Diana Fuss, *Identification Papers: Readings on Psychoanalysis, Sexuality, and Culture* (New York: Routledge, 1995), 1–21.

54. Padma Rangaswamy, *Namasté America, Indian Immigrants in an American Metropolis* (University Park: Pennsylvania State University Press, 2000), 168.

55. Ibid., 169.

56. Ibid.

57. Jigna Desai, "Planet Bollywood Indian Cinema Abroad," in *East Main Street: Asian American Popular Culture*, ed. Shilpa Dave, LeiLani Nishime and Tasha G. Oren (New York: New York University Press, 2005), 62.

58. Durham, "Constructing the 'New Identities'," 152.

59. Durham, "Constructing the 'New Identities'," 154.

60. Marr Maira, *Desis in the House*, 120–121.

61. Ibid.

62. Furthermore, intercollegiate competitions provide additional breadth to Bollywood dance at the college-student level as Indian students engage both college allegiance and cultural identity through Bollywood dance competitions. Jhoomti Shaam and Bollywood Berkeley are two prominent intercollegiate competitions on the West Coast where teams compete in choreography and execution of Bollywood dances.

63. Sunita. Interview by author. Email. Los Angeles, California. May 15, 2007.
64. Sunita. Interview by author. Email. Los Angeles, California. May 15, 2007.
65. Anita. Interview by author. Telephone. Los Angeles, California. May 20, 2007.
66. Ashish Rajadhyaksha, "Bollywoodization of Indian Cinema: Cultural Nationalism in a Global Arena," *Inter-Asia Cultural Studies* 4, no. 1 (2003): 28–29.
67. Mishra, *Bollywood Cinema*, 236–237; Desai, "Planet Bollywood," 65.
68. Nakul Dev Mahajan. Interview by author. Audio Recording. Los Angeles, California. February 15, 2008.
69. Nakul Dev Mahajan. Interview by author. Audio Recording. Los Angeles, California. February 15, 2008.
70. Ibid.
71. James Clifford, *Routes: Travel and Translation in the Late Twentieth Century* (Cambridge: Harvard University Press, 1997), 244.
72. Payal. Interview by author. Notes. Los Angeles, California, November 15, 2007.
73. Tara. Interview by author. Notes. Los Angeles, California. May 5, 2007.
74. Sheila. Interview by author. Notes. Los Angeles. California. April 10, 2007.
75. Nilesh. Interview by author. Notes. Los Angeles, California. June 6, 2007.
76. Shilpa Dave, "'Community Beauty': Transnational Performances and Cultural Citizenship in 'Miss India Georgia'," *Literature Interpretation Theory* 12 (2001): 337.
77. Ibid.
78. Nakul Dev Mahajan. Interview by author. Audio Recording. Los Angeles, California. February 15, 2008.
79. Ibid.
80. Ibid.
81. Anita N. Wadhwani, "'Bollywood Mania' Rising in the United States," U.S. Department of State, http://www.america.gov/st/washfileenglish/2006/August/20060809124617nainawhdaw0.8614466.html (accessed June 27, 2008).
82. Ien Ang, *Watching Dallas: Soap Opera and the Melodramatic Imagination* (New York: Routledge, 1985), 51–85.

83. Srividya Ramasubramanian, "A Content Analysis of the Portrayal of India in Films Produced in the West," *The Howard Journal of Communications* 16, no. 4 (2005): 246.

84. Prashad, *Karma of Brown Folk*, 21–22.

85. Ibid., 18–22.

86. Ramasubramanian, "A Content Analysis of the Portrayal of India in Films," 245.

87. Ibid., 244–259.

88. Ibid., 247.

89. Nakul Dev Mahajan. Interview by author. Audio Recording. Los Angeles, California. February 15, 2008.

90. Rajinder Kumar Dudrah, *Bollywood: Sociology Goes to the Movies* (New Delhi: SAGE Publications, 2006), 118.

91. According to the Czech novelist Milan Kundera, "'Kitsch' is a German word born in the middle of the sentimental nineteenth century, and from German it entered all Western languages." Milan Kundera, *The Unbearable Lightness of Being*, trans. Michael Henry Heim (New York: Harper Perennial Modern Classics, 1999), 248.

92. Clement Greenberg, "Avantgarde and Kitsch," *Partisan Review* (1939), www.sharecom.ca/greenberg/kitsch.html (accessed April 2, 2008).

93. Kundera, *The Unbearable Lightness of Being*, 251.

94. Frederic Jameson, "Postmodernism, or the Cultural Logic of Capitalism," in *Media and Cultural Studies*, ed. Meenakshi Gigi Durham and Douglas M. Kellner (Malden: Blackwell Publishing, 2001), 552.

95. Ruth La Ferla, "Kitsch with a Niche: Bollywood Chic Finds a Home," *New York Times*, May 2, 2002, http://www.nytimes.com/2002/05/05/style/kitsch-with-a-niche-bollywood-chic-finds-a-home.html (accessed June 5, 2003).

96. Mira Kamdar, "Le Bollywood," http://mirakamdar.blogspot.com/2007/06/le-bollywood.html (accessed June 1, 2008).

97. Dudrah, *Bollywood*, 137–140.

98. I was the Bollywood dance guest choreographer for this project.

99. Susan Sontag, "Notes on Camp" (1964), http://interglacial.com/~sburke/pub/prose/Susan_Sontag_-_Notes_on_Camp.html (accessed June 27, 2008).

100. As outlined in the Preface, I am one of the founders of this annual event.

101. Rob Cameron, "An annual celebration of Bollywood Film in Prague," Deutsch Welle Radio Report (October 17, 2008).

102. Suchi Rudra Vasquez, "Bollywood on Parade," *India Currents* (April, 2008): 68.

103. Mira Kamdar, "Le Bollywood," *Mira Kamdar: Writer at Large*, June 15, 2007, http://mirakamdar.blogspot.com/2007/06/le-bollywood.html (accessed June 30, 2007).

104. Ibid.

105. Mira Nair, "Jan chats with internationally-acclaimed director Mira Nair about her new film *Vanity Fair*," interview by Jan Huttner, *Films*, http://www.films42.com/chats/mira_nair.asp (accessed June 1, 2006).

106. Edward W. Said, *Culture and Imperialism* (New York: Vintage Books, 1994), 76–105.

107. William Makepeace Thackeray, *Vanity Fair: A Novel Without a Hero* (London: Penguin Books, 2001): 25.

108. Mira Nair, *About Film*, 2004, interview by Carlo Cavagna, www.aboutfilm.com/features/vanityfair/nair.htm (accessed May 20, 2006).

109. Said, *Culture and Imperialism*, 66–67.

110. Thackeray, *Vanity Fair*, 601.

111. Mira Nair, "Jan chats with internationally-acclaimed director Mira Nair about her new film *Vanity Fair*," interview by Jan Huttner, *Films*, http://www.films42.com/chats/mira_nair.asp (accessed June 1, 2006).

112. This description is based on my research notes of May 2008.

113. Gayatri Gopinath, *Impossible Desires: Queer Diasporas and South Asian Public Cultures* (Durham: Duke University Press, 2005), 100–101.

114. Ibid., 101.

115. R. Raj Rao, "Memories That Pierce the Heart: Homoeroticism, Bollywood-Style," *Journal of Homosexuality* 39, no. 3/4 (2000): 299–306.

116. Ashok Row Kavi, "The Changing Image of the Hero in Hindi Films," *Journal of Homosexuality* 39, no. 3/4 (2000): 307–12.

117. Dudrah, *Bollywood*, 137.

118. Ibid., 138. Rajinder Dudrah recounts several instances of queer subtexts between the film's male protagonists Aman (Shah Rukh Khan) and Rohit (Saif Ali Khan). In one instance, Kanta-ben, the maid, assumes that Aman and Rohit are involved in a sexual relationship

when she finds them sleeping in a bed together. In another scene, the two characters "flirt... and dance together with added suggestions of homosexuality, albeit through the use of humour as a backdrop."

Chapter 6

1. From author's research notes, Fall, 2007.
2. From author's research notes, Summer, 2007.
3. From author's research notes, Spring, 2007.
4. A Hindu God, Krishna is often depicted holding a flute.
5. For detailed discussion on SDIPA classes, refer to Chapter 3.
6. For a detailed discussion, refer to Chapter 4.
7. For a detailed discussion on the historical processes that affected Hindi film dance, refer to Chapter 2.
8. Marta Savigliano, *Angora Matta Fatal Acts of North–South Translation* (Middletown: Wesleyan University Press, 2003), 205.
9. For a more detailed discussion of nationally marked difference through Bollywood cinema, refer to Chapter 4.
10. Arjun Appadurai, *Modernity at Large: Cultural Dimensions of Globalization* (University of Minnesota Press: Minneapolis, 1996), 32.
11. This show description is based on my viewing of a recording of the show.
12. The *Nachle Ve with Saroj Khan* show premiered on NDTV on January 21, 2008.
13. Sunita Mukhi, *Doing the Desi Thing: Performing Indianness in New York City* (New York: Garland Publishing, 2000), 119.
14. Mukhi, *Doing the Desi Thing*, 121.
15. Shabina Khan, Interview by author. Mumbai, India, March 16, 2008.
16. Farah Khan. Interview by author. Notes. London, UK. May 5, 2003.
17. Choreographer Assistant. Interview by author. Notes. Mumbai, India. September 14, 2007.

Appendix 1

1. This narrative is based on a personal interview carried out by the author.

Appendix 2

1. This narrative is based on an interview carried out by the author.
2. A quarter in Kathmandu, Thamel is the city's tourist and nightlife hub.
3. This term describes employment drawing Buddhist paintings.
4. Four thousand Nepali Rupees translates into approximately US$60.
5. This term describes a Hindu ritual offering to specific deities.
6. These are two deities associated with dance in Hindu mythology.

Appendix 3

1. This narrative is based on an interview carried out by the author.
2. Gordon Thompson and Medha Yodh, "Garba and the Gujaratis of Southern California," in *Asian Music in North America*, ed. Sue Carole DeVale and Nazir A. Jairazbhoy (Los Angeles: University of California Los Angeles, 1985): 59–79. Garba is a folk dance that originates from the Indian state of Gujarat.

Appendix 4

1. This narrative is based on a personal self-interview carried out by the author.

Selected Films Cited

Film	English Title	Year	Director
Aama	Mother	1964	Hira Singh Khatri
Alam Ara	The Light of the World	1931	Ardeshir Irani
Awaara	Tramp	1951	Raj Kapoor
Bhool Bhulaiya	The Maze	2007	Priyadarshan
Black Friday		2004	Anurag Kashyap
Bollywood Dancing		2001	Nasreen Munni Kabir
Bride and Prejudice		2004	Gurinder Chadha
Chandni	Moonlight	1989	Yash Chopra
Devdas	Devdas	2002	Sanjay Leela Bhansali
Dhoom	Blast	2004	Sanjay Gadhvi
Dhoom 2	Blast 2	2006	Sanjay Gadhvi
Dil Chahta Hai	The Heart Desires	2001	Farhan Akhtar
Dil Se	From the Heart	1998	Mani Ratnam
Dil to Pagal Hai	The Heart is Crazy	1997	Yash Chopra
Dilwale Dulhania Le Jayenge	The Big Hearted Will Take the Bride	1995	Aditya Chopra

(Continued)

Film	English Title	Year	Director
Do Bigha Zamin	Two Acres of Land	1953	Bimal Roy
Fanaa	Destroyed in Love	2006	Kunal Kohli
Ek Vivaah... Aisa Bhi	A Marriage... Like This Too	2008	Kaushik Ghatak
Guide		1965	Vijay Anand
Gulabi Aaina	The Pink Mirror	2003	Sridhar Rangayan
Guru	Guru	2007	Mani Ratnam
Hum Aapke Hain Kaun	Who Am I to You	1994	Sooraj Barjatya
Hum Dil De Chuke Sanam	Straight from the Heart	1999	Sanjay Leela Bhansali
Inside Man		2006	Spike Lee
Jhanak Jhanak Payal Baaje	The Ringing of the Bells	1955	Rajaram Vankudre Shantaram
Kabhi Alvida Naa Kehna	Never Say Goodbye	2006	Karan Johar
Kabhi Khushi Kabhi Gham	Sometimes Happiness, Sometimes Sadness	2001	Karan Johar
Kaho Na Pyar Hai?	Say... You Love Me	2000	Rakesh Roshan
Kal Ho Naa Ho	There May Be A Tomorrow or Not	2003	Nikhil Advani
Khalnayak	Villain	1993	Subhash Ghai

Film	English Title	Year	Director
Koi... Mil Gaya	I Found Someone	2003	Rakesh Roshan
Kranti	Revolution	1981	Manoj Kumar
Krrish	Krrish	2006	Rakesh Roshan
Kuch Kuch Hota Hai	Something Happens	1998	Karan Johar
Lagaan	Land Tax	2001	Ashutosh Gowariker
Lage Raho Munnabhai	Carry On Munna Brother	2006	Rajkumar Hirani
Madhumati		1958	Bimal Roy
Main Hoo Na	I Am Here For You	2004	Farah Khan
Monsoon Wedding		2001	Mira Nair
Mother India		1957	Mehboob Khan
Moulin Rouge		2001	Baz Luhrmann
Mumbai Cutting...		2008	Rahul Dholakia, Rituparno Ghosh, Anurag Kashyap, Ayush Raina, Ruchi Harain, Jahnu Barua, Shashank Ghosh, Sudhir Mishra, Revanthi, Kundan Shah, Manish Jha
Namastey London		2007	Vipul Amrutlal Shah
No Entry		2005	Anees Bazmee
Om Shanti Om	Om Shanti Om	2007	Farah Khan

(Continued)

Film	English Title	Year	Director
Paheli	Riddle	2005	Amol Palekar
Pakeezah	The Pure One	1972	Kamal Amrohi
Pardes	Foreign Land	1997	Subhash Ghai
Parineeta	Married Woman	2005	Pradeep Sarkar
Partner		2007	David Dhawan
Race		2008	Abbas Alibhai Burmawalla
Ram Teri Ganga Maili	Ram, Your Ganges is Filthy	1985	Raj Kapoor
Rang De Basanti	Color of Sacrifice	2006	Rakeysh Omprakash Mehra
Salaam-E-Ishq	A Salute to Love	2007	Nikhil Advani
Salaam Namaste	Urdu and Hindi greetings, respectively	2005	Siddharth Anand
Sholay	Embers	1975	Ramesh Sippy
Swades	Homeland	2004	Ashutosh Gowariker
Taal	Rhythm	1999	Subhash Ghai
Umrao Jaan	Umrao Jaan	1981	Muzaffar Ali
Umrao Jaan	Umrao Jaan	2006	J.P. Dutta
Veer Zara	Veer Zara	2004	Yash Chopra
Yaadein	Memories	2001	Subhash Ghai
Zanjeer	Shackles	1973	Prakash Mehra

Glossary

In this section, I provide brief explanations of key foreign terms and personalities that recur in the text. This section is not intended to provide in-depth discussions as these occur elsewhere in the book. It rather intends to provide a brief reference for readers.

Term/Name	Explanation
Abhinaya	Expressive elements of Indian dance and drama.
Aishwarya Rai	Former Miss World and a very popular Hindi film actor.
Amma	Mother.
Amitabh Bachchan	Well-known Hindi film actor.
Arangetram	The first stage performance of a Bharata Natyam dance student.
Badi	Dancer/musician/entertainer community in western Nepal.
Bhangra	A folk dance and music form that originated in the Punjab.
Bharata Natyam	A dance from Tamil Nadu, formerly practiced by dancers in Hindu temples
Bigryo	Nepali term to describe something ruined or broken.
Charya Nritya	A tantric Buddhist dance historically practiced in the Kathmandu valley.
Choli	Short blouse.
Dalit	"Untouchable" caste.
Desi	Translated as "of the Earth," this term is used do describe persons of Indian origin.

Devadasis	Dancers in Hindu temples associated with the dance that is today known as Bharata Natyam.
Dola	Body position from the Bharat Natyam repertoire were the arm is relaxed and slightly raised.
Dupatta	Scarf
Femina	A women's fashion and lifestyle monthly magazine in India.
Filmi	Literally translated as "having to do with film" and formerly slightly derogatory, this term is now often used by dancers who dance by Hindi films to describe their work.
Ganesh Hegde	Hindi film dance choreographer.
Ganesha	Hindu God of good luck.
Garba	A folk dance from the Indian state of Gujarat.
Hrithik Roshan	A popular Hindi film actor who is recognized for his dance skills.
Ishq	Love
Kalaripayat	Indian martial art from the Indian state of Kerala.
Karan Johar	Indian film director and producer.
Kathak	A dance from northern India historically associated with the "*tawaif*s"
Kuchipudi	Dance historically practiced in the Indian state of Andhra Pradesh.
Kurta	A long top worn by men and women
Lahure	Term is associated with Nepal's Gurkha soldier and refers to the desire to go travel and go abroad. Today the term is often used to describe young Nepali's aspirations to travel to western Europe and America.
Laj	Shame and/or shyness.

Madhuri Dixit	Popular Hindi film actress.
Maiti	The maternal home in Nepali.
Masala	Translated as "spicy" this term is often used to refer to the multigenred, emotional spectrum of Hindi films, where one film may contain song, dance, fights, and comedy.
Masala Dosa	Indian snack.
Mehndi	Application of henna for skin decoration.
Mohiniattam	Indian dance form that originates from the Indian state of Kerala.
Mridangam	Drum
Muluki Ain	Nepali legal code.
Nataraj	Shiva as the Lord of Dance.
NDMBDS	Acronym that stands for Nakul Dev Mahajan Productions.
Nollywood	A branch of Nigerian cinema, that is, at least in part, inspired by Bollywood.
NRI	A term that describes persons of Indian origin living outside India or Non-resident Indians. In India today, the acronym is also jokingly said to stand for "Not Required Indian."
Parsi theater	A theater style conceived in the 1800s, associated with the Parsi community and known for its narrative digressions.
Pooja	The act of worship in Hinduism.
Sahar	Nepali term to describe place.
SDIPA	Acronym that stands for the Shiamak Davar Institute of Performing Arts.
Shah Rukh Khan	Popular Hindi film actor.
Shiv Sena	Translated as the "Army of Shiva" is a right-wing Indian party founded in 1966.
Sloka	A verse from a Hindi text.

South Asian	A problematic descriptor of the South Asian Association for Regional Cooperation (SAARC) member nations which include Pakistan, India, Maldives, Sri Lanka, Nepal, Bhutan, and Bangladesh. In academia, the term is often used interchangeably with India.
Sringara	Erotic desire as expressed through Indian drama and dance.
Tamasha	An Indian folk theater form linked with song and dance and general loud activity.
Tawaif	Dancer and entertainer versed in arts as part of a practice historically located in north India.
Western	Even as I recognize the shortcomings of the "West" and "East" discourse, I have made a conscious decision to cautiously apply these terms in my dissertation. I premise my decision on to considerations. Firstly, terms like "West," "East," "Western," and "Eastern" were often used by my respondents to identify aesthetic choices, production and consumption patterns. Secondly, the terms also surface frequently in academic discourse about Hollywood and Hindi cinema. My use of the term, however, tends toward a more ideological, rather than geographical description. In fact, my discussion will endeavor to reveal that there is "East" in the "West" and "West" in the "East."
YouTube	User-generated video website portal.

Index

About the Author

Sangita Shresthova is currently the Research Director of the Media Activism and Participatory Politics Project (MAPP) at the Annenberg School for Communication and Journalism, University of Southern California, Los Angeles, USA. She is a dancer and media artist who holds a PhD from the Department of World Arts and Cultures, UCLA. She earned an MSc degree from MIT's Comparative Media Studies program where she focused on Hindi film dance.

Sangita's work has been presented in academic and creative venues around the world including the Other Festival (Chennai), the EBS International Documentary Festival (Seoul), and the American Dance Festival (Durham, NC). Her writing has appeared in academic publications like *Global Bollywood*, an edited volume on Hindi cinema. Sangita was the Programming Director of the Prague Bollywood Festival, an annual event she helped found nine years ago.

Sangita studied Bharata Natyam under Malathi Srinivasan in Chennai, as well as Charya Nritya (Nepalese Dance), Kalaripayat (South Indian martial arts), and contemporary dance techniques. She was a guest choreographer for the Constanza Macras/DorkyPark production "Big in Bombay." Her documentary titled, "Dancing Kathmandu" (2007), was a curtain raiser at the Kathmandu International Mountain Film Festival. Sangita continues to explore the possibilities of Indian dance, film, and new media through Bollynatyam™, the company she founded in 2004.